# ALARM 38

Music & Art Beyond Comparison

Edited by Chris Force with Scott Morrow

ALARM Press, LLC
Chicago

PUBLISHED BY ALARM PRESS, LLC

ISBN 978-098263894-1

A version of this book has also been prepared as a magazine, ISSN 1555-8819

Library of Congress Control Number: 2010907255

Published quarterly by ALARM Press, LLC.
222 S. Morgan Street, Suite 3E, Chicago, IL 60607.

www.alarmpress.com

Printed in South Korea

10 9 8 7 6 5 4 3 2 1

First Edition

"I love it when the music itself takes me somewhere I'm not really in control of."

**TRENTEMØLLER**

# ALARM 38 / INVISIBLE

## 01 / INVISIBLE IMPACTS & FORGOTTEN HISTORIES

Recounting unseen forces and whitewashed narratives, these stories feature artists who erase their tracks, who call upon invisible members, who question our nature, and who seek to right injustices.

## 02 / OUT OF SIGHT

Meet obscure bands from other hemispheres, a cult icon who relocated and assimilated, a musician with millions of monikers, and an artist collective that arranges exhibitions in unsold condos.

*Photo of Krallice by Justina Villanueva*

## 03 / BLURRED BOUNDARIES

Heavy metal with traditional Japanese music, IDM with musique concrète, jazz rock with Eno-inspired atmospherics—these visionary musicians are blind to genre demarcations.

## 04 / BEHIND THE MASK

Seven contemporary artists explain their motives for going incognito.

## 05 / UNTOLD STORIES

Whether familiar or completely unknown, these names each have a tale to tell.

## 06 / OVERLOOKED ALBUMS

# 38 ALARM

# CONTRIBUTORS

**PUBLISHER & EDITOR**
Chris Force

**MUSIC EDITOR**
Scott Morrow
scottm@alarmpress.com

**CONTRIBUTING EDITOR**
Jamie Ludwig

**COPY EDITORS**
Michael Danaher
Punam Patel

**DESIGN DIRECTOR**
Lindsey Eden Turner
lturner@alarmpress.com

**THE CREW**
Timothy S. Aames
Buck Austin
Summer Block
Michael Patrick Brady
Chris Catania
Oakland L. Childers
Brendan Dabkowski
Michael Danaher
Nick DeMarino
Jonathan Easley
Katie Fanuko
Matt Fields
Daniel Fuller
Ali Gitlow
Patrick Hajduch
Connie Hwong
Pete Klockau
David Metcalfe
Jeff Min
Arthur Pascale
Adam Redling
Saby Reyes-Kulkarni
Luc Rodgers

Matt Seager
Marla Seidell
Jessica Steinhoff
Charlie Swanson
Jeff Terich
Kim Velsey

**PHOTOGRAPHERS**
Jonathan Allen
Cecilia Austin
Ellen Chu
Dusdin Condren
Christopher Eichenseer
Steve Gong
JUCO
Noah Kalina
Eric Luc
Cybele Malinowski
Bryan Sheffield
Justina Villanueva
Andrew Waits
Elizabeth Weinberg

**INTERNS**
Arthur Pascale
Liza Rush

Cover image of The
Tango Saloon drum
kit shot in Sydney by
Cybele Malinowski.

**TIMOTHY S. AAMES** grew up on a micro-nature reserve in Kansas and was, by default, an environmentalist by age 3. He is now a writer, advocate, and amateur activist in Chicago, where he lives with his wife, Allison. For this issue of ALARM, he chronicles the history of Bazombo trance group Konono No. 1.

**STEVE GONG** is a photojournalist and portrait photographer based in New York, London, and Beijing. He was born in Beijing, China and grew up in Rome, Italy. Steve attended the University of Virginia in Charlottesville, USA and holds a BA in biology and a BA in psychology. He is currently pursuing an MA in photojournalism and documentary photography at the London College of Communication. For this issue, he shot Konono No. 1 and Trans Am in London.

**KATIE FANUKO** is a Chicago-based freelance writer and has contributed to ALARM since issue 34. When she's not writing about musically inclined robots or street art made out of packing tape, she's checking out apartment art galleries. If she's not doing that, she's volunteering at Chicago's Open-Books. If she's not doing that, she's working on a compilation of short stories. And if she's not doing that, then she's probably catching up on her sleep. For this issue of ALARM, she wrote about LEMUR, Jorge Chamorro, Mark Jenkins, and Richard Colman.

**ERIC LUC** is a fine-art and editorial photographer living in New York City. His photographs capture collections of people and places that tend to render even the most banal assemblages unfamiliar. His contributions to this issue include pieces on J.G. Thirlwell in Brooklyn, NY and the duo Matmos in Baltimore, MD, its home city.

# LETTER FROM THE EDITOR

This is the 15th year that I've been making ALARM Magazine (please send pats on the back and love letters to the address on the copyright page), and it's still just as hard to explain what, exactly, ALARM is.

Our default answer is that ALARM is an independent music and art magazine—not to be confused with the genre of indie music, or the great majority of independent musicians trying desperately *not* to be independent musicians. The answer is never simple or satisfying. We've allowed ourselves the freedom and self-indulgence to be unbound and irresponsible to anyone else but ourselves—and in the process we've attracted like-minded musicians and artists. So for this issue of ALARM, we've sidestepped the word independent and discussed the concept of being invisible.

It's not that ALARM, or the artists within, can't be seen—many of them have widely available recordings, well-attended performances, and broad name recognition. It's their reasoning, inspiration, and motivation that go without being discerned or acknowledged.

Why would Mike Patton, a rock musician who has sold millions of records and maintains a fanatical following, move to an Italian town to learn the language and cover regional pop tunes from the 1960s with a 50-person orchestra? Music editor Scott Morrow asks him on page 64. And why does Tim Barry, a successful working musician also with his own legion of fans, live off the grid with a "compost bucket and no running water"? Contributing editor Jamie Ludwig discusses the reason on page 40. Carolina Chocolate Drops, one of the last remaining African-American string bands, pays homage to its region's vast, but largely overlooked, black banjo- and fiddle-playing history. Author Jessica Steinhoff writes about the group on page 14.

So, for the 15th year, we're presenting an amazing, inspiring, and eclectic group of musicians and artists in ALARM. We're grateful to be surrounded by such strange and wonderful artists willing to do what they love for whatever reasons, visible or not, that make sense to them.

- Chris Force

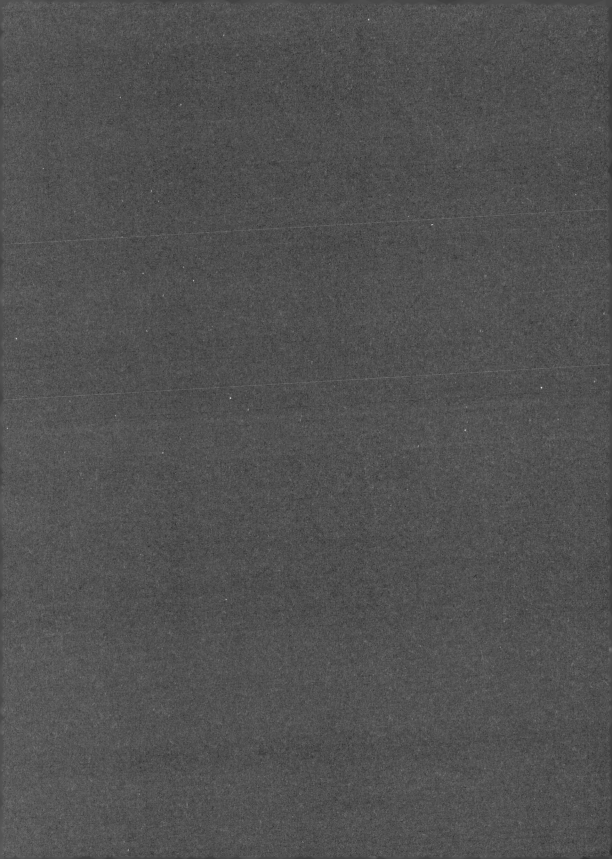

# INVISIBLE IMPACTS & FORGOTTEN HISTORIES

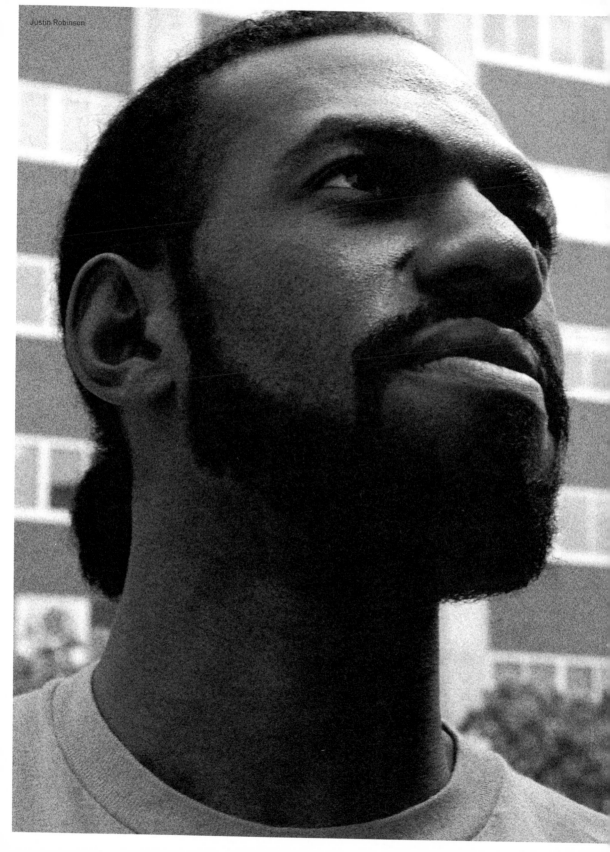

Justin Robinson

# CAROLINA CHOCOLATE DROPS

JESSICA STEINHOFF / *PHOTOS BY ERIC LUC*

Carolina Chocolate Drops knows a thing or two about blending in. On the cover of the trio's new album, *Genuine Negro Jig*, Rhiannon Giddens makes camouflage out of a bright-red dress. Draped on the sofa like a blanket, she matches her surroundings (a red velvet curtain and Oriental rug) so well that she almost disappears.

Maybe she's remembering the old days of the band's home base of Durham, North Carolina, where until the '60s, black faces occupied the backs of buses and the margins of their local community, even though they'd created a thriving center of industry, culture, and especially music.

Or maybe she's channeling the spirit of writer Mary Mebane, who likened her 1930s Durham childhood to an elaborate game of dress-up. Mebane described this Durham as a place where "black skin was to be disguised at all costs" and where those with the darkest faces drowned their insecurities in makeup and whisky.

So perhaps standing out is an even larger feat for Giddens and her bandmates, Dom Flemons and Justin Robinson. They can't help it, given their musical chops, but they don't just accept it. They embrace it. And they get their gusto from the ghosts of North Carolina's past, the black folks who pioneered much of the Appalachian music that launched the careers of white guys like Bela Fleck, the New Lost Ramblers, and the Avett Brothers.

Surprisingly, it was Fleck and the Ramblers who helped Giddens, Flemons, and Robinson find one another at the 2005 Black Banjo Gathering in Boone, NC. The three expected to learn about the instrument's African and African-American roots, not come away with a globetrotting ensemble and a record deal.

The timing must have been just right. Fleck had recently returned from an African tour, and Mike Seeger of the Ramblers had left New York for a southern sojourn. Flemons traveled all the way from Phoenix just to learn from them. But it was an 86-year-old fiddler named Joe Thompson who sealed the deal, transforming three wandering souls into a tight-knit ensemble.

Now 91, Thompson is thought to be the last living performer from the golden age of Piedmont string bands. In the early 20th Century, he and his family were playing socials and square dances for black and white families alike. At the time, it was one of the rare instances where the racial divide softened, if only for a few hours.

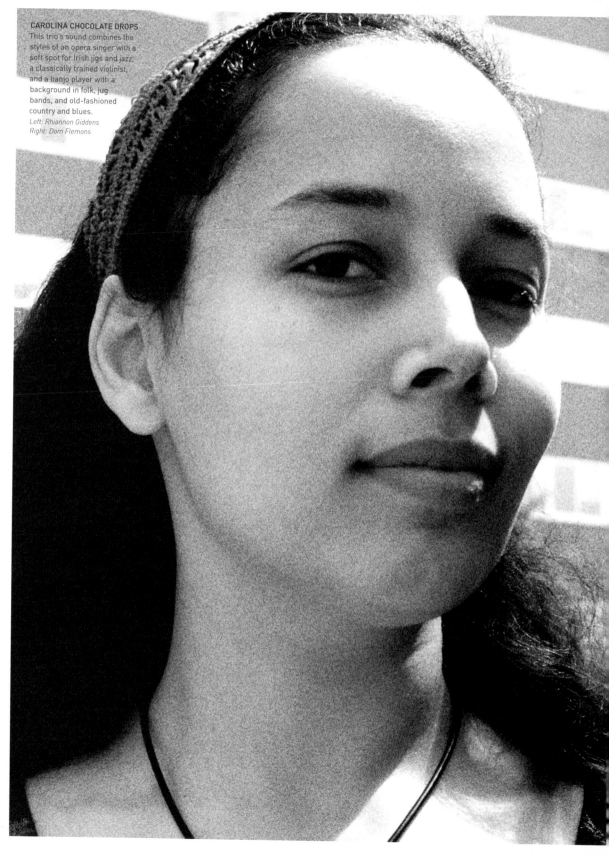

Many people are familiar with the white fiddle-and-banjo music of the southern Appalachian region, but the Piedmont tradition is slightly different. Unlike other Appalachian music, it gives the leading role to the banjo, which sets the tone and tempo of the tunes. The fiddle tends to come second, providing backup along with instruments such as the jug and spoons. This unique combination was pioneered by families of black musicians. Although the banjo was created in the USA, it was inspired by a few lute-like West African instruments. Banjo music was often passed from one black family to the next, and it eventually made its way to other ethnic groups. Until the early 20th Century, young white musicians usually befriended an older black musician if they wanted to learn it.

Learning the banjo also helped the Drops find its identity as a band. Though the group is an old-time string band steeped in Piedmont's unique blend of folk and blues, it's a melting pot of other influences as well: some hip hop here, some bluegrass there, with rock and jazz essences filling the gaps. But the three musicians didn't meld together until Thompson entered the picture.

Somebody had to figure out how to integrate the styles of Giddens, an opera singer with a soft spot for Irish jigs and jazz, with those of Robinson, a classically trained violinist, and Flemons, an Arizona native with a background in folk, jug bands, and old-fashioned country and blues. A Piedmont fiddler through and through, Thompson decided that the best way was to teach them to accompany each other in music and in life.

"We'd go down to his house on Thursday nights and learn how to back him up," Flemons says. "He'd tell us about some of the older ways of [southern] living, things like tobacco auctions and frolics, which are square dances in the black community. We really learned about the social functions of the music."

Pretty soon the band was swapping melodies and instruments, do-si-do style. Now Robinson takes the lead on fiddle, adding banjo, autoharp, and jug as needed, while Flemons lends his skills on various

banjos, plus the jug, quills, and harmonica. Giddens plays fiddle, banjo, and kazoo when she's not wowing the crowd with her vocals.

The audience has added instruments to the lineup too. One fan gave Flemons a set of bones, which also spice up the rhythm of minstrel songs, zydeco, and bluegrass.

"She insisted that I learn how to use them, then showed me how to play them," he says. "There have been a lot of interesting and wonderful experiences where people have shared songs, instruments, and memories with us. For some reason, our music has opened that up inside of them. Being able to do that is truly amazing."

Though the group's goal is to make great music and build a bit of community, it comes with a side of history, especially at its live shows, where Carolina Chocolate Drops is interested in telling the history that history books left out. The trio isn't breaking out Howard Zinn's books on stage, but it's telling it like it is: black people pioneered much of the traditional folk music that spawned country songs. And the banjo wasn't invented by Bo Duke and The Balladeer. It evolved from several types of African lutes, thanks to the ingenuity of slaves—a fact that banjo players themselves often are surprised to learn.

In other words, though Appalachian tunes have become the music of all Americans, there's another truth lurking in the shadows: the story behind the music has been whitewashed. We tend to remember the white banjo students but not their black teachers. As a result, much of tradition's richness is buried, along with the bones of those who played the minstrel shows of the 1880s and the hoedowns of the 1920s and '30s.

Carolina Chocolate Drops makes music that breaks down cultural barriers and brings together people from various walks of life, but it's making those black musicians and teachers stick out—in a good way. It's also helping them gain their rightful place in history and in the imaginations of those listening to the music today.

This theme of rewriting history is heavy one moment and lighthearted the next, much like the songs of *Genuine Negro Jig*. At least half of the album is good, old-fashioned hoedown fare. There's hooting and hollering and crazy kazoo solos. There's more banjo than the *Dukes of Hazzard* theme song and plenty of material for stomping, swinging, and square dancing.

Most recently, the music opened the doors of Nonesuch Records, the label that the Magnetic Fields, Brian Wilson, and David Byrne call home. This, in turn, unlocked a Pasadena mansion that once belonged to President Garfield's widow—and where producer Joe Henry now lives. It was the perfect place to record an album built upon American history.

## "WE'RE NOT TRYING TO BRING THE OLD TIMES BACK, BUT WE'RE USING THEM TO HELP PEOPLE ENJOY THEMSELVES."

The other half has some frank messages: advice on how to treat a cheatin' man and exorcise one's inner demons. It's the kind of stuff that gets you talking after passing out from moonshine and dancing. You can't help but get to know your neighbor.

This is a novel concept for people who spend most of their time on Facebook and iPhones. Yes, the Internet is great at bringing people together, but you can't dance with it. That's why Carolina Chocolate Drops blends the whimsy of eras past with the stuff that makes people human today: getting drunk, making out, showing off, and screwing up.

Flemons says that the group marries old and new with the West African concept of Sankofa, which means "go back and fetch it." It takes good ideas from the past, brings them to the present, and gives them new life.

"We're not trying to bring the old times back, but we're using them to help people enjoy themselves," he says. "Building community by getting people to sing and dance together at a concert makes sense in the modern world."

But there's more to it than that. They're creating something new as well.

These sessions led to a haunting rendition of Tom Waits' "Trampled Rose" and a fiddle-hop take on Blu Cantrell's "Hit 'Em Up Style." On the latter, Giddens' vocals create shivers as she alternately sets the track on fire with her fiddle. Underneath, Flemons' beat boxing conjures the streets better than a cranked-up bass and a set of chrome rims. Then on the old Charlie Jackson tune "Your Baby Ain't Sweet Like Mine," the band traces the blues back to its roots and gives them a Vaudevillian twist, while the Carolinian standard "Trouble in Your Mind" creates the insanity of which it warns with an out-and-out hootenanny. It's hardly the way to blend in with the crowd.

Flemons says that the album is more of a genre bender than the band's earlier releases, but don't expect Carolina Chocolate Drops to change its tune anytime soon.

"We're proud to be who we are: an old-time black string band," he says. "We don't need to turn into a '60s girl group or a hair band to stand out." ●

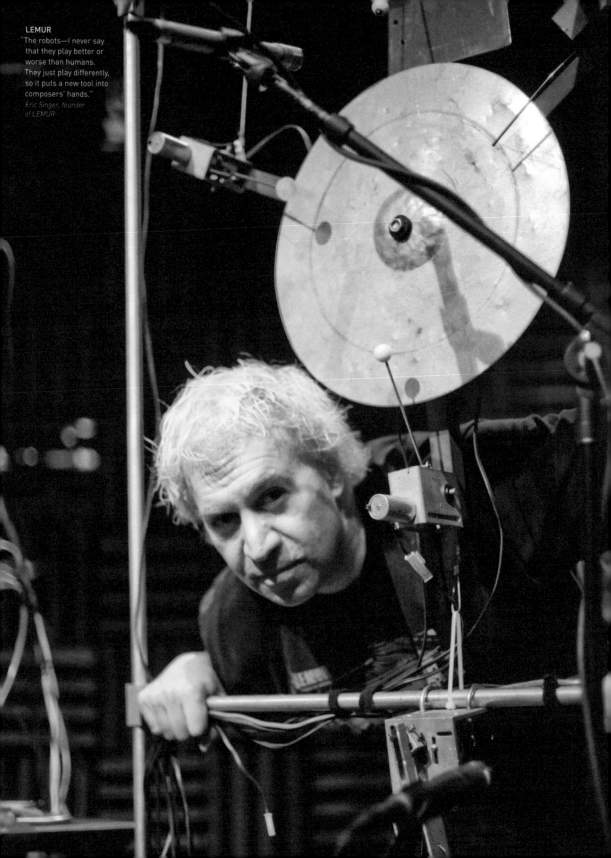

**LEMUR**

"The robots—I never say
that they play better or
worse than humans.
They just play differently,
so it puts a new tool into
composers' hands."

*Eric Singer, founder
of LEMUR*

# LEAGUE OF ELECTRONIC MUSICAL URBAN ROBOTS

KATIE FANUKO / *PHOTOS BY ELIZABETH WEINBERG*

The concept of robots that play music—let alone ones that do so on stage and in perfect time—is alien to the population at large. So it's not uncommon for Eric Singer, the founder of the League of Electronic Musical Urban Robots (LEMUR), to raise eyebrows when describing his creations.

"I was once asked, 'What does a musical robot sound like?' and I said, 'That's kind of like asking, 'What does a piano sound like?'" he says from his headquarters in Pittsburgh. "It entirely depends on who's playing it and who's performing."

Even though the notion of instrumental robots can feel ahead of its time, a quick trip to YouTube easily dispels any disbelief. A search of "Pat Metheny" and "LEMUR" pulls up a seven-minute video in which Metheny, a jazz-fusion composer, plays guitar and is accompanied by an orchestra of LEMUR bots—automated arms, levers, and gears that can command a small army of accompanying instruments. The performance is intuitive and seamless, and it's hard to believe that living, breathing musicians are not playing it. "I didn't know quite what to expect when I started this whole thing, especially making a record with it," Metheny says during the video, referencing his newest album, *Orchestrion*. "The result is absolutely nothing like what I would have imagined."

Singer formed LEMUR in 2000, but he has tinkered

with computers and robotics since attending Carnegie Mellon University, where he graduated in 1988 as a computer-engineering major. While at Boston's Berklee College of Music over the next few years, he discovered the school's music-synthesis department and started taking serious strides in fusing his interest in technology and music. "I had been a musician for most of my life, so I always had this left-brain, right-brain fight, knowing that I would never sort of be happy just doing one or the other," Singer says. New-wave artists like They Might Be Giants and XTC heavily influenced his work, and the growing role that electronics played in music creation spurred him to keep pushing the envelope. "Back in the late '80s and early '90s, it was sort of a difficult thing to do compared to today," Singer says. "We didn't have microprocessors or development kits or things like that, so my first instruments were hooked up to Apple II computers."

During his years in grad school at New York University in the mid-'90s, he started incorporating what he was learning in the classroom into the music that he was creating. His growing interest in artificial intelligence also had a major impact on the direction of his future career. "We had this [CGI] saxophone player created in the lab that I was working at, and we wanted to make him improvise along to the music," Singer says. "We would send him information about what the piano player was playing, and he would

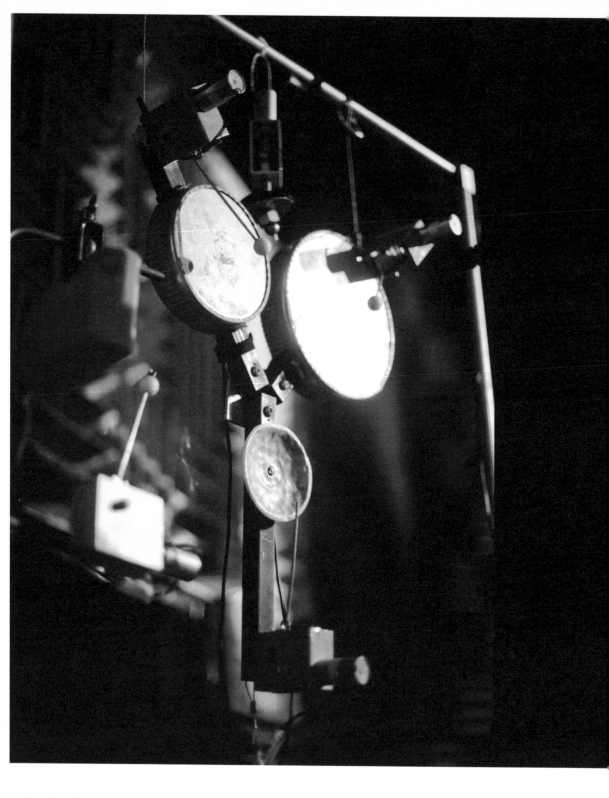

Above: One of LEMUR's many percussion bots
Facing page: The LEMUR guitar bot

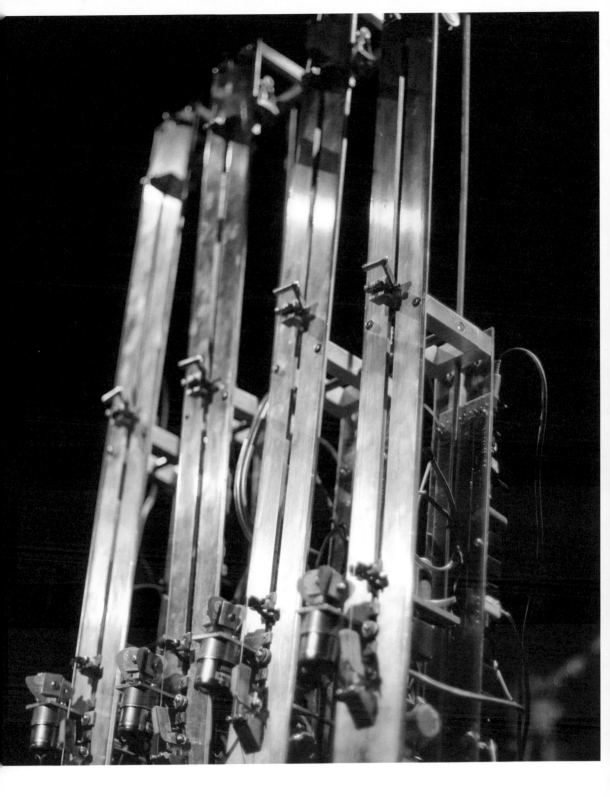

create a saxophone improvisation based on that. Bear in mind that NYU's computer-science program really has nothing to do with music, but I was able to see the connections between techniques in computer science that could be purposed in music."

Singer had made instruments that produced computerized sound for nearly a decade before he decided to find ways to incorporate acoustic instruments into the mix. "I thought one day, 'If I reverse the equation and have a computer do the talking, that could go out to real instruments," he says. Soon enough, he started brainstorming with colleagues, and the League of Electronic Musical Urban Robots was born. Contrary to the images that thoughts of a musical robot can conjure, LEMUR bots often look and sound just like regular instruments that are simply guided by MIDI software and computer programming. "One of the philosophies of the group is to create instruments that are robotic as opposed to adding robots to existing instruments," Singer says. "It's given the same kind of control over acoustic instruments that musicians have enjoyed for a long time over electronic sounds, and acoustic instruments have particular advantages over synthesizer sounds. They sound, in general, just more rich and live." Over the years, musicians such as contemporary composer Todd Reynolds, experimental violinist Mari Kimura, and electronic pioneer Morton Subotnick have created music utilizing LEMUR, and Singer's observations of their compositional styles has informed the evolution of his project. "It's my job as a creator to make my instruments as easy to use and as intuitive to use as possible," he says, "and that has frankly taken a long time—several iterations and interfaces on the robots themselves. I've learned a lot from watching the composers work and what it takes to work seamlessly with the instruments."

In terms of selecting musicians for collaboration, Singer tends to be open to different genres, and it's not uncommon for musicians to approach him with ideas. In Metheny's case, he commissioned Singer to create custom LEMUR instruments that would accompany him on a Spring 2010 tour and essentially act as his backup band. "In his show, he comes out playing a live acoustic guitar for a few songs, and

then he plays a song with one robot," Singer says. "Then he lifts the curtain up and unveils the orchestra that is about 60 instruments, and about 45 were created by us."

Singer also took his act on the road during his first (of many) collaborations with Reynolds, a former member of Bang on a Can as well as Steve Reich and Musicians. In 2008, Reynolds toured with LEMUR and Singer through Poland, where Reynolds was so dedicated to the project that he would compose pieces throughout dress rehearsals and then play them live later the same night. "I spend a lot of time staring at a computer screen producing and creating," Reynolds says, "and on stage interacting with scenarios that I have set up in the laptop. My journey in the electronic-music world has involved creating a hybrid, augmented instrument built out of old and new technology, so considering another set of instruments [that] were also hybrids was a no-brainer—and very compelling." This past May, Singer and Reynolds collaborated again for two shows, one at Joe's Pub in New York City and another with the Albany Symphony Orchestra's chamber group, Dogs of Desire, at the Experimental Media and Performing Arts Center in Troy, New York. "I think that his style is very well suited to work with the robots," Singer says of Reynolds, "and he does a lot of improvisation with the robots and the instruments. That, to me, is a really good thing and a driving force for what can be done with the instruments."

Kimura, a 2010 Guggenheim Fellowship recipient, is another musician who has taken an improvisational approach with LEMUR. She originally teamed up with Singer in 2003 while she was in New York City. After seeing a demo of his guitar bot, she knew that she had to do a duet with it. "I enjoy a certain randomization with limits so that 'we' can both be facing the same direction, but not necessarily taking the same road every time," Kimura says. "[The project] certainly does have an enormous influence on my compositional process."

A personal milestone in Singer's career occurred in 2007, when he was able to perform with his idols They Might Be Giants and other luminaries like

Subotnick, jazz trombonist George Lewis, and unclassifiable composer J.G. Thirlwell during Robosonic Eclectic: Live Music by Robots and Humans—a concert that included everything from laptop performances to a stringed LEMUR ensemble. "I decided to have a string quartet in my composition," Thirlwell says of his contribution to the evening. "I enjoyed working with the guitar bot sitting right next to me, as all its mechanics are quite squeaky and percussive. I started getting used to its idiosyncrasies. It starts to feel human."

For Singer, the concert was an opportunity to see the multitude of ways that technology could be used by

says. "And every time they collide, a corresponding pair of robots play or a percussion sounds. It's a very integrated, very interactive sound video and robotic experience and is very unique among the field."

In addition to his work with LEMUR, Singer has delved further into algorithmic composition, which allows music to be generated by a computer based upon specific equations or set parameters. One of Singer's projects allows a computer to take pieces written by Johann Sebastian Bach, analyze them, and reconstruct modern interpretations of Bach's work. "I wouldn't purport that they necessarily write anything that accurately sounds like him or is as

"WITH MUSICAL ROBOTS, I HAVE HAD PEOPLE SAY 'WHAT'S THIS GOING TO DO TO REAL MUSICIANS?' AND I SAY, 'WELL, I'M A REAL MUSICIAN, AND SO ARE THE PEOPLE WHO CREATE MUSIC FOR THEM AND PERFORM WITH THEM.'"

musicians of completely different genres, allowing them to branch out into new creative territories. "There are always ways of simulating what real instruments sound like," Singer says. "But the robots—I never say that they play better or worse than humans. They just play differently, so it puts a new tool into composers' hands and is one that he or she can play with and experiment with until their heart's content."

Aside from its music applications, LEMUR also has lent itself to a number of art installations, including at the Children's Museum of Pittsburgh and the Snug Harbor Cultural Center and Botanical Garden in Staten Island, New York. The LEMUR installations often take on an interactive approach and invite viewers to intermingle with the robots via video projections and motion sensors. "A typical reaction is [that] you see a projection of billiard balls on the floor, and you walk in and start kicking the balls around," Singer

good in his style, but they are creating something new based on a composer from the past," he says.

Singer's creations are an indication of the future high-tech leaps that will be made within the industry. Though his work may spark discussion about technology's growing impact on the music, Singer considers LEMUR's progressions to be nothing out of the ordinary. "To me, it is just as society has done for thousands and thousands of years: create new ways to make music," Singer says. "And musicians have generally embraced those, almost universally. With musical robots, I have had people say, 'What's this going to do to real musicians?' And I say, 'Well, I'm a real musician, and so are the people who create music for them and perform with them.' So there you go; it's real musicians making real music on real instruments." Ⓐ

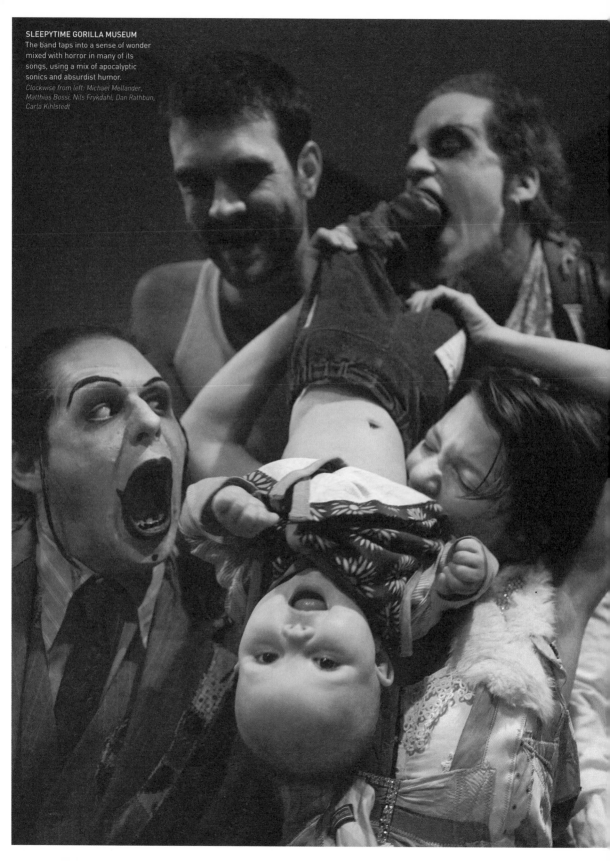

**SLEEPYTIME GORILLA MUSEUM**
The band taps into a sense of wonder mixed with horror in many of its songs, using a mix of apocalyptic sonics and absurdist humor.
*Clockwise from left: Michael Mellander, Matthias Bossi, Nils Frykdahl, Dan Rathbun, Carla Kihlstedt*

# SLEEPYTIME GORILLA MUSEUM

JESSICA STEINHOFF /
*PHOTOS BY CHRISTOPHER EICHENSEER*

Many children dream of running off and joining the circus, but only a few brave souls pursue fire eating and tightrope walking as adults. Sleepytime Gorilla Museum has done something even wilder: it has invented its own freak show, something more bizarre and beautiful than any clown-filled big-top.

The fearless five-piece performs one musical stunt after another, bleeding into performance-art territory as it carves genres such as metal, prog, and avant rock into strange new shapes. But this is no novelty act: the group has some substantial—even shocking—things to say about the nature of human life and 21st Century culture.

Most recently, Sleepytime has explored the theme of human extinction, which it began to dissect on its 2004 LP, *Of Natural History*. Described as a debate between Unabomber Ted Kaczynski and Filippo Tommaso Marinetti, founder of the Futurist movement, the album seems to boil down to a central question, phrased as a song title: "What shall we do without us?" This question leads to another too: "What might those last days be like?"

The group's Fall 2005 tour provided a few answers via Shinichi Iova-Koga, a movement artist who specializes in Butoh, an avant-garde dance form that grew out of student riots and cultural taboos in 1950s Japan. After hanging beneath a sheet, upside down, for the first half of each Sleepytime show, he would

emerge as "The Last Human Being," painted head to toe in white, writhing like a demon-possessed corpse as his shadows danced upon the wall.

These days, the band—clad in tattered tutus, badass boots, and braids—provides a soundtrack for these eerie encounters whether or not Iova-Koga is part of the act. But to take a closer look at this theme of extinction, Sleepytime will soon release a short film called The Last Human Being that explores Iova-Koga's character while presenting a few new songs.

a circus attraction, entertaining guests by making crafts and arrowheads.

"He's this touching, tragic character," Frykdahl says. "His life went from a tribal world that was decimated, where he'd seen only a few dozen humans in his entire life and survived, in isolation, in very rough terrain, to suddenly being exposed to Ocean Beach, with thousands of people. He probably stood there with his mouth open, shocked that there were so many human beings in the world."

## "I REALIZED PRETTY QUICKLY THAT ONE OF THE MOST DIRECT WAYS TO HAVE A UNIQUE, ORIGINAL SOUND IS TO PLAY INSTRUMENTS NO ONE ELSE IS PLAYING."

"During the [2005 tour], we would talk about the human being and what had happened to them, how they used to be all over the place," says Nils Frykdahl, Sleepytime's guitar- and flute-playing vocalist. "The film takes that idea even further. It looks like that 1970s TV show In Search of... where Leonard Nimoy was the host and would 'investigate' something. We have actors playing a panel of scientists on a talk show. The human is the mysterious creature being 'investigated.' It's fairly comic at its roots."

Frykdahl says that the film and its music were also inspired, in part, by the story of Ishi, the last of California's indigenous Yana people. After crossing paths with a group of cattle butchers in 1911, Ishi was quickly put on display at the University of California-Berkeley's Museum of Anthropology. Though Ishi helped scholars learn about his tribe's rapidly dying customs and language, he also functioned much like

Sleepytime taps into this sense of wonder mixed with horror in many of its songs, especially newer offerings like "Salamander." A mix of apocalyptic sonics—machine-gun drumming, theatrical vocals, commanding rhythms, and loads of distortion—illustrates the struggle to survive in a hostile environment while the band's absurdist humor seems to mirror the cosmos, laughing at each tiny creature's fragile existence.

A few tracks from past albums may find their way onto the film's soundtrack as well. One possibility is "Phthisis," a song from Of Natural History that imbues Sleepytime's live act with the essence of an ancient death rite. Beginning with a dose of wailing vocals and metaphorical lyrics from violinist Carla Kihlstedt, the song descends into a primordial ooze of passionate melodies and precise, pounding rhythms. And it's one of the group's more straightforward compositions. Another contender is "The Greenless Wreath," from

the band's 2007 release, *In Glorious Times*. Frykdahl's voice scrapes and scratches like Tom Waits' as custom-made instruments create a jungle of futuristic sounds. Built by bassist Dan Rathbun, these instruments create a new lexicon of sounds with which the band can communicate its vision. (Examples include the Pedal-Action Wiggler, a pedal-powered version of the Brazilian berimbau, and the Electric Pancreas, a set of thin metal slices that make a crunching sound when whacked with a stick.)

Then there's a metal spring, inspired by the one that Einstürzende Neubauten plays in "Selbstportrait mit Kater." Sleepytime uses it as a percussive instrument and a zany stage prop, along with a bicycle wheel, a kitchen sink, and other found objects.

"Bands like Einstürzende Neubauten—just the number of different things they would make into instruments is inspiring," Rathbun says. "I realized pretty quickly that one of the most direct ways to have a unique, original sound is to play instruments no one else is playing."

Frykdahl admits that it's hard for the band to stick to simple musical concepts—or traditional instrumentation—in its recordings because it has mastered so many daring feats onstage. "Our natural tendency as composers is to fill the space with notes and harmony and melody, which means not leaving room for listening to the noise," he says. "What we often wish we could do is make beautiful, simple music with a focus on the sound itself, but we like playing notes too much to do that. It seems like the people who do that best are non-musicians who don't really practice their instruments."

In other words, Sleepytime isn't just another prog band with death-metal growls and guitars; it's an ensemble of classical musicians making high art from unconventional sources. Frykdahl is more likely to gush about modern classical greats Pierre Boulez and

György Ligeti than experimental contemporaries Meshuggah and Melt-Banana—when he's not wrapped up in fairy tales, that is.

Frykdahl, his baby daughter, and Dawn McCarthy—his wife and bandmate in psych-folk project Faun Fables—recently traveled to Idyllwild, California to take in the scenery and make a "fairy-tale rock musical" with a bunch of high-school musicians. Like *The Last Human Being*, it's a tale of being left behind. It's also the perfect story for a tiny hamlet that's mile high in mountains.

"We arrived with the idea of doing something with the *Pied Piper* story, where there's a town that's infested with rats and the piper leads the rats away," Frykdahl says. "When the town doesn't pay the piper, he leads all the children away too, except for this one kid who has a bad foot. That kid doesn't reach the mountains with the other kids, so he spends his life haunted by what he missed. So, of course, we decided to focus on him."

The updated fable begins 30 years later than the original, with the bum-footed kid as town mayor. One day, his childhood playmates begin to reappear, as young as the day that they left. Pretty soon the village is filled with orphans, and he must decide what to do with them. According to Frykdahl, using lots of orphan characters makes for lots of acting roles, which allows all of the kids to play themselves—or wilder, more mythical versions of themselves—as they write original songs for the project.

"Right now, we're madly finishing up parts they can sight-read on French horn and cello, and we may need to do a polyrhythms workshop," he says, swept up in a flurry of creativity. "But hey, we get to indulge our obsession with fairy tales and mythology, which is really where it all started for us as performers—with cool stories." Ⓐ

# OPEN SOUND NEW ORLEANS

MARLA SEIDELL / *PHOTOS PROVIDED BY OPEN SOUND*

Storytellers abound in New Orleans. Take, for example, a 95-year-old man dragging a suitcase down St. Claude Avenue in midday heat. Nursing student Freya Zork offers him a ride and gets an earful about the old days. "The Street of My Life," Zork's recording of the interview, details the man's personal history of the neighborhood.

This is one of over 200 recordings on OpenSound-NewOrleans.com, the website founded by media producers Heather Booth and Jacob Brancasi in March of 2008. With the intent of making the authentic, unedited sounds and voices of New Orleans more accessible, the mission is also to show the Big Easy in a more positive light.

"New Orleans and her people have been impacted by a long history of problematic and often damaging media portrayals," Booth says. Demonized as "cockroaches" by the media during and after Hurricane Katrina, and blamed for crime in a number of American cities, New Orleans residents get back the respect that they deserve with Open Sound.

The beauty of Open Sound is in its accessibility. Anyone can suggest a recording for the site, and recording equipment is provided on loan where needed.

The site reveals a unique soundscape of New Orleans while documenting a city that still is picking up the pieces and holding on tight.

Aware that journalists were working within the confines of traditional media, Booth and Brancasi created Open Sound to show that every story in the city is multidimensional and complex. "We knew that locals would recognize these sounds and voices as distinct to particular places around New Orleans, where every conversation has a part in constructing the city, both imagined and real," Brancasi says.

"It makes me feel like I live in a small place," says Zork, a Dallas native who moved to New Orleans in 2004. Despite Katrina, Zork stayed to pursue her nursing degree. Before she had even heard about Open Sound, she carried a recording device around to capture "spontaneous storytelling."

Zork was one of the first to upload her recording on the site, and "The Street of My Life" spoke to the spirit of the project. Booth notes that Zork's recording achieved one of the best outcomes of cooperative technology in converting present knowledge into deep memory. "It was the first of many exhilarating moments for us," Brancasi recalls. Dozens of contrib-

NO LOITERING!
BY ORDER OF N.O.P.D.

**OPEN SOUND NEW ORLEANS**
Aware that journalists were working within the confines of traditional media, Heather Booth and Jacob Brancasi created Open Sound to show that every story in the city is multidimensional and complex.

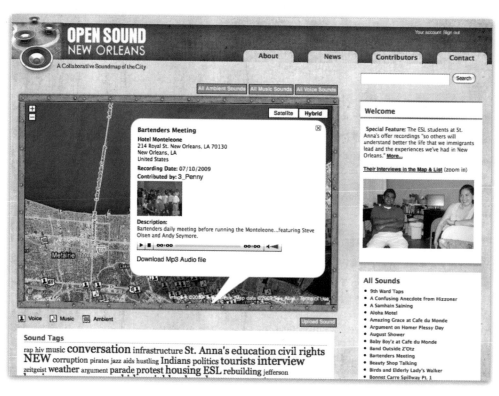

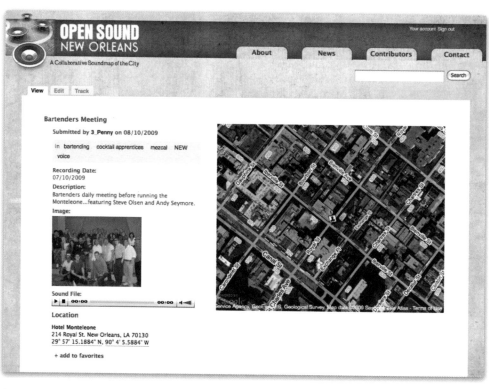

uted sounds followed, and some contributors adapted sounds in music and art pieces.

After a year of pro-bono work, Booth and Brancasi sought funding in an effort to make the site more fulfilling. To date, Open Sound has received grants

Meanwhile, local pride and research are uncovered by Hilairie Schackai's recording of a couple's "priceless stories" about pursuing the American dream on the "other" side of the line in the suburb of Pontchartrain Park. Through her interview, Schackai discovers that water is not intuitive in New Orleans; it flows to

---

"NEW ORLEANS AND HER PEOPLE HAVE BEEN IMPACTED BY A LONG HISTORY OF PROBLEMATIC AND OFTEN DAMAGING MEDIA PORTRAYALS. NEW ORLEANS RESIDENTS GET BACK THE RESPECT THEY DESERVE WITH OPEN SOUND."

---

of support from the New Orleans Jazz & Heritage Foundation, the Corporation for Public Broadcasting, and Maker's Quest 2.0. Now redesigned with an interactive sound map that geo-locates each sound posted, the site offers greater accessibility and ease of use. "Most importantly," Booth says, "we have implemented a new model for collaboration with our community."

Recorded sounds range from the everyday to the politically charged. One can listen to Darlene Wolnik's recording of rain falling through the gutter at Tulane University Square or Rick Tippie's recording of the brassy jams of Baby Boy'z performing outside Café Du Monde.

areas where one wouldn't expect. "The recordings have a spontaneous nature," Schackai notes, "but they also document all these details that make up the fabric of New Orleans."

Open Sound showcases the vibrant sounds of a city still rich in character after the storm. It's homey, a bit melancholy, and resonating with life force— in all senses, New Orleans. And it's a way to keep pushing forward.

"We're definitely still recovering, and I feel like Katrina keeps taking," Schackai says. "There's still a lot of healing to be done." ◉

# GORD HILL

SUMMER BLOCK

Five hundred years of history across a continent may seem like rather dense subject matter for a graphic novel, particularly when that history involves hundreds of actors and a fair amount of arcane legalities like territory disputes and treaties. But artist and activist Gord Hill was convinced that he could turn the material into something widely accessible, a galvanizing account that would serve to rouse a generation to action. The result is the comic book *500 Years of Indigenous Resistance*, a bold, graphic, and gripping account of indigenous struggles, past and present.

Hill is a member of the Coast Salish peoples—an anglicized term, Hill explains, for an indigenous tribal group whose territory includes Canada's Lower Mainland and South Vancouver Island.

Hill grew up on North Vancouver Island, spending some time on reservations, before he and his mother settled in South Surrey when Hill entered high school. There he took the art classes that formed his only formal art education before he became an apprentice to Native carvers in Alert Bay, a village on Cormorant Island in British Columbia with a large indigenous population.

"On the coast, there is a strong tradition of carving— mostly red cedar but also yellow cedar, alder, [and] yew," says Hill, who uses carving knives that are

adopted from traditional tools. Though he has made masks, rattles, and plaques, Hill primarily carves cedar boxes with images of thunderbirds, ravens, wolves, sea serpents, bears, and heron. Hill values the boxes as aesthetic objects while also recognizing the income that they bring as essential to his larger political goals.

"I've had many jobs," Hill explains, "as a janitor, dishwasher, and store clerk—but my main occupation is resistance."

In 1992, Hill first wrote the original text for *The 500 Years of Resistance*, a sprawling account of organized indigenous efforts against colonization in North America, from the Incas in 16th Century Mexico to the Secwepemc in present-day Canada. This comprehensive textual history was followed by the illustrated version that Hill is now distributing through progressive publisher Arsenal Pulp Press.

"The comic version I did so as to make this history more accessible to Native youth and people in general, who may have a hard time sitting down with a long article," Hill says. (The original book also recently was reprinted by California's PM Press.)

"[The book] starts with the arrival of Columbus in 1492 and progresses through the centuries up until

the present day," Hill says. "The format is mostly two- to three-page stories about a number of different tribes' resistance against European colonization, including the Inca, Mapuche, Seminole, Lakota, Apache, [and] the Northwest Coast."

Though the book begins with the earliest European colonists and includes legendary indigenous figures of the 19th Century like Geronimo and Crazy Horse, Hill is quick to emphasize that the indigenous resistance movement is a living one, and *500 Years* illustrates a number of key events of the recent past, including the beginnings of the American Indian Movement in the 1960s, the Wounded Knee Incident in South Dakota in 1973, the Oka Crisis in Québec in 1990, and the Ipperwash Crisis and Gustafsen Lake Stand-Off in Canada in 1995. All of these incidents are told in Hill's signature style: hard, angular lines; bright, bold colors; and collage effects created with the use of other print media like contemporary newspapers.

"The aim is to provide a history of resistance for Native peoples, to show that their ancestors resisted colonization, had many victories, and that this resistance continues to this day. I hope to accomplish their mental liberation from the colonial coma many are presently in."

To that end, the book concludes on a note of victory, with the Six Nations land reclamation in Ontario. Members of the Six Nations made public claim to a tract of land in Caledonia, Ontario, an area that was to be developed into a subdivision, and assumed control of the area in 2006. The dispute is unresolved to this day, but all development has ceased, and it appears likely that the Six Nations will eventually be granted legal dominion over the land.

"My main concern is distributing [the book] into Native communities," Hill says, "which will necessitate foot work on my part, and in this way, it will be a useful organizing tool.

"There is no distribution network that reaches into many Native communities," he continues. "Plus there are over 600 separate bands spread across the country as well as within urban areas. Virtually all national and regional newspapers are owned by the Aboriginal business elite, and all governance as well as social spaces are controlled by the government. This makes distribution and communications difficult."

Effective communication is a hallmark of Hill's activism, whether through print media or YouTube. For the past three years, Hill was involved in the movement to prevent the 2010 Winter Olympics from being held on seized Native land in Vancouver, and as a result, he created the documentary video *Resist 2010: 8 Reasons to Oppose the 2010 Winter Olympics*, posting it to the video-sharing site as well as to No2010.com, a website that Hill maintains.

"The Olympics was…a tremendous waste of money that benefited the business and corporate class while the people are stuck with the bill," Hill says. Despite Hill's organization, the Olympics went on as scheduled in February of this year, but Hill feels that the anti-Olympics protest movement was productive nonetheless.

"We organized a successful resistance campaign that focused attention on some of the worst aspects of the industry overall," he says, "and [we] helped to limit the most negative impacts, such as homelessness and the 2010 police state. The documentary video was useful in mobilizing resistance and communicating the basic message of our movement." And

MEXICA EAGLE WARRIOR WITH OBSIDIAN-EDGED CLUB!

515 YEARS

INDIGENOUS · RESISTANCE

1492~2007

that message now extends far beyond Vancouver; No2010.com continues its work, now focused on displacements accompanying the 2012 Olympics in London. Hill's anti-Olympics campaign, however, sat at odds with the Native band councils, many of which supported the Olympics bid.

"The band councils were established by the federal government under the 1876 Indian Act," Hill says, "which imposed government control over all Natives

"His basic concept," Hill says of Hall, "was to educate the people, inspire them with empowering imagery and writing, and raise their fighting spirit. He helped renew the 'warrior movement' among the Mohawks in the early 1970s."

Hill also admires the work of kindred creators such as Art Wilson, Clifford Harper, Seth Tobbacman, and John Yates, but other influences are closer to home, including Hill's cousin David Neel, who creates

## "THE AIM IS TO PROVIDE A HISTORY OF RESISTANCE FOR NATIVE PEOPLES, TO SHOW THAT THEIR ANCESTORS RESISTED COLONIZATION, HAD MANY VICTORIES, AND THAT THIS RESISTANCE CONTINUES TO THIS DAY. I HOPE TO ACCOMPLISH THEIR MENTAL LIBERATION FROM THE COLONIAL COMA MANY ARE PRESENTLY IN."

in Canada and covered primarily the establishment of reserves, band councils, and membership. It also comprises a separate set of laws for indigenous peoples as in apartheid. Some of these provisions, for example, were used to ban traditional governance and ceremonies. Today the band councils are the primary forms of state control at the reserve level, and they are replicated in urban areas by state-funded political organizations and service providers, which include housing, employment, and childcare, as well as community centers. The bands upon whose territory Vancouver is now located are highly urbanized, and it was their band councils who collaborated with the government and corporations for the 2010 Olympics."

By taking on these seemingly insurmountable challenges, Hill is heir to a long tradition of uncompromising indigenous political artists/activists, including, most famously, Leonard Peltier. Hill cites Peltier as an influence and also looks up to Louis Karoniaktajeh Hall, a Mohawk artist and writer who designed the warrior flag.

traditional masks that represent contemporary social situations like political injustice and environmental pollution.

"I don't frequently do art for art's sake," Hill says. "I usually have a purpose—it's for a poster/magazine/event/T-shirt, or it's something that someone is going to pay me for, so it's work."

The practical limitations of effective and efficient activism drive the technical construction of his pieces, and Hill usually works in one color so that mass production is less expensive. He finds that a bolder, simpler black-and-white style is better for propaganda work, but this doesn't prevent him from recognizing the importance of art in political struggle.

"Art is used to record the people's history, the story of their ancestors, [and] family lineage," he says. "It manifests in the daily physical world the supernatural powers that are largely intangible." Ⓐ

GORD HILL
"I've had many jobs...but my main
occupation is resistance."
"Resist 2010"

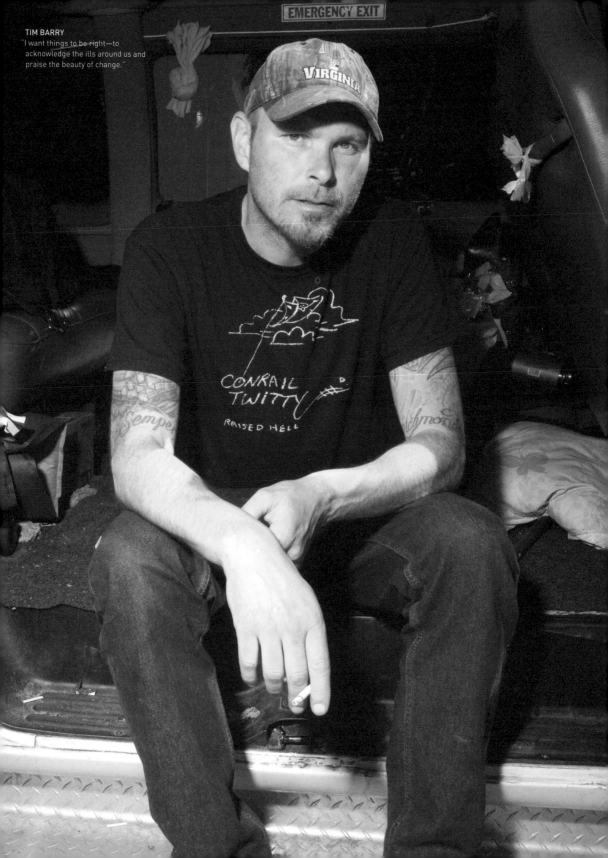

TIM BARRY
"I want things to be right—to acknowledge the ills around us and praise the beauty of change."

# TIM BARRY

JAMIE LUDWIG / *PHOTO BY CHRISSY PIPER*

The night after a Chicago performance from singer/songwriter Tim Barry, a man in a local drinking establishment learns that he missed the show. "I wish I would have known Tim was in town," he tells his friend. "Sometimes I go home after work and watch his old videos on YouTube to make myself feel better about the world." This isn't a teenager talking. It's a grown man, roughly 40 years old.

On tour to celebrate the release of his fourth solo album, *28th & Stonewall* (Suburban Home), Barry seems to have an uplifting effect on everyone who meets him, projecting a natural, confident charisma that brings out the best in those around him. Even the opening band from the previous night—Roanoke, Virginia swamp-country quintet Red Clay River—drove 168 miles out of its way to give Barry and his dog, Emma, a lift to the venue when his van broke down.

By speaking with Barry, or by listening to his onstage banter, one gets the sense that maybe life isn't so complicated, and that the answers to life's toughest questions are right in front of us if we just open our eyes. "I don't understand...all of these motherfuckers who complain about their life, and then they go back to work," he says.

Barry is best known as the vocalist for melodic hardcore-punk band Avail, a staple of Lookout! Records throughout the 1990s. With Barry at the helm, Avail's heartfelt, spirited songs made the members into heroes to disenfranchised youth in hardcore scenes around the world. In 2006, Barry released his first solo release, *Laurel Street Demo 2005*. The music changed from charged punk rock with pop leanings to stripped-down country-folk ballads, but Barry's sincerity and humility continued to stand out among his peers in the often plastic-feeling world of the entertainment industry. "I don't care about how songs were written, or how much money you make," he says. "It's just all fucking boring, that some people base their ego off of minimal accomplishments of art, or filmmaking, or ballet dancing." Despite his dedication to his songwriting, and what many would consider a successful music career by underground standards, Barry remains ambivalent about the true value of art and music in society. "Is it meaningless?" he asks. "I think some people are born to do stuff. I might be too black and white for philosophy."

Barry is in an admittedly unique position. Still based in Virginia, Barry chooses to live off the grid but is as likely to take off from his humble abode to tour Australia or Europe in support of his latest record as

he is to go on an adventure via freight train (a favorite pastime). "I live in a shed with a compost bucket and no running water," he says. "I've never been happier. I don't need a lot. As long as my niece and my sister are well taken care of, I'm happy."

His tremendous work ethic and thirst for knowledge can be seen beyond his extensive music catalog and

city I live in and the ultimate neglect of the people in power to the people that make up the town." The song was written in tribute to Gabriel Prosser, a literate slave from Richmond, Virginia who was set to lead the country's first major slave uprising. When news of the revolt was leaked, Gabriel was hanged along with 26 of his coconspirators, and the ensuing paranoia led to the first of what would become Jim

---

"I DON'T UNDERSTAND...ALL OF THESE MOTHERFUCKERS WHO COMPLAIN ABOUT THEIR LIFE, AND THEN THEY GO BACK TO WORK."

---

exhaustive tour schedule. He's maintained a long-running seasonal gig as a jack-of-all-trades for the Richmond Ballet during the company's annual run of *The Nutcracker*. Lately, in what spare time he does have, he's been teaching himself law and economics. The mix has benefited him creatively. By his account, the songs just pour out.

"Prosser's Gabriel," off of *28th & Stonewall*, is a prime example. "The song 'Prosser's Gabriel'—I didn't really write it," Barry says. "It just showed up. It's about the

Crow laws. Gabriel's body is most likely in a slave burial ground that today is covered by a parking lot along Richmond's Monument Avenue, which is lined with statues commemorating Confederate leaders such as Jefferson Davis and Stonewall Jackson.

Barry, along with many in his community, considers this erroneous city planning negligent at best, a grave injustice at worst. "There is a Bojangles monument in one of the black neighborhoods," he says, "but there's nothing for the people whose backs and arms

and legs were ultimately used to make those people filthy fucking rich—blacks, indentured whites, poor people, etc. I challenge people in 2009—'Whitey,' just like me—how would you feel if your family member was buried below a parking lot?"

Barry turned his feelings into a song that shed light on the controversial subject. "I kept wondering if people knew the name Gabriel Prosser," he says. He soon performed "Prosser's Gabriel" on a local public radio station, and he was honored when Gabriel's descendents contacted Barry and used the song and lyrics in their annual commemoration of the uprising. "The question is: Where do we go from there? I give it a 1–2-year cap. If there isn't a monument where Gabriel was buried, I'm going to hire a sculpture and I'm going to get a film crew, and alert the media and cement that motherfucker into the ground." He says earnestly, "I want things to be right—to acknowledge the ills around us and praise the beauty of change."

Though "Prosser's Gabriel" is based in local politics and history, like many of Barry's songs, it has a universal message. "It's relevant to the secret histories everywhere we live," he says. Barry points to Howard Zinn's A People's History school of thought, which takes a look at historical events from a point of view different than the mainstream high-school-textbook accounts. "That's where great stories and films and music comes from, flipping the perspective," he says. "Step into someone else's shoes; it makes it more interesting. I'm a firm believer in what Woodie Guthrie says: 'You look around; there's plenty to write about.'" Along with the positive reception he got from Gabriel's descendents, Barry received E-mails from listeners from different parts of the world who were prompted to do research on their communities and found out some interesting facts in the process.

Barry maintains this observational, open-minded outlook wherever he goes. He describes a recent trip around the Northeast, which he (uncharacteristically) began by Amtrak. "There's nothing better than sitting in the dining car listening to these big swinging dicks from the financial world talking about how to manipulate their coworkers, then being in Williamsburg with guys with ironic mustaches and women with the most incredible bodies you've ever seen," he says. "Then taking the Chinatown bus down to Philly, ending up in a scummy neighborhood, and finally riding a freight train to Richmond. By the time I got there, I looked like a homeless person, and when I got off the train, no one would talk to me because they think I'm going to ask them for something. From start to finish, the trip is a mind fuck."

No matter how far he travels, though, Barry's heart remains in Richmond, and his mind is set on improving the world around him. "It goes back to 'Prosser's Gabriel'—the way people treat one another," he says. "It became a thought, and for me, it came out in a song." ⓐ

New York Video, in Midtown Manhattan, was around when video stores were the next big thing—and when they *were* the big thing.

# NETFLIX VS. THE LITTLE GUY

KIM VELSEY / *PHOTO BY DAVID BUFFA*

On a sun-drenched September morning in New York, the mail-order-movie company Netflix presented a $1 million prize to a team of seven computer experts.

The winners appeared bleary eyed but giddy, basking in the afterglow of a scientific breakthrough. They had devised the algorithm that would improve the company's recommendation system by twice the accuracy of the current one. It took 700 statistical models and three years, but 10 million Americans would soon be using their system—a system that the company boasted will work better than word of mouth.

"The old-fashioned talking-to-someone [method] is the most imperfect system there is," says Steve Swayze, vice president of corporate communications. "What Netflix offers now in terms of ratings is the best there is."

Netflix ships its red envelopes across the United States from a variety of regional centers, but its home is in Los Gatos, California, the beating heart of Silicon Valley. The Netflix breakthrough embodies the ethos of the region. It is a victory for the Internet, for the ascendancy of technology, and is a testament to the power of remote communication: the ceremony was the first time that the winning team had all been in the same room together.

On a far less spectacular fall afternoon in Midtown Manhattan, the kind of afternoon where the only promise is rain, David Buffa stands in his store, New York Video (a name that sounded more hopeful when he picked it 22 years ago), and reflects on Netflix's achievement.

"Netflix can do all the algorithms they want," he says. "It's not the same as actually talking to someone."

A handful of video stores still dot the streets of New York, survivors among the multitudes that have vanished from the American landscape in the past decade. As they disappear, lost to competition from Netflix, "movie boxes" at supermarkets, or the Internet, thousands of recommendation systems go with them, based on the proclivities of the clerks, sometimes hindered by hangovers or shoddy communication, by nature imperfect. They run on human relationships rather than spectacular algorithms.

New York Video sits beneath a soot-streaked red awning on 1st Avenue, on a block of four-story brick buildings surrounded by hulking office and condo towers. It opened in 1987. It was around when video stores were the next big thing—when they *were* the big thing—and it is here now.

The store houses 30,000 titles—allegedly the big-

gest collection in New York. (Netflix has 100,000.) Movie covers are laminated and sorted into bins along the walls: Marlene Dietrich, Bette Davis, Greta Garbo, Woody Allen, Danish, Horror, Cult, the 1940s, Superhero Films, Brit Classics, Stand-up, and Hallmark Hall of Fame—right next to John Waters. Like Netflix, New York Video delivers, but on foot and only between 42nd and 65th Streets, Lexington Avenue and the East River.

David Greene has worked here, on and off, for the past 20-some years, and he's working today, wearing a green bandana around his neck and asking a customer, "Did *Mean Girls* do it for you?"

When the store is quiet, which is more and more these days, he listens to Yankees games on the radio. "I didn't love working at the video store when I was younger," he says. "It's a hard job; customers can be difficult. It's not the highest-paid job in the world. Usually, people work here while they work on their other careers. But I like it now. The things I minded then, I don't mind anymore."

Greene has left the job at various times to play in a rock band, to act in plays and a movie called *Remembering Maria* (a VHS copy appears on the shelf but not on IMDB or Google), and to paint pictures of pop icons that look like photographs. "It was stressful before," he says, "I like waiting on people now. I'm not as ambitious."

The phone rings, and Greene hustles to the new release wall. "Did you see *Che* with Benicio Del Toro? *Lymelife?* Didn't like it? *Ghosts of Girlfriends Past?* It's a new release. I know you like new releases. It's a comedy—romantic comedy."

He hangs up and adds the movie to the delivery pile. The caller, a Mr. Gilbert, rents two to three times per week, dislikes anything with sex or violence, and is picking a movie to watch with his wife, who also is fussy. "He has seen almost everything," Greene says wearily.

Explaining his recommendation system, Greene says, "You start talking about movies; you get a feel for what they like. It's good when they have sort of an idea of what they're looking for. A lot of people just want affirmation. When we haven't seen them before, it's very difficult." But new faces are not really a problem. When asked how many customers are regulars, Greene replies that they're all regulars.

"It's rare to go to most stores and have a conversation with the sales help," he adds. "Something about movies and music—when I talk about movies I like, the emotional connection is there."

A couple enters. They browse, confer softly, and pace. They don't need any help and leave without renting anything.

"I see couples arguing in here all the time," Greene says. He mimics, "'You rented last; I get to pick this time.'" He tries to find a commonality when advising them. "If one wants a romantic comedy and the other is looking for action, I would recommend *Terminator.* It's an action movie, but it's also a very romantic movie. He comes back from the future to save her because he's in love with her."

Netflix's new system doesn't try to counsel couples. It recognizes only one person on each account, like the last system, producing sometimes-strange results when two or more people with different tastes share an account. It also has trouble recommending for newcomers and people who can't be bothered to use the five-star ranking system. Its next competition will attempt to address the latter issue, releasing new data and two $500,000 prizes for teams that create more accurate algorithms based on demographic information.

"We are halfway between where we were and perfection," Swayze says confidently—Netflix rating every movie exactly as the customer would. There is a pause, and Swayze speaks again, less confidently this time. "It's hard to do. We're using a mathemati-

cal process to determine human emotions. Essentially, it's an emotional issue, and it's very difficult to predict that perfectly."

Jennifer Chien, a fan of indie horror flicks and 1970s movies, keeps accounts at both New York Video and

worked there too. When the company went bankrupt, Buffa, who had no small-business experience, bought it with some of the other employees. "We flew by the seat our pants; we had no idea what we were in for. At the time, it didn't matter. We were making tons of money."

---

# AS [VIDEO STORES] DISAPPEAR, LOST TO COMPETITION FROM NETFLIX, "MOVIE BOXES" AT SUPERMARKETS, OR THE INTERNET, THOUSANDS OF RECOMMENDATION SYSTEMS GO UP WITH THEM, BASED ON THE PROCLIVITIES OF THE CLERKS, SOMETIMES HINDERED BY HANGOVERS OR SHODDY COMMUNICATION, BY NATURE IMPERFECT. THEY RUN ON HUMAN RELATIONSHIPS RATHER THAN SPECTACULAR ALGORITHYMS.

---

Netflix. The Netflix account is less expensive she says, and Netflix carries more Blue-Ray. But she wants a place to rent impulse movies, and she doesn't always like the Netflix recommendations.

"They don't really work for me," she says. "One time you rent something embarrassing like a Sandra Bullock movie, and 27 Dresses keeps popping up. It's easier to go to New York Video and explain all your neuroses to the person there. They all have their own taste; you get to know who will recommend the stuff you like. I'm pretty sure there's one guy there who's seen every horror movie."

Based on the employee's recommendation, Chien rented The Sentinel the last time she visited. "It was very creepy and odd, and not exactly what I was expecting, but I'm glad I watched it," she says. Buffa started working at New York Video in 1985, back when it was part of a local chain. Greene

Over the years, he learned about small business. Increasingly, he has learned about the down side. "I don't see a future for our stores," he says. "There will be holdouts, but people are going to give it up. There will be a point when stuff just disappears. People think that it's all on the Internet. It's not."

How long New York Video remains open depends on a lot of things, Buffa says—the customers, the economy, the neighborhood. "On how much I want to sacrifice," he adds. "I need to pay my own bills, not just the store's." Ⓐ

# MARK JENKINS

KATIE FANUKO

IF YOU'VE WALKED DOWN THE STREETS OF WASHINGTON, D.C. IN THE PAST COUPLE OF YEARS AND DONE A DOUBLE TAKE WHEN SEEING A MAN WITH HIS HEAD STUCK THROUGH A CONCRETE WALL OR A PLASTIC BABY PULLING DOWN A STREET SIGN, THEN YOU'VE PROBABLY WITNESSED THE WORK OF INSTALLATION ARTIST MARK JENKINS.

Since 2003, the DC-based artist has altered urban spaces throughout the world by constructing off-kilter creations with little more than packing tape and plastic wrap. In addition to showing his work in galleries like Stricola Contemporary Art in New York and the SESC in Sao Paulo, Jenkins also likes to bring site-specific pieces to the streets so that the average pedestrian can interact with his art as well. "I figure that if you do something in a public space, you might as well do something where there are people walking around," Jenkins says.

Seven years ago, Jenkins was hiking through the Andes with a former girlfriend. The couple planned to relocate to Brazil to teach English, but she ended up moving back to the USA, and he fell in with a group of street-installation artists. Their influence motivated Jenkins to hone his tape-casting skills. "When I was

in Brazil, I would put plastic wrap down first and then tape over it, and you can capture a lot more detail," he says. "So I think, with this technique, it was what really enabled me to get in there and really get every detail, whether it was horses or human forms or just any object that you're casting."

Though his incredibly life-like installations look as though they took hours to painstakingly craft, Jenkins can usually set up his pieces in high-traffic areas in less than five minutes. He feels that a quick "drop" allows people to have a more natural reaction to his work because the viewer can perceive his installations in a completely different context without his presence. "I don't want it to be a project that is tethered to me," he says. "I want people to have the experience of art without the artist being around."

Although Jenkins often tries to disassociate himself from his work as quickly as possible once he's gone public with it, he usually sticks around for a few minutes to take a couple of pictures from across the street. However, he doesn't stay long. "I don't usually like to be there watching for some reason," he says. "It doesn't feel right to be sitting there gawking when people are looking at the art, because I want their experience to be genuine. And if I'm standing across the street, it just doesn't feel right to me."

Regardless, he's witnessed some tense reactions to his work over the years. Back in 2006, Jenkins set up an installation that resembled a panhandler sitting on the ground, wearing jeans and a hoodie with the hood lowered over his head. Jenkins snapped a quick photo of a little girl sneaking up to the installation to check if it was real while her father abruptly stepped in to usher her away. But that was nothing compared to what happened next: "One guy came up and looked at it, and he kicked him to see if he was

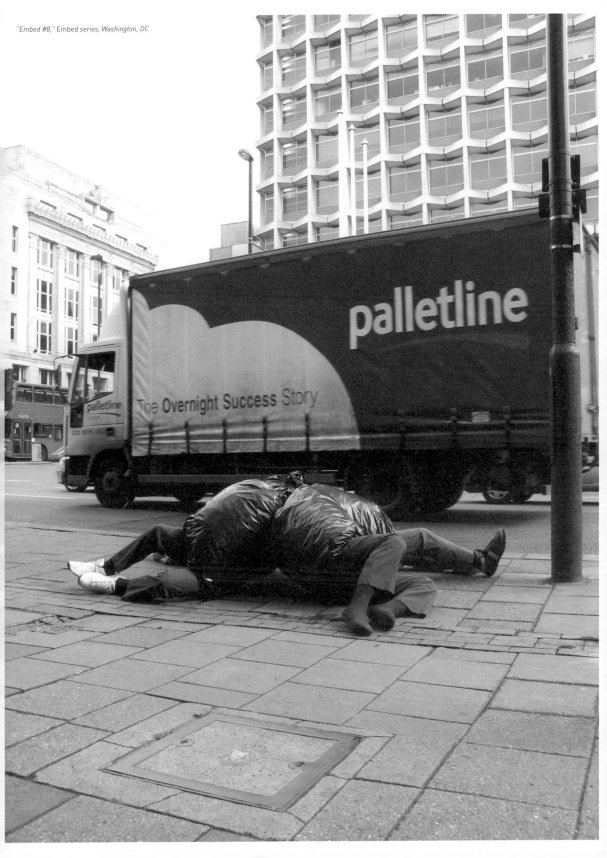

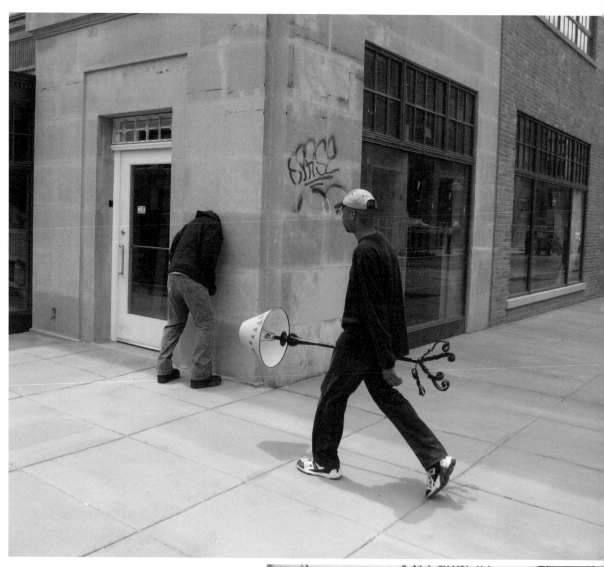

MARK JENKINS
This street-installation artist prefers
for viewers to perceive his work
without his presence, allowing for a
more natural reaction.
*Images from* Embed *series, Washington,
DC (this page) and Malmö, Sweden
(facing page)*

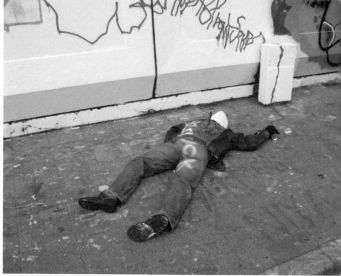

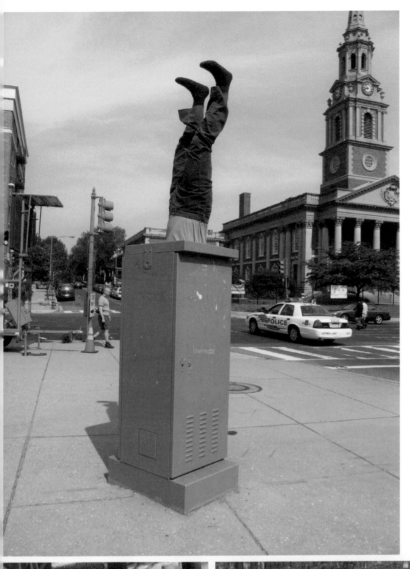

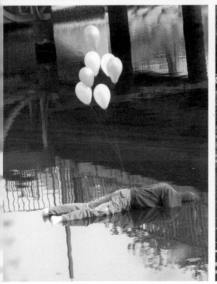

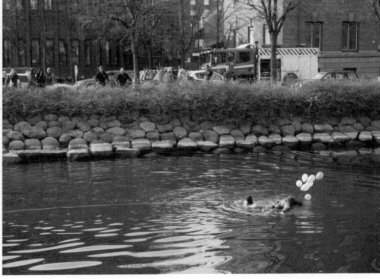

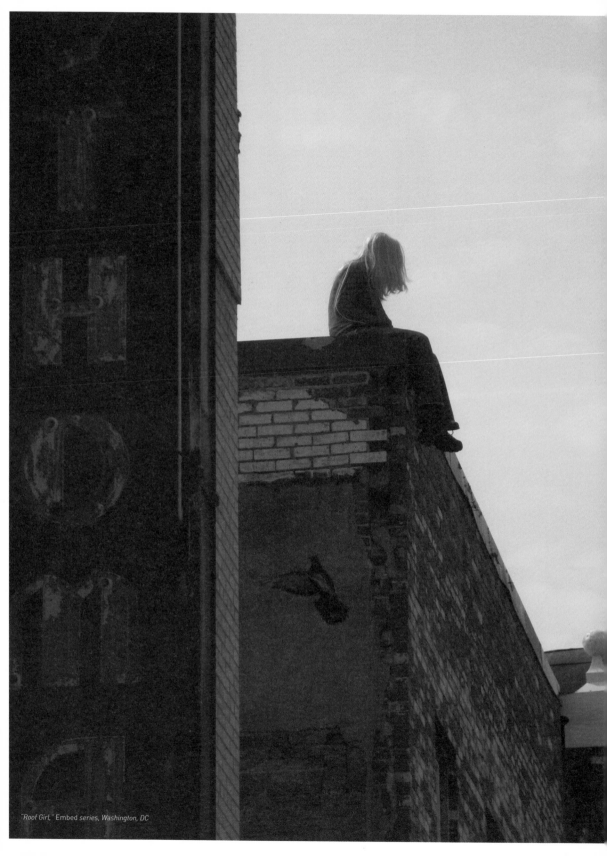

*"Roof Girl,"* Embed series, Washington, DC

real instead of reaching down to touch him," Jenkins says. "It's kind of weird because everyone else walking around didn't realize that it's not real; [they] just [saw] some guy kicking a beggar."

And then there was the situation in Malmö, Sweden. In April of 2008, Jenkins traveled to Sweden and decided to place a replica of a fully clothed body floating under a bridge with multicolored balloons attached to the torso. A passerby thought that it was a real body and called the police. Just as Jenkins and

Jenkins created a piece with a pair of legs haphazardly sticking out of a huge black garbage bag. As he took a photo of it, a Palestinian student mistook him for being a member of the Israeli media, and within a couple of minutes, others took notice of the situation and got the local police involved. "I had a small mob screaming at me, and they were kind of backing me into a corner, so I was pretty happy to have the cops show up," Jenkins says. "The cops took us into the station and made us erase our pictures. But in the end, we had coffee with them, and they let us

## "I DON'T WANT IT TO BE A PROJECT THAT IS TETHERED TO ME. I WANT PEOPLE TO HAVE THE EXPERIENCE OF ART WITHOUT THE ARTIST BEING AROUND."

his friend were leaving the area, they saw a squad of emergency vehicles descending on the scene. "While we were driving away, three fire trucks and all of these ambulances were coming," Jenkins says. "It's pretty memorable when it escalates to a point when you have a rescue diver swimming out to rescue the guy."

The police are another reason that Jenkins tries to be as covert as possible with his work. "When you're doing a street job, you don't want a cop or some of these people in the city," he says. "In DC, they have a couple of companies that are contracted by the government to watch out for what's going on in the street. You don't want to get out there and have that call made and have your project stopped because you are dilly dallying around talking to some guy on the street." Although he hasn't had too many run-ins with the law in the USA, the same can't be said for when he's gone abroad.

While in Palestine, he was working on a project that was facilitated by famed British street artist Banksy.

take pictures with them and all of the sculptures. It's intense when the authorities get called, but at the end of the day, if anyone gets riled up, they simmer down pretty quick."

Jenkins doesn't plan to let these setbacks keep him from traveling abroad. In fact, he spent a good portion of the fall of 2009 in Russia at the invitation of an artist-residency group called CCP. "A lot of art teachers have started contacting me and asking [me] to teach students how to do this," he says. "So this is one of those ones where they will have between 30 and 50 students all being part of this project." Invitations like this have become so commonplace that Jenkins actually left his nine-to-five job in order to bring his art to the masses on a full-time basis. "With the human sculptures, it's about creating a stage," he says. "The people on the street kind of become part of what is happening, the art just turns into a catalyst for what is happening, and people just become actors, basically." Ⓐ

# OUT OF SIGHT

# J.G. THIRLWELL

PETE KLOCKAU / *PHOTOS BY ERIC LUC*

Back in 1981, a cryptic record with hugely uninformative album artwork began turning up in record store bins, emblazoned with the words "You've Got Foetus On Your Breath." Anyone daring enough to bring home a copy was assaulted with a frenzied blast of alarming, confrontational bombast as soon as needle was set to groove. Here was a complete mental breakdown set to music. If mass panic, a train wreck, or an oil-tanker explosion needed theme music, surely, this was it. The LP was labeled "DEAF!!" and it delivered on its promise.

In the years that followed, record store clerks around the world found themselves befuddled by this mysterious madman again. Does "Scraping Foetus Off the Wheel" get filed under S or F? How about "Foetus Under Glass"? And what kind of music is this anyway?

As more and more confounding manifestos crept their way into stores and onto turntables, the more industrious fans of "blank blank" Foetus "blank" noticed a clue to each puzzle buried in the liner notes: "Foetus is J.G. Thirlwell."

Yes, there was a real flesh-and-blood person behind this madness.

"There is certainly a level of anonymity running through my work," Thirlwell says from his top-secret lair deep in the bowels of New York City. "Foetus was

born in the studio. On those early albums, I was playing every instrument you heard. As I made more and more records in the studio, the studio itself became one of my instruments."

Meanwhile, on the outside world, a new kind of grinding bastard hybrid of dance music, thrash punk, and metal was being made popular by bands like Ministry, Public Image Limited, and Nitzer Ebb. Looking for a possible jumping-off point, the music press was quick to lump Foetus into the industrial movement, even crediting him as one of the founding fathers of the genre. But Foetus never made industrial music. Even at his most bombastic, deep under those crushing, rhythmic waves of noise, Thirlwell was experimenting with found sounds and wonky time signatures more in line with avant-garde jazz and art rock than anything else.

Tucked away from prying eyes, Thirlwell continued to involve new and more elaborate instrumentation into his repertoire. His studio became a mad-science laboratory, where horn sections, exotic percussion, and found-objects-turned-instruments replaced the mangled limbs, brains in jars, and electrical coils.

"I find the term 'industrial' rather meaningless, but people like to categorize things," he says. "I've always aimed to reach conclusions using different building blocks. There have always been classical elements, new instrumentation, and

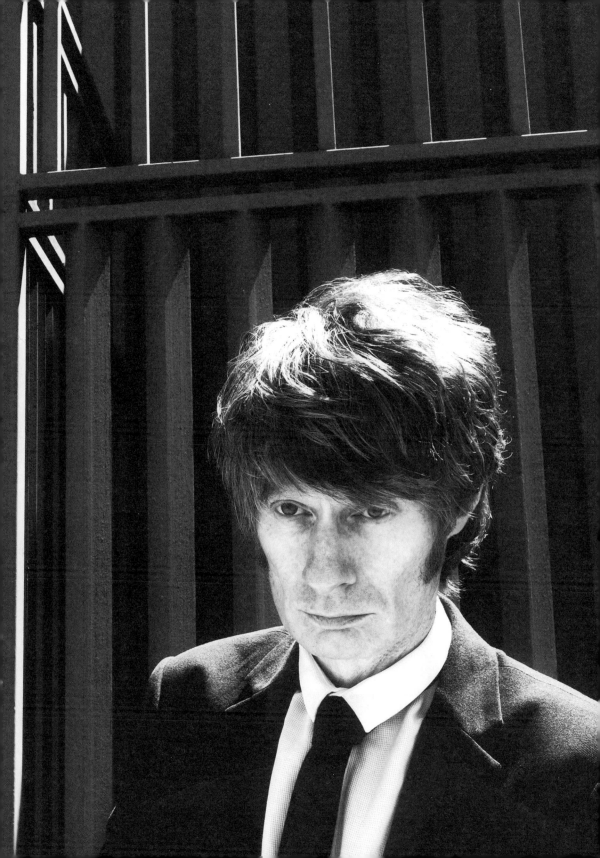

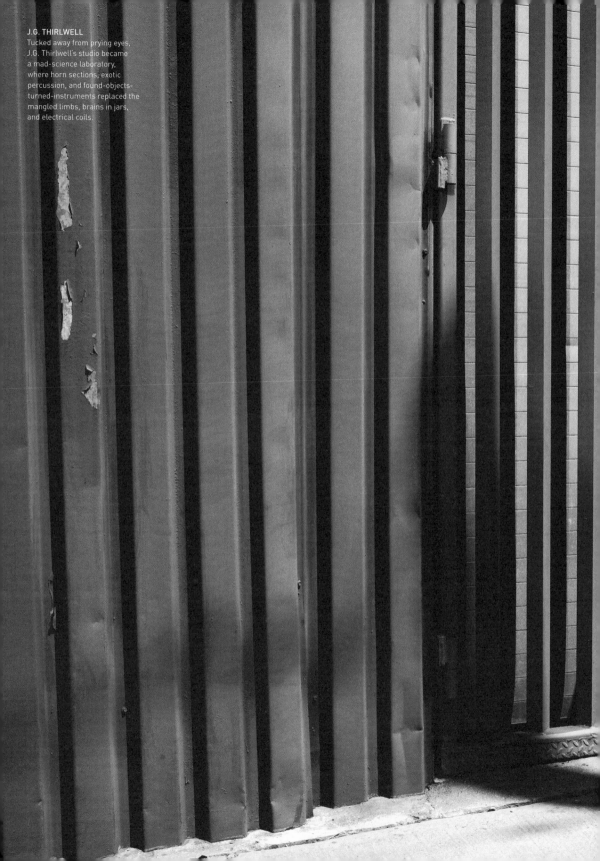

**J.G. THIRLWELL**
Tucked away from prying eyes,
J.G. Thirlwell's studio became
a mad-science laboratory,
where horn sections, exotic
percussion, and found-objects-
turned-instruments replaced the
mangled limbs, brains in jars,
and electrical coils.

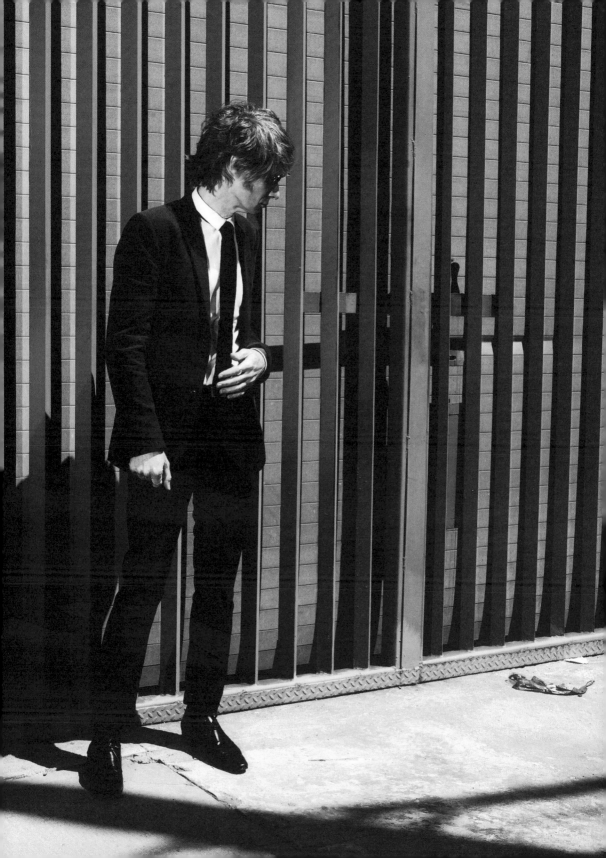

different ways of approaching a composition in my music."

Thirlwell's growing collection of Foetus monikers was not enough to contain the composer's ambitions. Though, certainly, there was an ascertainable Thirlwell glue holding the recordings together, the Foetus sound began, slowly but surely, to morph into something very different. The albums became more instrumentally varied, shifting away from the nails-on-concrete explosiveness of their predecessors. By the early 1990s, it was different enough to warrant an entirely new non-Foetus project, Steroid Maximus.

"Steroid Maximus began because, by that time, the Foetus works had become almost entirely instrumental," he says. "Even though there were these long instrumental passages and new layers of atmosphere, people still perceived them as confrontational and coming from a first-person narrative simply because they were Foetus records. I decided to let those instrumental passages breathe on their own; I pulled them away and let Foetus become more song based."

Under the guise of Steroid Maximus, Thirlwell was free to explore vastly different, entirely instrumental terrain. Alongside the familiar skronky electronics and amphetamine drum machines of Foetus, here were elements of campy spy and bachelor-pad lounge music, classic globe-hopping exotica, and blaxploitative funk. But even when the sound was as far away from those *DEAF!!* days as seemed sonically possible, Thirlwell, the composer, was discernable underneath. The canvas was the same; only the paints had changed. Steroid Maximus brought the most cinematic qualities of Foetus to the fore.

"If there is a running thread through my work, it's that it is very cinematic," Thirlwell says. "I am very interested in soundtracks disembodied from film. With a soundtrack, the logic of the composition is often dictated by a visual element. When you strip that visual element away, the music is put on a different framework. Suddenly, there are weird accents existing as musical events rather than narrating a visual. The music takes on its own skewed internal logic."

Through *Quilombo* (Big Cat Records, 1991), *Gondwanaland* (Big Cat Records, 1995), and *Ectopia* (Ipecac, 2005), Steroid Maximus created three of the greatest movies you've never seen. Each "soundtrack" is teeming with such a distinct personality that it negates the need for visual stimulation.

"I write very amorphously," Thirlwell says. "I don't see pictures; it's more about feeling. Music is bigger than pictures. Pictures are a literal translation. As soon as you attach music to them, it is forever interlocked with that translation, which is unfair to the music. I prefer to let it exist on its own terms."

Through it all, Foetus continued unabated, shifting like a manic chameleon. Thirlwell produced and re-mixed work for other artists, and he even teamed up on a collaboration with former Swans member Roli Mossiman to form the brutal and crushing Wiseblood. Yet Thirlwell, ever the prolific Renaissance man, began to seek new outlets for his indefatigable wellspring of musical muses.

Under the *nom de plume* Manorexia, Thirlwell began truly honing his soundscape chops. It is among his most classically bent and sonically varied work to date, playing with ambient noise, room tone and drone elements, and classical string-quartet passages. Through *Volox Turbo* (2001) and *The Radiolarian Ooze* (2002), Thirlwell showed his adeptness at balancing audio spaciousness with his trademark dense bursts of instrumentation. Manorexia brings to mind the work of Krzysztof Komeda—the Polish composer who created eerie landmark soundtracks for *Rosemary's Baby* and *The Fearless Vampire Killers* for Roman Polanski—as well as newer avant-classical groups such as Bang on A Can and the Kronos Quartet, with which Thirlwell has collaborated, adapting his Manorexia-based work to string quartet.

With such an impressive body of instrumental work, it was only a matter of time before someone sought to employ Thirlwell to apply his music to his or her visuals. Perhaps unexpectedly, this someone was not a horror-movie director, drama writer, or action-adventure producer. It was Christopher McCulloch (also known as Jackson Publick), who had begun adapting a new cartoon for Cartoon Network's Adult Swim called *The Venture Bros.*

"It was natural that someone would come to me to score something," Thirlwell says. "It doesn't happen as often as you'd think. The creators of *The Venture Bros.* came to me specifically for what I do, wanting me to impart it on the show. I was kind of the matching musical counterpart to what they were doing." In the liner notes for Williams Street's 2009 release, *The Venture Bros.: The Music of J.G. Thirlwell* (the first record released under his birth name), show creator McCulloch says, "Without J.G. Thirlwell's music,

The Venture Bros. would not move at all. Yes, I have a confession to make: The Venture Bros. wouldn't exist without J.G."

Thirlwell was contacted, and the rest is history. Since 2003, he's been setting the animated exploits of McCulloch's Venture brothers, Brock Samson, and Sergeant Hatred to music. Though it's only a slight variation on what Thirlwell had created with Manorexia and Steroid Maximus since the early

But its reclusive composer has plans to take it to the stage. "This will be kind of a concept record," Thirlwell says. "I'd like to incorporate a live-performance element, but I'm not sure what form that would take yet. A theatrical form might make the most sense."

For Manorexia, revered composer John Zorn's label Tzadik recently released The Mesopelagic Waters, an album featuring versions of previous Manorexia works that were readapted for string quartet. Later this year,

---

# "MUSIC IS BIGGER THAN PICTURES. PICTURES ARE A LITERAL TRANSLATION. AS SOON AS YOU ATTACH MUSIC TO THEM, IT IS FOREVER INTERLOCKED WITH THAT TRANSLATION, WHICH IS UNFAIR TO THE MUSIC."

---

1990s, the music holds differences from when Thirlwell is operating from his internal musical muse.

"A really great soundtrack can, potentially, go completely unnoticed by a viewer," he says. "I try to make the best background music possible. I also make foreground music. The difference between this and my other projects is that you are somewhat at the behest of the script. There are long talkie passages to work around that push you in different directions, anomalous to what's come before. I don't intend for my scores to blend. I want the viewer to notice them.

"The script gives me room to exaggerate a bit more here and there," he continues, "but I don't find myself feeling the need to make goofy, gag-y cartoon music. I leave the gags to the dialogue. I see my part more as an action-adventure score guiding and highlighting the story."

Never one to rest on his laurels, Thirlwell has plenty on the horizon. This summer saw a 20-piece live performance of Steroid Maximus' Ectopia in Brooklyn's Prospect Park, and the rest of this year will bring brand-new albums from Foetus and Manorexia (or, for simplicity's sake, J.G. Thirlwell).

The new Foetus record, titled Hide, features several songs set in a first-person narrative, a song structure that has not surfaced in Foetus' music for some time.

yet another Manorexia volume will surface—but like the old days with Foetus, it will be a studio effort, entirely performed by Thirlwell.

"This will be the first studio-based Manorexia album," he says. "The last was performed with an ensemble. I hope to adapt it to a live setting at a later date, but I'm planning on doing this one in 5:1 surround sound."

As if that weren't enough, an anthology of early Foetus singles is in the works, along with aspirations for feature-film work.

"I am always busy, always changing things, and always trying to challenge myself," Thirlwell says. "I try to follow whatever urge has placed itself in front; one day it might be a string quartet, the next a remix project, and the next after that a piece for The Venture Bros. Sometimes they all happen on the same day. Whatever is in front of me is primary, but I'm capable of working on a lot of different things. The hope is always that one or two of them will be completed and actually work out. The more I do this, the bigger my ambitions get. That's a problem, because they just get harder and harder to realize." Ⓐ

# MIKE PATTON

SCOTT MORROW / *PHOTOS BY BRYAN SHEFFIELD*

In 1994, the musical aberration known as Mike Patton prepared for a pair of life-altering experiences. The anomalous vocalist married Italy native Titi Zuccatosta, and the two purchased a home in Bologna— a city that Patton has since described as the "place where you want to die."

Putting the personal ties aside, his infatuation with the city is easy to understand. At one time the "second city" of Italy, Bologna holds a rich and deep history. It is home to the oldest university in the West and an abundance of monuments that span the past two millennia. Visitors flock to Piazza Maggiore and the San Petronio Basilica, two symbols of a city renowned for its expansive porticos and the red roofs of its historic center. Its humid climate makes seasonal swings feel more extreme, but given Bologna's location in Northern Italy, its inhabitants aren't as hard hit by heat waves as the south of the country. And Bologna is, naturally, a culinary hotspot thanks to its famous Bolognese sauce.

Though the couple separated in 2001, Patton had, by that time, immersed himself in the country and its culture, refusing to speak English while abroad in order to become fluent in Italian. Every day was a learning experience, he says, and his most important education came in linguistics.

"Being 'invisible' or in disguise helped me learn the language," Patton says. "The great thing about Italy [is that] if you just say two words, like 'ciao bello,' [they say], 'Wow, that's amazing! You sound just like an Italian!' It really boosts your confidence. The whole attitude [in Italy is] toward acceptance and tolerance. The reason that I learned the language and did it so fast…is because the people were so amazing."

The thought of Patton concealing himself, however, seems like a non sequitur. His voice, after all, is one of the preeminent and most recognizable in independent music. It has been involved in dozens of personal projects, invited on scores of guest spots, and heard on more than a hundred studio recordings. His malleable voice is known for any combination of dramatic cries, harrowing screams, smooth croons, lilting falsettos, and otherworldly chants.

Patton's days fronting alt-rock favorites Faith No More were a gateway drug for many, leading first to the mind-altering, genre-demolishing tastes of Mr. Bungle. Then came dalliances with John Zorn, arrangements for Fantômas, time in Tomahawk, pop adventures as Peeping Tom, and copious collaborations. His time on the radio all but ended after Faith No More's breakup, but his distinct sounds and

**MIKE PATTON**
With a body of work that even
diehard fans have trouble
chronicling, it won't be
surprising for future projects to
sneak by, unheard—ironic for
such an ever-present voice.

diverse palette—coupled with a reputation for stage antics and off-the-cuff interviews—cemented his place in modern music lore.

So given these identifiable attributes, the words "Patton" and "incognito" don't seem to follow each other. But his newest project, Mondo Cane, stems from just such a union—with Patton disguising his American accent and assimilating to a new culture.

some point, it became obvious to him that he'd pay tribute to these expansive orchestrations, and the Mondo Cane project was born.

In the years after World War II, American pop influence began permeating the globe, and the Italian Republic quickly embraced bebop, big band, and rock and roll. By the late 1950s, Italian singer-songwriters—known as cantautori—had come to

---

"IN THE EARLY STAGES [OF WORKING WITH THE ORCHESTRA], I'D FLY OFF THE HANDLE AND GO CRAZY, AND IT GOT ME NOWHERE. ORCHESTRA PEOPLE DON'T WANT TO SEE THAT, DON'T WANT TO HEAR THAT. THEY *ALREADY* THINK YOU'RE A FREAK FOR DOING THIS."

---

"I did have a lot of friends there," he says of Italy. "Most of them spoke English, but my whole deal was 'don't speak to me in English; I have to learn.' I'm not doing any DVD Rosetta Stone bullshit. Trial by fire, you know?"

Yet Patton learned more than Italian. His interest in Italian counterculture led him to figures like Demetrio Stratos, a 1970s prog-rock revolutionary who explored the limits of the human voice. He later met, befriended, and collaborated with modern musicians, including Zu, a Roman avant-garde trio whose recent sludge-jazz album was released via Patton's Ipecac Recordings.

But despite his affinity for these kindred artists, Patton found himself drawn to the lavish, layered Italian pop music of the 1960s that he had encountered through friends and the radio. (He is, in the end, an artist whose catalog appeals as much to casual listeners as to ardent experimentalists—an artist as likely to sing with Norah Jones as Melt-Banana.) At

prominence, at first influenced by Italian folk but then drawing inspiration from traditional American pop singers. As the '60s progressed, cantautori appropriated bits of rock, psychedelia, and film-score dramatics, culminating in a heavily layered style that just as readily embraced guitars as string sections.

It was this dense, intelligent take on pop that attracted Patton. Legendary composers of the time, both in Europe and the USA, had begun writing and arranging for singer-songwriters, either out of artistic interest or for financial gain (or both). Prominent cantautori such as Gianni Mecca, Gino Paoli, and Luigi Tenco were working with names like Ennio Morricone, Nino Rota, and Tony De Vita. Others recorded their own Italian-language renditions of famous pieces by American or European composers such as Elmer Bernstein or Bert Kaempfert, who worked with some of the most recognized singers of the time.

One such tune, originally titled "The World We Knew (Over and Over)," exemplifies the cultural difference

and the impact that it had on Patton. Renamed "Ore D'Amore," this selection—which would be appropriated by Mondo Cane—was first sung by a vocal giant.

"Sinatra did that song!" Patton says. "But it's completely different. It's much more lush and big bandy and orchestral. For whatever reason, the Italian version was much more fuzzed out and '70s and psychedelic—totally different words, totally different everything. Somehow, I feel, a lot of these [reinterpreted] tunes were given an Italian soul. They're much more tragic, much more romantic, and much more exaggerated, and that's definitely something that interested me."

With a growing catalog of tunes in mind, Patton contemplated a few one-off cover performances with a quartet. However, when a festival promoter called and offered access to an orchestra for three concerts, he couldn't say no. He began sifting through hundreds of pop songs—many that perched atop the charts but some with more obscure origins—and the wheels were in motion for Mondo Cane.

Loosely translating to "dog's world," Mondo Cane was a massive undertaking, consuming months and months just to prepare for the initial three performances. Patton had his selections transcribed and began working with a 10-piece band, while a conductor was put in charge of a 40-piece orchestra. There were no initial plans for the dozens of concerts that would follow, nor plans to record an album—but at some point, Patton figured that this effort warranted documentation. Italian producer/composer Daniele Luppi came on board for arrangements, and over three new concerts in 2008, the group took part in live recordings that would be assembled into the first of two Mondo Cane albums, released in May of 2010.

"That led me down, let's just say, another vortex of getting it perfect," Patton says. "Hey, it's a live concert, and I *hate* live-concert recordings. I just can't listen to them; I can't deal with it. It took me

a long time to correct all the mistakes and redo the arrangements, maybe the way I really wanted them and heard them in my head from the beginning but didn't have time to execute for the concerts."

The performances, many of them in public squares, were a success by all accounts, but the entire process proved overwhelming at times.

"There were times when I wanted to tear my hair out," Patton says, "because you feel like, 'Who's helping me? Who's got my back?' I thought of this [project]; Jesus Christ, I guess it's all my responsibility! It was definitely a huge learning period for me, and you have to learn where to pick your battles, when to be a politician, and all that kind of stuff. In the early stages, I'd fly off the handle and go crazy, and it got me nowhere. Orchestra people don't want to see that, don't want to hear that. They *already* think you're a freak for doing this."

A few "offbeat" inclusions made Patton unsure of how the project would be received in Italy, particularly in front of mixed crowds at the piazza performances. But despite the unconventionality of the project, the selections on Mondo Cane are, by and large, approachable, appealing to Patton lovers as well as their parents.

"I remember one sound-checking [when] we were playing one of these gigs in an outdoor square," Patton says. "We were sound checking between songs, and an old lady comes up toward the stage. [She said], 'Excuse me; excuse me. You know, you have a fabulous voice, son. Is there anywhere that I can buy your cassette?' I was just so touched. That was total validation for me."

To younger generations, the most recognizable track might be the opener, "Il Cielo in Una Stanza." Written and sung by Gino Paoli, who imagined the song while lying in a brothel, the tune was later used in Goodfellas and sung by Mina Mazzini, one of Italy's most famous pop singers of the 1960s and '70s. Patton's version is just as centered on swelling

strings and a dynamic vocal range, but his includes an atmospheric intro with vocal additions ("la las" panned left and right) as well as a buzzing guitar riff, flute accents, and rain sound effects.

Though Patton and crew used the live performances to tease out that type of elongated, augmented introduction, the *Mondo Cane* album is restrained in its alterations. The most deviating sounds might belong to "Urlo Negro" and "Senza Fine." The first, belonging to a '60s garage-rock group called The

"We're just sniffing at the surface, really, of all the stuff that was going on at that time," Patton says. "If I were to dedicate myself to this particular thing, Italian pop music from the '60s, I could go on and on and on. It's a vortex; believe me. But you can't get frustrated. It's exciting, like, 'Oh, shit—I missed that!' It makes you want to know more and explore more."

Between the second Mondo Cane installment and another tour, Patton isn't done exploring. His restless nature won't allow for that. And like usual, he and

---

## "SOMEHOW, I FEEL, A LOT OF THESE [REINTERPRETED] TUNES WERE GIVEN AN ITALIAN SOUL. THEY'RE MUCH MORE TRAGIC, MUCH MORE ROMANTIC, AND MUCH MORE EXAGGERATED, AND THAT'S DEFINITELY SOMETHING THAT INTERESTED ME."

---

Blackmen, is the only to feature Patton screaming his ass off. The latter, another offering by Paoli, builds from a sleepy, romantic ballad to a jazzy crescendo to close out the album.

Of course, a pair of Morricone-related highlights should be mentioned as well. The film-scoring guru is recognized with one of his lesser-known pop numbers (by US standards), the theme for 1968 film *Danger: Diabolik*. Featuring the album's finest falsettos, "Deep Down" is a swoon-inducing powerhouse, as catchy and as direct as its original—with parallel aesthetics, down to the nearly identical guitar distortion. But the following track, "Quello Que Conta," might be the album's greatest treasure. Originally from the 1962 film *La Cuccagna*, the somber track first touched listeners with the tender pipes of Luigi Tenco, a stirring classical guitar, and an arrangement by Morricone. Patton's rendition leads with a distant, swelling storm of brass and cymbals, with trumpeter Roy Paci adding a Western-tinged solo. The rest flows much like the original, but orchestral accents and an operatic backing vocalist make it even more alluring.

Ipecac partner Greg Werckman have a full schedule of upcoming releases, including a soundtrack by Daniele Luppi and a new album by experimental-rock studio project The Books of Knots. And after the possibility of even more tour dates from the reunited Faith No More, Patton's commitments, to be finished in no particular order, include a film score for the adaptation of *The Solitude of Prime Numbers*, an electronic Fantômas album, another Tomahawk release, the Crudo collaboration with Dan the Automator, and another Moonchild disc with the Zorn crew.

Though each release should sound nothing like the next, each will be characteristic of a catalog that has flourished with diversity. And with a body of work that even diehard fans have trouble chronicling, it won't be surprising for future projects to sneak by, unheard—ironic for such an ever-present voice. Ⓐ

# KONONO NO. 1

TIMOTHY S. AAMES / *PHOTOS BY STEVE GONG*

Vincent Kenis is attempting to light his cigarette with a lamp. His voice is marbled with a thick accent and long pauses as he constructs words to describe his field recordings in Africa. A Belgian musician/producer now well known for his knowledge of Congolese music, he is relaying the story of Konono No. 1, a group from Kinshasa that had all but disappeared until the sudden exposure of *Congotronics 1* (Crammed Discs) in 2005 brought global recognition.

"He came to Kinshasa when he was very young," Kenis says of Konono's founder, Mawangu Mingiedi, who started the band in the 1970s. "I think he came when his father died. He was born in the village, and his father was...the leader of the king's orchestra. They had local kings in the Congo region. He learned the likembe (a Central African instrument also known as a thumb piano) from his father, and carrying the likembe into town was maybe for him a way to continue to evoke the sounds he heard when he was a kid. It's like a portable village."

Mingiedi's history is tangled up in the history of his country: nebulous kingdoms upended by Belgian colonization, remade into arbitrary regions like incongruous patches on a quilt; a nationalist movement for independence and then the brutality of dictators like Joseph-Désiré Mobutu, who, as the Western and Eastern Blocs played tug-of-war for the globe,

renamed the country the Republic of Zaire; and emergence from bloody conflict as the Democratic Republic of Congo.

"Our music is the heritage that was passed on to us by our parents," the group says in an E-mail exchange, while en route to the UK, through its translator Aharon Matondo. "Because of the total lack of means, we had to look for elements in garbage dumps—for instance, car alternators, from which we took wires to construct microphones and amplify the likembes. And the cymbals were made from old kitchen-pot lids. After we started touring in Europe and America, we improved the amplification, but we always kept those original elements. It became part of our music."

Its eclectic array of instruments, heard again this summer with *Assume Crash Position*, centers on the likembe, a small wooden box with metal tines that are plucked with the musician's thumbs in order to mimic the region's traditional horn polyphony. Konono uses several in its lineup—each one handmade by Mingiedi—that weave back and forth across each other like ripples from divergent waves, helping transition call-and-response choruses into electronic jams and filling out the band's style of Bazombo trance music that garnered it a spot on Bjork's *Volta* and Herbie Hancock's upcoming *The Imagine Project*. (Also known as Zombo, the

Bazombo are an ethnic group with roots near the Angola border.)

Konono's odd blend of instrumentation was not borne out of the vacuum of novelization, but rather its physical context. In 1971, Mobutu launched

in the late 1970s, this music that was "so radically different than the rumba and the soukous" became like a muse for him. He had traveled to Congo in '71, just as the Authenticity Program was beginning, and returned in 1989 and 1996, making recordings of groups like Kasai Allstars and a number of oth-

"OUR MUSIC IS THE HERITAGE THAT WAS PASSED ON TO US BY OUR PARENTS. BECAUSE OF THE TOTAL LACK OF MEANS, WE HAD TO LOOK FOR ELEMENTS IN GARBAGE DUMPS—FOR INSTANCE, CAR ALTERNATORS, FROM WHICH WE TOOK WIRES TO CONSTRUCT MICROPHONES AND AMPLIFY THE LIKEMBES."

his Authenticity Program—a mandated, nationwide purge of European culture. The impact on local music was enormous. Radio stations only played Congolese music, and bands of relative obscurity were suddenly seen as spokespeople at the very least, saviors at most. "Mobutu...realized the political strength of the music in Congo," Kenis says. "Independence is considered by Congolese as a victory brought to them by musicians, as well as politicians."

The government could only corral musical experience so long. Traditional groups like Konono fell out of favor after only five years, paralleling the prosperity of the nation. The band's music was again confined to the local public.

It was during this time that Kenis, who was first drawn to Congolese music as a kid—a result of the dense diaspora around Brussels—heard Konono's music. He made a cassette of it, and while on tour

ers. Twenty years passed and he had still not found Konono, which remained shrouded by rumors; some reported that Mingiedi had died.

Kenis finally discovered a pocket of Bazombo in Kinshasa. He found the members scattered, eking out livings; Mingiedi was driving a taxi. They met and talked, and two years later, Kenis returned once more to Kinshasa to record the group—a haphazard process that eventually became *Congotronics 1*.

Even as it gained global acclaim, Konono's repetitive, almost toy-ish electronic sound was not instantly accessible to the broader audience, especially with track lengths that range between 2 and 12 minutes. When audiences hear Konono, there often is a lull, a lag before they appreciate it.

"After 10 minutes, there's a kind of uneasiness," Kenis says. "And then the uneasiness usually goes

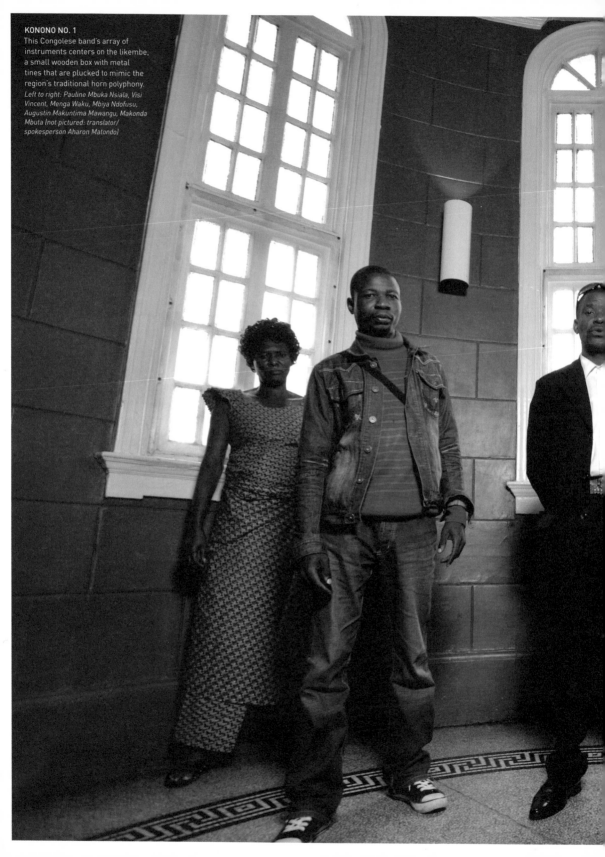

## KONONO NO. 1

This Congolese band's array of instruments centers on the likembe, a small wooden box with metal tines that are plucked to mimic the region's traditional horn polyphony.

*Left to right: Pauline Mbuka Nsiala, Visi Vincent, Menga Waku, Mbiya Ndofusu, Augustin Makuntima Mawangu, Makonda Mbuta (not pictured: translator/spokesperson Aharon Matondo)*

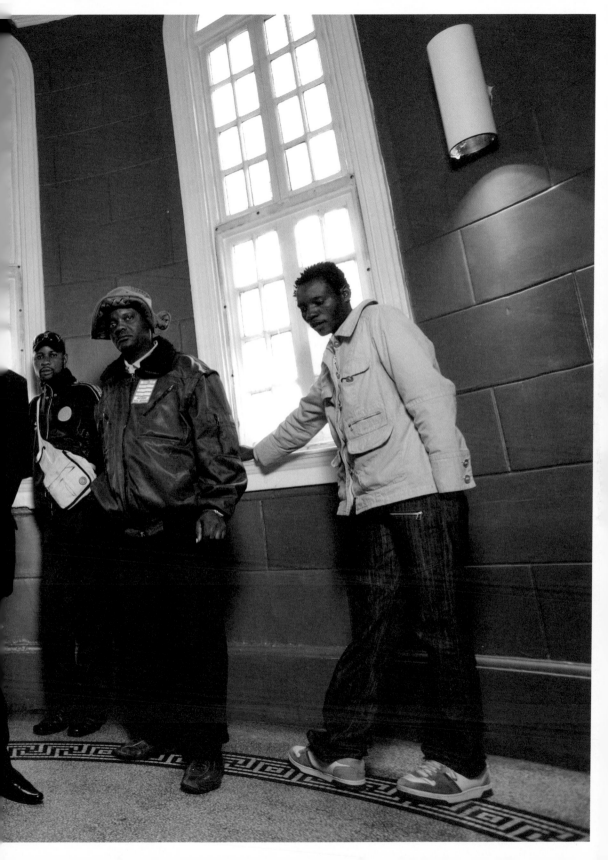

after 20 minutes, because they catch the thing, the swing. The Konono music...cannot be divided by two infinitum. It's not in 4/4—it's like 5/4 or 3/4. It's very specific. You have to come to terms with the sound—which is evolving constantly and minimalistically over time, but basically staying the same—and [you have to] realize that the shifts in that sameness is the whole game. As soon as people get into it with their bodies—without knowing it, just intuitively—they get it."

The music of Africa is like this—foreign but deeply understood, with primal roots that unearth hesitation.

"I've noticed that what works in the dense sense eventually works everywhere—you just have to find the right method," he says, noting that in this case, the right method involves thinking like the band and utilizing even a corrugated iron roof if it suits its purposes. "I always put two microphones pointed toward that ceiling, and it gives that really industrial reverb."

Despite challenges like finding reliable electricity, the environment in Kinshasa lends itself to recording because limitations often drive creativity. Like Crammed Discs label mate Staff Benda Bilili, a group of paraplegic musicians also from Kinshasa, Konono

---

## "IN THE CONGO, WHAT PREVAILS IN OUR CONCERTS IS THE FESTIVE ATMOSPHERE, A FEELING OF JOY, AND A FEELING OF COMING TOGETHER WITH OUR PEOPLE AND OUR TRADITION."

---

And yet there is a sense of lacking. Musically, it is rich—both soothing and invigorating, like the view from the continental divide. But there's a disconnect, a rift between what a Westerner will hear and what the band's Bakongo brothers and sisters will hear.

"We like playing in the Congo and abroad," the group says, "[but] in the Congo, what prevails in our concerts is the festive atmosphere, a feeling of joy, and a feeling of coming together with our people and our tradition. These are moments when the spirits of the ancestors are working a lot, and we can feel that. In the rest of the world, it's [just] the joy and the festive atmosphere."

Even though international audiences may not fully grasp the weight of Konono's music, there are numerous layers to explore—aural, historical, and spiritual. They are like layers of earth—gravelly guitar riffs and the deep, clay-like warmth of skin drums under the fertile topsoil of shouts, drums, and bass guitar. Kenis sought to preserve these layers by recording in Kinshasa.

is fortunate, in one sense, to have had its formative years outside the spotlight.

"You can see it really clearly in guitar players from Congo coming to Europe," Kenis says. "As soon as they come here, they...start imitating music from Europe. Because they've been isolated from it for so long, they don't have the tools to understand it. They miss the whole point of what's really interesting. They lose the specificity, which is bad. But of course, staying isolated is bad also. The thing is to get the tools to understand what's going on around you."

Konono's identity is secure, at least for the older generation of players. Kenis describes Mingiedi by saying, "He could tour the world for 200 years, and he wouldn't change a bit in the way he plays." However, Mingiedi's son Augustin, who has taken over playing the lead likembe part, is much more aware of outside musical influence. This paradigmatic tension between generations helps flavor Assume Crash Position, which adds additional instruments and influences to the band's Bazombo style in a piecemeal production

process, which took place in a Kinshasan hotel room. "I record everything with a Mac Book Pro computer," Kenis says, "so I can take it wherever I like. The rest of the production work was to invite people into my hotel room and hand them a guitar or...a fader, or even the mouse and say, 'Okay, just fool around with this and see what happens.' If I have a role, it's like a translator. [It's the] difference between a literal and a literary translation. I'm just trying to interpret it in a way that is more clearly legible."

Although Mingiedi, who is illiterate, and his band-mates weren't used to recording on the computer, Kenis says that they intuitively understood it and became collaborators during the production stage. He found it odd that in this way, without a formal studio and with a continuously open dialogue, much of the

demonizing that has infected the culture of Congo was stripped away. When the Congolese elite needed an enemy and a scapegoat, whites fit the bill, but Kenis says that the recording process transcends this type of ideology, and his status as an outsider even allows him a different perspective.

"As a stranger, I can suggest things that they would never dream of doing. For example, a guy from Kasai would never play music with a Konono, because he's from Kasai and he's from Bakongo—period. But... when they realize that it indeed works musically, it's a big surprise for them. It changes the way they see their own music. That's really fascinating for me, to see that what's not supposed to work *does* work." Ⓐ

# WU FEI

DANIEL FULLER / PHOTOS BY ELLEN CHU

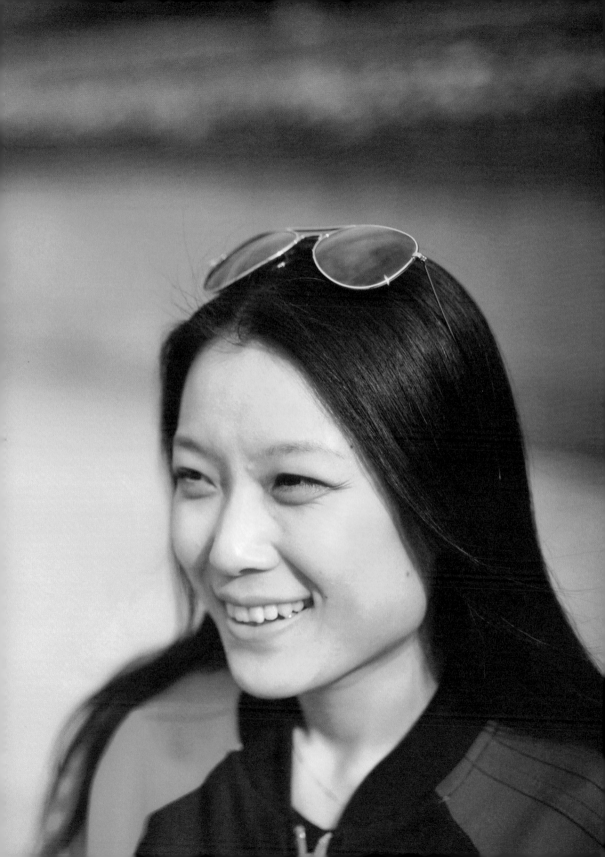

THE GUZHENG IS AN INSTRUMENT IN THE ZITHER FAMILY THAT DATES BACK MORE THAN 2,000 YEARS IN CHINESE HISTORY. ITS BEAUTY STEMS FROM THE SOUND THAT RESONATES FROM ITS 21 STRINGS (ALTHOUGH THAT NUMBER CAN CHANGE), COMPRISED OF BOTH STEEL HIGH STRINGS AND COPPER BASS STRINGS, AND THE PURE, CLEAN SOUND FROM A PLUCKED STRING CAN HANG IN THE AIR FOR WHAT SEEMS LIKE DAYS.

A guzheng player tapes a pick to each finger of the right hand; the left is used more for ornamentation, but an advanced player will tape picks to the fingers of both. Sometimes a player plays elegantly, evoking images of the Chinese countryside or an ancient temple, and at other times he or she might play more energetically, providing a wilder image like horses galloping.

What you almost never hear, however, is anything improvisational or experimental. That is, of course, unless you're listening to Wu Fei. She has managed, somehow, to make these seemingly incongruous elements work together in a fascinating and beautiful way. Like most artists, her ability did not come about accidentally, for Wu is indeed, as she says, "an old-school craftsman" who has taken to heart everything she has learned and observed during her varied life, even though it has left her stranded in a place between two cultures.

Born into a "lao Beijing" (old Beijing) family, Wu was assigned to the guzheng by her parents by the time that she was five. As musicians themselves, they had noticed her penchant for melodies and accurate pitch, and they were determined to get her on the path toward a musical existence. This involved living a life that was quite unlike most of her peers.

"I couldn't do anything but practice," she says. "From when I was about five years old, I had to finish my homework during school at break time between classes, so I wouldn't have to do homework when I got home, so that I could have a solid two hours to practice every day. When I was seven, I was in a choir. At eight, I was going to the conservatory to get training and some music theory every weekend. I started playing in Chinese ensembles when I was nine and an orchestra when I was ten. I almost did nothing else except music."

Just like other teenagers, Wu grew more independent as she got older. She didn't want to spend all of her time working; she just wanted to be young like her friends. She grew frustrated at her diverted youth, developing a poor relationship with her father during her teenage years.

Yet despite the tediousness of her early life, the hard work paid off when Wu was accepted into one of the best conservatories in the city, the China Conservatory of Music. This immediately changed her attitude.

"When I got into the conservatory, I felt, 'Wow, this is pretty awesome,'" she says. "The entrance exams were so difficult, and I had this overnight realization, just seeing how few students from all over the country got in, and we had the best musician teachers in the whole country protecting us, raising us like little genius kids. We were just so privileged."

The students were so privileged, in fact, that even their parents were told by the school's teachers to lay off the children. "My composition professor had a serious talk with my father right after I got into the conservatory," Wu says. "Because he noticed that I was acting kind of nervous around my dad, he told

him, 'If your daughter's going to become a composer, then her mind needs to be freed; it needs to be liberated. She cannot behave like this. She needs outrage, or to do some crazy things. So don't make her feel nervous.'"

As a student of composition, Wu had studied plenty of Western composers. But she felt that in order to truly grasp them, she needed to get closer to the subject matter. So she moved to the United States, and from 2000–2002, she worked on her undergrad music degree in the composition department of the University of North Texas College of Music. Adjusting to university life can be tough for anyone, never mind someone who has moved to a completely new culture and country to do it. At that time, there weren't many Chinese students in the music program, and there were none in the composition program. That sense of isolation was bad for Wu, but things became worse after a seemingly innocuous question from a professor.

"I remember when my first professor asked me a question about composition," she says. "He asked me, 'Why do you feel like you need to compose music?' I was stunned. [It was] the simplest question, and I didn't know how to answer it. My mind just went blank. Nobody had asked me that before in my life. I was put on this path. I said, 'I don't know.' He was like, 'If you want a career, you need to think about it!' I was really troubled for quite a long time, almost depressed. I thought I had been betrayed somehow, that I was put on this path without knowing what to do about it. Before that I was excellent, a top student, promising young composer, the future of Chinese music. Suddenly, I felt like I had wasted my time. I hadn't figured out who I was with all these crowns on my head."

Her salvation came in the form of a master class that she took with Frederic Rzewski. His advice led her to Mills College, where she completed her master's in music composition from 2002–2004, studying from people like Fred Frith, Alvin Kearne, and Joëlle Léandre. It proved to be a pivotal decision, but one that took time to welcome. If her early life in the

States was about trying to live in a different culture, then her early life in Mills was like trying to live on a different planet.

"The first semester, I was completely confused," Wu says. "I thought I had chosen the wrong school. It's a very experimentally oriented, artistic, avant-garde style. Students are really good players and really good improvisers, or electronic musicians who can't read any music at all but have just brilliant minds. At the same time, I'm there, [with] the sort of traditional, classical background, like a craftsman. But they're doing so many weird things! I was really confused!"

Having never much listened to that style of music, Wu felt like she had chosen poorly. She even went to see Frith and told him that she wanted to quit. This place was just too different for her, too confusing. He convinced her to try to embrace it and give it one more semester.

"And that's when I really started to study improvisation," she says. "The teachers there were quite brilliant. So that got me thinking, 'Maybe this is an interesting place that I can get something worthy out of.' Once I started studying improv, I just loved it—almost overnight. I never knew you could create music like that."

Her professional life progressed pretty quickly. She toured Europe, made a successful and well-received first album called *A Distant Youth*, and spent time in New York. She started playing at The Stone, a performance space run by prolific composer John Zorn, at the invitation of multi-instrumentalist Elliot Sharp. She had the opportunity to play with such people as Eric Friedlander, Billy Martin (Medeski Martin & Wood), Serbian composer Stevan Tickmayer, György Ligeti, Evan Parker, and Miya Masaoka. Arguably the most important moment came when she played in an improv group with Zorn, giving her the opportunity to meet him and pass along her CD. He contacted her two days later, wanting her to do a record for Tzadik under his composer series. *Yuan* was the title of the album, which was released in 2008, and it featured ensemble pieces for traditional Chinese instruments

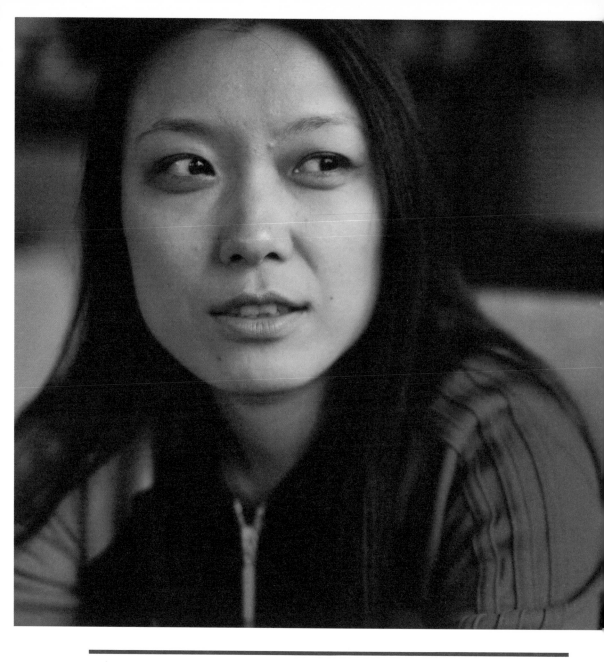

"[MY FIRST PROFESSOR] ASKED ME, 'WHY DO YOU FEEL LIKE
YOU NEED TO COMPOSE MUSIC?' I WAS STUNNED. [IT WAS] THE
SIMPLEST QUESTION, AND I DIDN'T KNOW HOW TO ANSWER IT."

**WU FEI**
Guzheng virtuoso Wu Fei has fused elements from both sides of the globe, even though it has left her stranded between two cultures.

images of the ancient Chinese temple are still evoked by the soft caresses of the guzheng, the pleasant whine of the erhu, the clang of Beijing opera gongs, and all the other assorted Chinese instruments, but that temple has been placed within a Western concert hall and complemented by its piano, marimba, glockenspiel, tambourines, and other elements. With this and her first CD, Wu has brought some traditional Chinese music to the ears of the West within the context of its own instrumentation. But can she also bring sounds and elements of the West to China in a similar way?

"Music here in general is pretty crappy," she says. "It's not that the people don't have a taste for good music; it's just that they're not exposed to it. When they see a violin or piano doing improv, they just think, 'Oh, well, that's just their form.' But when they see a traditional Chinese instrument doing innovative stuff, you can see in their eyes that they're really interested, really thinking about it. And actually, I incorporate a lot of traditional Chinese elements into the new music, and they really like it because they feel familiar with the sound, but they realize that it's something new that they've never heard. Even older folks, like 55-year-olds, find it really interesting. Audiences need to be educated as well. So it's changing, but the mainstream in China is so powerful [that] it's hard to break."

So there's hope that improv and genre mixing will catch on with the people of China, and there's hope that someone like Wu Fei can increase the understanding between the two cultures by straddling that place that lies between them, and showing each aspects of "the other" that they can enjoy. Recognition from her own government, however, seems to be farther from coming to fruition.

"My friend was in charge of the China new-music section at the Europalia International Arts Festival in Belgium in 2009, which was the year they highlighted Chinese music," she says. "They asked me to provide a list of artists who I think are interesting, who the Belgian audience should see, in the innovative area. So I gave them a list, and of course, the Chinese government didn't approve all of them, and they need to approve it. I heard through the Belgian officials that the Chinese culture ministers had said that because I had an American passport, I couldn't play the festival—that I wasn't allowed to represent Chinese culture. And do you know what's ironic? During this whole new-music festival, I was the only one who played a traditional Chinese instrument!" Ⓐ

like the guzheng, dizi (a bamboo flute), erhu (a small, two-stringed violin-type instrument that rests on the knee), and the pipa (a four-stringed lute) as well as for piano and percussion.

As one can tell strictly from that range of instruments, *Yuan* is not just about traditional Chinese music but a fusion of elements from both sides of the globe. The

# THE TANGO SALOON

DAVID METCALFE / *PHOTOS BY CYBELE MALINOWSKI*

Some artists seek pleasure, some seek fame, and a rare few **fall in love with the very process of creation**. "My grand plan is just to keep making music," muses multi-instrumentalist Julian Curwin, and his plan seems to be working. A veteran of the Sydney jazz and experimental scenes, he divides his time between Monsieur Camembert, Darth Vegas, Gauche, The Fantastic Terrific Munkle, and his personal project, The Tango Saloon.

Dancing its way through an expert blend of styles, The Tango Saloon creates a contemporary tango fit for barrooms and brothels, lounging comfortably in any international port of call. Gypsy jazz runs smoothly into tenacious Latin rhythms; soulful accordions add an old-world touch, while elegant electronic atmospherics anchor the sound firmly in the 21st Century. Achieving this rare synthesis requires musical manpower, and the group's first album featured 15 musicians culled from Autralia's jazz-drenched underground, including double-bassist Mark Harris and accordionista Svetlana Bunic, both from Monsieur Camembert, as well as Danny Heifetz, former drummer for Mr. Bungle and Secret Chiefs 3.

Successful execution of such a take on traditional

music stems from a diverse diet of influences. Cur-win's compositions find inspiration in the revolution-ary style of Ástor Piazzolla, the Argentine provocateur who revolutionized traditional tango in the 1950s despite the outcry of purists, and the wide-ranging and colorful soundtracks of Ennio Morricone. Piaz-zolla and Morricone both created music that sounds fresh 50 years on, and The Tango Saloon teases out the nuances of these masters, adding a visionary holism where most musicians would stumble into pastiche. Taking some cues from the experimental traditionalism of downtown New York jazzists such as John Zorn, Marc Ribot, and Bill Frisell, Curwin com-poses pieces that are complex conversations between instruments and expressionist themes.

His works have been compared to film scores "by everyone but those in charge of scoring films," he says with a smile. The visual elements in The Tango Saloon's music are undeniable, but the composition is based on pure aural exploration. "A lot of bands do the 'pop' album first; we took a different approach and experimented wildly on the

first album," Curwin says. "I guess we were able to do so because we weren't really trying to prove anything to anyone." The band's self-titled debut—released in the USA in 2006 through Mike Patton's Ipecac label—presented an experiment in twisted traditional forms that remains authentic despite reaching far into the fringes.

More recently, songs such as "Into the Castle"—from *Transylvania*, the band's 2008 sophomore album—have dragged the experiment into a dungeon laboratory. With droning chords, picaresque guitar accentuated by sparse snare rolls, and the sounds of birds in the distance, the track captures a full cinematic scene. As the fog lifts, the listener is sent running on "The Chase," with Heifetz's military percussion leading the way for tremolo guitar and pensive piano that pull the song into anxious violins. "I might start writing," Curwin explains, "and then go, 'You know what? This sounds like Dracula creeping around his house,' and follow that instinct. Though often the process is purely musical, and images and titles come later."

Left to right: Danny Heifetz, Christian Watson, Mark Harris, Marcello Maio (not pictured: Jess Ciampa)

Curwin's compositions are adept at setting individual parts against the whole and manipulating tension through effortless thematic shifts. Each song could develop into an entire album. Nothing is safe from surprises; the changes are painless and unexpected, with vibrant experimentation sitting next to songs like "The Dance of the Dead," which captures a more traditional style while shifting the listener's expectation with Bunic's accordion flourishes.

Now The Tango Saloon is preparing to release two new explorations, a chamber set and a full-length, continuing its deep dive into the hidden side of traditional sounds. The chamber set, affectionately titled *The Mango Balloon*, provides a glimpse into the band's quieter moments, bringing out the intimate side existing on the edges of its last two works. "I must admit, sometimes I'll take on a project partly to educate myself about a particular type of music," Curwin says. "It's always important to keep a sense of humor about it. The Tango Saloon can be seen as a tango project, but we're definitely not treating it

academically. We try not to take anything too seriously."

The title track of the chamber release turns the sexual intricacies of klezmer into terse melodic movements with accordion and guitar engaging in a close-knit dance. "Dog Day Night" floats over Spanish guitar rhythms on a melancholic trumpet touched by accordion counter melodies. Whereas the thematic color of the first two albums relied on a close blending of each band member into a full-bodied atmosphere, the chamber set highlights the individual players, creating intricate interplays of solo virtuosity. The songs give the listener an opportunity to meet each musician directly, approaching their unique voices in arrangements centering on more isolated compositional elements.

That's not to say, however, that The Tango Saloon has lost its edge; the chamber album is a side step prior to the release of its third full-length. "The other album we've been working on for the past year or

"I MIGHT START WRITING AND THEN GO, 'YOU KNOW WHAT? THIS SOUNDS LIKE DRACULA CREEPING AROUND HIS HOUSE,' AND FOLLOW THAT INSTINCT."

so continues the darker themes we had in *Transylvania*, possibly even a bit darker, focusing on more of a crime/noir theme," Curwin says. If its predecessor's wide-ranging exploration of vampirism is any indication, there's no one more qualified to tackle this angular expressionism of noir.

Curwin already is devising ideas for a fourth album, which he imagines will be a complete change of pace from the group's recent dark descent (likely a "bright, cheery affair," he says). He remains active with his other groups—including Darth Vegas' live accompaniment to F.W. Murnau's classic film *Nosferatu* at

the Sydney Opera House earlier this year. But The Tango Saloon, now hitting its stride, reflects Curwin's personal passion.

"With the Tango Saloon, we've become a tight-knit unit," he says. "The first album was a real labor of love, where the band comprised 15 musicians that I connected with playing in various groups. Now the core nine or so players have become like a family. Five years in, now we're getting into the groove of it— really playing music, not just reading off a page." Ⓐ

# SUPER/PRIME

ALI GITLOW

In neighborhoods across New York City, from heavily gentrified areas to seedier spots, stand towering, elegant, unsold condominiums. Most were erected before the start of the current US recession—and if it is already tough to sell swank high-rise lofts to wealthy clientele in Bushwick or Bed-Stuy, doing it during an economic collapse is even harder. Yes, it's likely that these apartments will attract owners eventually (it is New York, after all). But for the moment, there is square foot upon square foot of unutilized space ripe for the picking.

Enter Super/Prime, an innovative quartet of kids in their early 20s who began mounting art shows in alternative spaces in September of 2009. Harry Gassel, Zach Steinman, Brittany Taylor, and Corwin Lamm met at Oberlin College in Ohio, where they all studied art, writing, or film before flocking east to seek out the collaborative, creative community that is Brooklyn. These core members, along with a gaggle of friends, recognized a unique opportunity to showcase their work and challenge the public's idea of what exactly makes a proper art exhibition. "I don't think it's all that political, and I think we've all agreed it's not our place to make that kind of statement directly," explains Gassel, one of Super/Prime's organizers. "The motivation is to be able to find whatever opportunities are viable and interesting and maybe have a dialogue with the work, maybe just present really good space, and to bring work together and put on shows."

So far, the group has held an inaugural show in a Crown Heights condo, participated in the Fountain Art Fair in Miami, curated work in a three-floor residential space in conjunction with a nearby warehouse exhibition in LA, plotted a takeover of a Madison Avenue retail space, and, with any luck, will hold a one-night-only show in a psychic's storefront. Currently, its biggest challenge as a collective of young artists is figuring out the level of importance to place on finances—to be or not to be a 501(c)(3)? "We are casually commercial," Steinman says. "We're not a non-profit, but we're not making a lot of money, so we're not profitable yet. That's something we're still figuring out. Right now it's just a project that we're doing."

Super/Prime's first show, held at 717 Prospect Place in Crown Heights, Brooklyn, came about when Taylor called a meeting of her artistic friends and coconspirators. At the time, she was working for Art Observed, a blog with close ties to real-estate firm Tungsten Properties. She revealed that the firm would let the group mount a show in one of its unused condos to generate positive press, and the crew jumped at the chance. "It seemed great because of the free space, and also the opportunity to at least interact with this thing that was going on in New York—these weird, empty condos, this real-estate boom and bust," Gassel ruminates. "It felt really present to us. It was nice to not have to make a critique specifically but to be present in that kind of zeitgeist."

Wanting to avoid a hierarchical structure, all four members cheekily took the title of vice president, and they decided to curate the first exhibition as a group. "It was a tough meeting," Gassel says. "Things got heated. The fat was cut by everyone's strong opin-

"Six Loaves and Two Point Four Fishes," silkscreen prints by Harry Gassel
"Bread," silkscreen prints by Harry Gassel

ions, and what remained was really strong." They came up with a final lineup of work by ten artists, including themselves, acquaintances, and total strangers, entered via a submission process.

One of the pieces in that show was Gassel's "Six Loaves and Two Point Four Fishes" from his marble-rye series, for which he made silkscreen prints of the middle pieces from loaves of the bread in order to highlight the artisanship and patterns in a product that can seem so monotonous, especially when compared to white bread. "I was talking to my grandmother, who completely doesn't understand my attitude toward abstraction," Gassel says. "She's in

the client or some kind of external force that would drive the work," he says. "I think fine artwork has always had some of that. A lot of what really good graphic design does is take similar forces and make artwork within confines."

Some of his bread prints were also shown at the Fountain Art Fair in Miami, Art Basel's DIY-punk little sister based in hip, downtown Wynwood. The group raised money for a booth there by throwing fundraisers with bands including Silk Flowers and Teengirl Fantasy, and soon enough the four were headed south for one of the country's biggest clusters of art happenings. For four days, they held court in a

---

"IT'S EXCITING TO HAVE THE OPPORTUNITY TO PUT SOMETHING ON MADISON AVENUE OR IN A WAREHOUSE IN LONG ISLAND CITY AND KEEP REINVENTING HOW PEOPLE ARE GOING TO LOOK AT THE WORK WE CURATE, OR ART IN GENERAL, AND KEEP MAKING THESE SURPRISING THINGS HAPPEN."

---

love with the '50s and hasn't really left it, loves the Abstract Expressionists and mid-century furniture and jazz, and just doesn't look past. I brought her down this imaginary conversation: 'picture yourself in the bread aisle of the supermarket, and take away all the plastic from the bread and think about these as sculptures.' They may not be expressionistic art choices, but at the same time, they do express this really delicate study of form."

Gassel, who originally hails from New York, is currently enrolled in the MFA program at Yale University to study graphic design. Most of his work is primarily concerned with its own materials—prints about the act of printmaking, designs about design theory. His commercial endeavors are done under the pig-Latin moniker Eeshirtay (a key indicator of his love for language play). Gassel is quick to point out that his for-profit designs should not be so easily separated from his artistic practice. "If you look at the fine-art-gallery system and see how people make work specifically for shows, you're starting to introduce elements of

warehouse among mostly New York-based galleries like Glowlab, Milk Studios, and Grace Exhibition Space. As Steinman explains, they found it rewarding to show alongside these well-established institutions. "We're coming in, basically an unheard-of group of people, and getting a response and developing an identity, which was really interesting as a group," he says. "It gave us a lot of good momentum, which was probably the most valuable part of going down there."

In the corner of Super/Prime's booth stood an unassuming lamp that connected to a stereo. It played "Got Your Money," the rap anthem by deceased Wu-Tang Clan member Ol' Dirty Bastard, on loop. Whenever the song's iconic clap clap rolled around, the lamp would turn on or off, comprising Steinman's piece, "ODB Clapper Memorial." With the help of a whiz-kid friend, he hacked into that bizarre piece of Americana, The Clapper, causing it to respond to the song in just the way he wanted. "What I like about the clapper is I can set it up in 20 different ways, and it runs itself," he says. "I definitely have a

very minimalist approach to using space. Everything has to be really loaded and well chosen. I generally like to keep it as reductive and un-haphazard as possible while still seeming like it could have just fallen there."

Steinman grew up in San Francisco before heading to Ohio for school and then settling in Brooklyn. Currently, he works as an assistant to artist Wade Guyton, and he has worked at different times for Carroll Dunham, Piotr Uklanksi, and Jean Shin. His artistic practice is centered on balancing the hyper-referential and the extremely ambiguous. Another of his self-operating "machines" is a 2007 performance piece entitled "Phantasmagoria." Steinman commissioned 14 of his friends, some of them professional dancers, to stand underneath long, white circular swaths of fabric and do the "Macarena" while wearing black and white outfits with no musical accompaniment until they couldn't do it any longer. "I thought of it as the Abu Ghraib of the 'Macarena' or something," he chuckles. Recalling Yoko Ono's instruction paintings, his creation set strict guidelines and left little room for the performers to improvise. "It's the 'Macarena,' which is the least creative dance you could think of," he says. "Anyone can do this. I like that it's the everyman dance and that it was a real fad."

Now Steinman is creating a large marble engraving with the Washington Redskins logo on it, and he also is making a series of epoxy-resin paintings that are part of an ongoing project using glitter. In addition, he plays synthesizers and a drum machine in a band with friend Sam Haar (called Blondes), and he occasionally DJs under the same name. Gassel is continuing to study printing methods and creating work around it; similarly, he is hoping to begin making work that involves documenting Super/Prime's efforts. "There are really interesting ways to string these things together that I'd like to try and make happen," he says. "Even something as simple as having a tripod in the same place and taking before and after photos—it's so simple, to see what it looks like and learn from that process."

For Super/Prime's next trick, the group is planning to create more focused, site-specific projects that will allow its stable artists the freedom to play with unconventional spaces. What's most important right now is staying diplomatic and trying to show work by a wide range of artists. "I think we're all looking around a lot and trying to ask people to be involved," Steinman says.

But real estate is a fickle industry, and because of its nature, the group is not specifically committed to condos. "It's a little tricky dealing with these real-estate people because you can never really believe a word they say," Gassel laments. "But it's exciting to have the opportunity to put something on Madison Avenue or in a warehouse in Long Island City and keep reinventing how people are going to look at the work we curate, or art in general, and keep making these surprising things happen, which I think will give the artists and the artwork a great opportunity to surprise itself, the viewers, and the community." Ⓐ

"Phantasmagoria," performance piece by Zach Steinman

# JORGE CHAMORRO

KATIE FANUKO

Somehow, Jorge Chamorro always had an inkling that he would become a graphic designer, even before he could grasp exactly what that meant. "When I went to films with my father, I was so bored by the films, but I would always look at the lettering instead of the pictures," he says. "I was always interested in graphic design without knowing it was called graphic design."

Despite studying audio/visual communication in college, Jorge managed to find his way to the design world after graduation. The Madrid native worked with a number of design and advertising firms throughout the city, but he eventually became burned out by the daily routine once the lines between creating art and creating profit margins started to blur. "I think that graphic design is work where you have to communicate, not work where you have to sell," Chamorro says. "[In advertising], it's all about selling without any kind of love or worth; that's why I hate it so much. I like to be happy with my work and not only earn money."

This realization is what fueled Jorge's decision to leave the advertising industry behind and chart his own career path about four years ago. It was around this time that he started to delve deeper into his own artistic projects—focused on his interest in collages—

which allowed Chamorro to step away from digitally produced images and explore a more DIY approach. "I work with a computer all the time, but I don't like them," he says. "So when I do handmade collages, I enjoy the paper and the scissors in my hands, and I like it very much...they are like my sons."

Initially, Chamorro intended for his collages to simply be a personal project and didn't plan on doing anything serious with them. He also prefers to keep his designs simple and unfussy. "I admire designers that do very complicated things, but to look at it for five seconds, I say, 'I couldn't do that in all my life,'" he says. "The kind of design that I like is very much just black and white. I was reading a book [by Eduardo Chillida], and he finds that black and white is the highest way to communicate. I like things simple; I think that your life and your work have to go in the same way."

Chamorro took a surrealistic approach with his Women series by incorporating images of women's body parts juxtaposed with landscape scenes and geometric elements. Though the images draw similarities to Salvador Dalí's intricate and whimsical paintings, Chamorro mentions that he was not directly influenced by Dalí's work and that he simply wanted to create pieces and leave their meaning open ended.

Handmade collage, untitled, 2009

Left and center: handmade collages from the
*Apariciones, Desapariciones* series, 2009
Right: handmade collage, untitled, 2009

"With many of them, I really have no idea where any of them come from," he says. "With *Women*, I really didn't think anything, just 'make, make, make,' and that was it. When I try to do something, I really don't wish anything. I just try to have a good time and learn from myself."

His work took a political turn with his recent "VIVA ESPA__A" series. Chamorro also does work for a Spanish graphic-design magazine and was inspired to create a project that focuses on an iconic bull image, which has become a popular symbol of patriotism. "In the last few years, [the bull image] has become important to the people of Spain, and they put it on their cars for example," he says. "To me, it sucks. I hate it, but so many people love it because

it is so Spanish." As a result, his project focuses on playing with variations of this iconic image in a way that is meant to provoke viewers to question the symbol's original intent. "I don't like how the world goes and how Spain goes, and I think that art is a good way to fight and express yourself," Chamorro says. "You don't always have to be political, but I think that if you can express yourself in freedom, it is good for you and good for everything."

Chamorro also brings this philosophy to the next generation of artists. When he's not creating his own collages, he facilitates creativity workshops for students in Madrid's schools. "I think that my work is very lonely work, and to be with 15 children can be a good mix," he says. "When you see a collage made

"I WAS READING A BOOK [BY EDUARDO CHILLIDA], AND HE FINDS THAT BLACK AND WHITE IS THE HIGHEST WAY TO COMMUNICATE. I LIKE THINGS SIMPLE; I THINK THAT YOUR LIFE AND YOUR WORK HAVE TO GO IN THE SAME WAY."

in five minutes by a 10-year-old, it can be shocking, but I also learn a lot from them." When it comes to the kids, he not only wants to impart an eye for design but also hopes that they will learn how to push society's buttons as well. "I don't like the education [system] in Spain," he says. "I think that education should be more about teaching how to think. The world likes people who don't think too much—'just make money and shut up.' I like to teach the children critical thinking, and that's my objective. I would like to see a more critical population." Ⓐ

# BLURRED BOUNDARIES

BEN PEROWSKY'S MOODSWING ORCHESTRA

MATMOS

COUGAR

GOD OF SHAMISEN

KENAN BELL

TRENTEMØLLER

BEN GOLDBERG

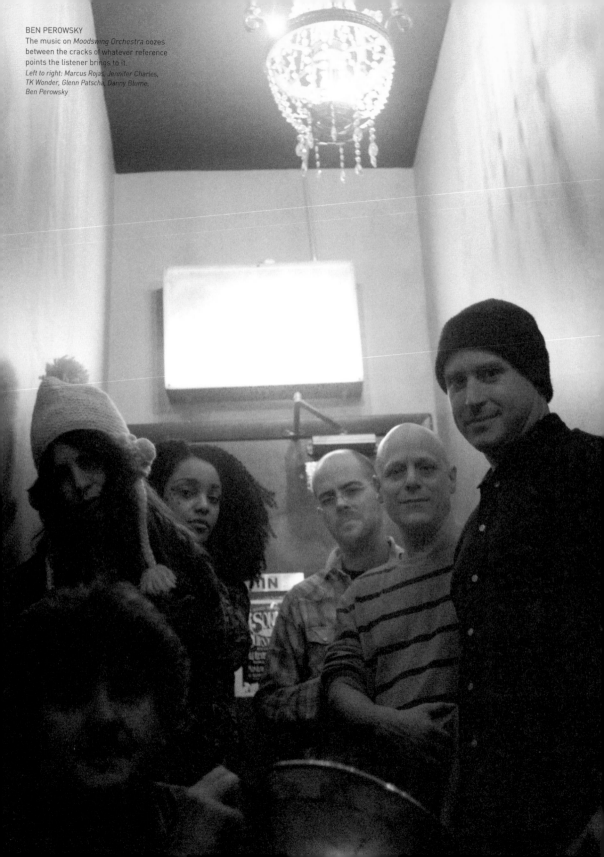

BEN PEROWSKY
The music on *Moodswing Orchestra* oozes between the cracks of whatever reference points the listener brings to it.
*Left to right: Marcus Rojas, Jennifer Charles, TK Wonder, Glenn Patscha, Danny Blume, Ben Perowsky*

# BEN PEROWSKY'S
# MOODSWING ORCHESTRA

SABY REYES-KULKARNI / *PHOTOS BY DUSDIN CONDREN*

Even after several decades of cross-pollination be-
tween the worlds of rock and jazz, it could be argued
that a true (or at least natural-sounding) hybrid has
yet to be invented. Ironically enough, one of the most
cohesive combinations of the two genres has recently
arrived in the form of drummer Ben Perowsky's
Moodswing Orchestra. The fact that Perowsky can
shuttle freely and fluently between both domains is
hardly surprising given his résumé, which on the jazz
side includes work with John Zorn, the Lounge Liz-
ards, Uri Caine, and John Scofield, and on the rock
side includes Joan As Policewoman, Elysian Fields,
and Ricki Lee Jones. Still other collaborations meet
in the middle, including work with Walter Becker (of
Steely Dan) and his old group Lost Tribe. After all,
if anyone were to venture into sonic terrain where
jazz and rock converge, it *should* be someone with
Perowsky's varied background.

But what qualifies his new album, *Ben Perowsky
Presents: Moodswing Orchestra*, as such a left-field
candidate for most-promising new genre bender is
that it doesn't actually sound like jazz *or* rock—at
least not in obvious or easily definable ways. In fact,
"ambient" is probably the first classification that makes
sense, but this music seems to strain against catego-
rization in the first place. More accurately, it's as if
the music on *Moodswing Orchestra* oozes between
the cracks of whatever reference points the listener

brings to it. As a result, not only do conventional
definitions of rock and jazz dissolve as the music
unfolds, but labels as a whole—and the comforting
sense of direction that they provide—break down in a
dreamlike, highly inventive swirl of sound.

Much of *Moodswing Orchestra*'s texture derives from
Perowsky's post-production manipulation (edits, ef-
fects treatments, etc.) of what originally began as a
recorded archive of live improvisations. In 2002, the
project's nucleus—Perowsky, pianist Glenn Patscha,
turntablist Markus Miller, and bassist Oren Bloedow
of Elysian Fields—landed a weekly residency at the
now-shuttered Brooklyn club North Six, where they
frequently let loose with a rotating cast of special
guests. In an effort to improvise from a place that
"wasn't coming from a jazz language," Perowsky
issued a simple instruction to his collaborators: "less
Herbie, more Eno."

"I told them that [directive] after the first set of the first
night," he explains. "Glenn can pay anything. He's a
total virtuoso. And we all know we can do that—not
that we can play like Herbie Hancock—but I didn't
want to push it in that direction."

Interestingly enough, Perowsky took the inverse
approach on his new Ben Perowsky Quartet album,
entitled *Esopus Opus*. The quartet features progres-

sive-jazz heavyweights Drew Gress, Chris Speed, and Ted Reichman improvising, at Perowsky's direction, like a garage band. Yet the drummer still sees a clear delineation between *Opus* and *Moodswing*. The former, he insists, falls more squarely in jazz territory. (Other listeners may not be so ready to call *Opus* jazz—or call it any one thing.)

To better understand Perowsky's vision, it helps to know that he is the son of saxophonist Frank Perowsky—a jazz veteran who has played with Woody Herman, Sarah Vaughn, Billy Eckstine, and Stan Getz—and that his first love was classic rock. "Jazz," Perowsky recalls, "was on all the time at home. It's not that I necessarily was rebelling against it. It just wasn't the first music I went for. That wasn't my music; it was my parents' music. It wasn't until I was a teenager that I started to open my ears to it."

But even after a brief teenage spell of eschewing rock to immerse himself exclusively in bebop and post-bop, Perowsky returned to his first love—but with a broadened sense of how to approach it. Meanwhile, hip hop had already seeped into the picture before he'd even begun playing drums, thanks to his older brother's interest in graffiti and comic books. Born in New York City in 1966, Perowsky falls perfectly within the age group that absorbed rap and graffiti culture when it was a new, cutting-edge aesthetic percolating in the air. Looking back at the ground he's covered as a listener, his versatility as a player and natural instinct to bend boundaries makes perfect sense.

"I still feel like classic rock is my roots," he explains. "I still enjoy music that's coming out of that mode as a jumping-off point. It feels like home, like a place to come back to and then go away from. I never stopped enjoying rock and roll or soul music or funk. I just then had this whole other jazz thing. But I was always letting it all in."

Given his adeptness at creating seamless new fusions, Perowsky's tendency to keep the two forms separate in his head is somewhat puzzling. He explains that much of his need to do that arises from having to be aware of the business side of playing music. "It's not necessarily a bad conflict," he says of mediating business and art. But he also concedes that, for him, the conflict doesn't revolve around marketing alone, and that there is some internal push-pull going on within his own thinking.

Although Perowsky gravitates to open-minded musicians—Joan Wasser (a.k.a. Joan as Policewoman), for example, is nothing if not a textbook example of an artist who employs heavy jazz elements in a pop/songwriter context to sublime effect—he is aware that some players just aren't conscious of music being made outside of their own idioms.

"Dialogue" would perhaps be the best term for how Perowsky has always seen the relationship between

ger apply. There certainly is a pervasive mood here, and sure enough, it does swing, but there is no easy way to figure out what that mood is supposed to be. This ambiguous quality works in the album's favor, not only because it coats the music in a sheen of freshness, but also because the musicians maintain their poise while conveying its various shades and subtleties. By turns, the music feels unmistakably but not quite languid, melancholy, relaxing, dissonant, ethereal, sensual, fanciful, etc. Ultimately, the album

"I STILL FEEL LIKE CLASSIC ROCK IS MY ROOTS. IT FEELS LIKE HOME, LIKE A PLACE TO COME BACK TO AND THEN GO AWAY FROM. I NEVER STOPPED ENJOYING ROCK AND ROLL OR SOUL MUSIC OR FUNK. I JUST THEN HAD THIS WHOLE OTHER JAZZ THING. BUT I WAS ALWAYS LETTING IT ALL IN."

rock and jazz. After all, he describes landmark jazz albums such as Sonny Rollins' *Night at the Village Vanguard* and Thelonious Monk's first trio albums with drummer Art Blakey as having a "raw, gutteral, punk-rock essence."

"My favorite jazz records are not really safe," he adds. Centered (somewhat) on the core group of Perowsky, Patscha, Miller, and Bloedow, *Moodswing Orchestra* also is peppered with numerous guest appearances, most conspicuously from the likes of Wasser, Bebel Gilberto, Miho Hatori of Cibo Matto, and Jennifer Charles, also of Elysian Fields. Unsurprisingly, vocalists like Wasser, Charles, and Gilberto bring a sultry elegance to their vocals as the music slinks toward—and past—the abstract edges of what we might consider to be surrealist lounge. Woodwinds, drifts of keyboard mist, bleeps, bells, whistles, and the sound of crackling vinyl exude from a dense soundscape that positively drips with atmosphere, with an overall effect that's like listening to a warped variation of jazz from within a vibrant, eerie, and disorienting dream.

Meanwhile, a kind of harmonic humidity hangs over the music and even weighs it down; for most of the tunes, it's as if Perowsky and company have bent pitches into a space where major and minor no lon-

comes across as more engaging than threatening as all of these disparate sensations gel into a fluid nine-track sequence.

Again, Perowsky does acknowledge a tension between these various styles of music. Perhaps, at the end of the day, it is this tension that, strangely enough, enables divergent musical traditions to coexist so smoothly in Perowsky's work. When family members live under the same roof, he points out, tension is an inescapable but vital bonding agent that often underpins the harmony between them. Likewise, Perowsky and his cast of players are able to wring an uneasy, appropriately messy, but nonetheless jovial coexistence between jazz, rock, and their assorted offspring. But aside from any artistic insight that Perowsky might be able to shed on these matters, a more telling truth emerges when he laughs nervously while thinking about his father's upcoming (as of press time) 75th-birthday celebration.

"I have a gig with Moodswing Orchestra on that day," Perowsky chuckles. "So he's like, 'All right, I'm going to come down and have my party there.' It should be an *interesting* mix of age groups." Ⓐ

# MATMOS

MICHAEL PATRICK BRADY / *PHOTOS BY ERIC LUC*

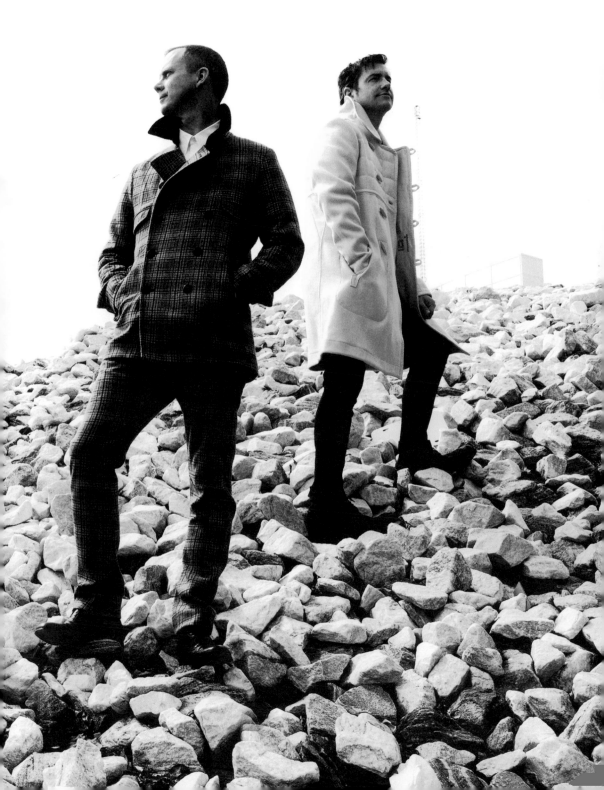

# T
HE PATRONS OF THE LOFT, A RUSTIC WINE BAR IN THE SLEEPY SKI-RESORT TOWN OF WHITEFISH, MONTANA, WERE MOST LIKELY EXPECTING THE EVENING'S ENTERTAINMENT TO BE A LAID-BACK AFFAIR, SOMETHING SMOOTH AND SUBTLE THAT WOULD PAIR WELL WITH A PINOT NOIR OR CABERNET SAUVIGNON.

Attentive connoisseurs may have taken note of the unusual array of items piled up at the back of the narrow room: vibraphones and melodicas, a pair of MacBooks Pro, Reynold's Wrap tin foil, Roland synthesizers and buckets of water, the ever-popular children's game Let's Go Fishin', and last but not least, a bulbous yet stately cactus perched atop a barstool. It looked more like a garage sale than a musical performance, a catastrophe of junk arranged senselessly with no discernible meaning. When the artists finally settled in behind their curiosities, their performance did little to dispel the confusion.

"I think they were expecting something more like Joni Mitchell," is the dry summation of M.C. Schmidt, who, along with his partner Drew Daniel, comprises the avant-garde electronic duo Matmos.

"A lot of people were looking really puzzled," Daniel says, "but the show was really a freak magnet for Montana. I got the feeling that it drew people in from all around any nearby cities who wanted to hear some kind of experimental music. So it was really fun to be there."

The pair was joined on stage by their friends in So Percussion, a Brooklyn-based quartet that brings the transgressive compositions of artists like David

Lang, Iannis Xenakis, and John Cage to life for new audiences. It was Cage's organic chance piece *Child of Tree* where the cactus came into play and where Matmos believes it may have strained the crowd's open mindedness, though the duo's self-deprecation is belied by the eager and focused throng that clustered around it, seeming to hang on every note, no matter how unusual or surprising. Even if experimental music isn't your cup of tea (or glass of wine), it's not every day that you get to see a man tenderly coaxing notes from the prickly spines of a cactus.

"[So Percussion] were having some trouble," Schmidt says, "and I suggested they use this amazing contact mic, the Barcus-Berry Planar Wave Transducer. You just nestle it in one of the arms of the cactus and, sure enough, it just becomes this beautiful, live thing."

Matmos is no stranger to finding beautiful sounds in unorthodox places. Its career has been an exercise in lateral thinking, turning the unlikely and unobvious into compelling music that satisfies on both an emotional and an intellectual level. The duo is one of the foremost contemporary purveyors of musique concrète, an often controversial cut-and-paste art form that transmogrifies existing sounds into new and surprising pieces through extensive sampling,

interpolating, and editing. That may sound very high minded and academic (and much musique concrète is), but Matmos welcomes listeners into its world by maintaining a whimsical sense of humor and underpinning its adventurous compositions with familiar footholds like techno beats and dance rhythms. Its 2001 album, *A Chance to Cut is a Chance to Cure*, is so infectious and danceable that listeners may never have known that it was made up almost entirely of surgical field recordings, the sounds of liposuctions, rhinoplasties, and bonesaws. Each successive album—the folk-tinged *The Civil War*, the anthemic, genre-hopping *A Rose Has Teeth in the Mouth of the Beast,* and the all-synthesizer *Supreme Balloon*—defies expectation, with Matmos perpetually redefining its musical scope, challenging listeners to purge themselves of their prejudicial notions of what can and cannot be considered musical.

One of the duo's latest albums, *Treasure State*, finds Matmos in full collaboration with So Percussion, which forced both groups to make a few adjustments to how they approach making music. Graduates of the Yale School of Music, the members of So Percussion come from a world of order and precision, whereas Matmos adheres to a more DIY aesthetic borne out of punk rock and techno.

"We're just straight-up not trained," Daniel laughs. "We're like cave people about music."

"They're used to things being composed in advance," Schmidt says, "where I'm more likely to run around yelling, 'Ah! Do something like this! Now I want it to sound like Bow Wow Wow!'"

"We meet in the middle, coming from very different places," Daniel says. "But So Percussion is already accustomed to people whose sound world approaches noise and embraces pitches that aren't standard or embraces playing an object. I had reviewed a So Percussion record for KALX when I was DJing there, so I knew their work and that they had done the David Lang piece ("The So-Called Laws of Nature"), where they were drumming on cups and ceramic objects, playing non-musical objects musically. I felt that there was something immediately in common."

Despite that common ground, both Daniel and Schmidt admit that *Treasure State* would never have happened without the help of Brett Allen, a resident of Whitefish and owner of the Snow Ghost recording studio.

"Snow Ghost is this incredibly fancy studio that this guy runs—for free," Schmidt says, clearly dazzled by the concept behind Allen's endeavor. "And there was no hurry. Stay as long as you want. [The studio] was an invisible collaborator."

"Brett is incredibly generous if he likes the work that you're doing," Daniel adds. "We got to use microphones and recording techniques that we could never afford. It's an amazing studio."

*Treasure State* clearly benefitted from the relaxed, wide-open atmosphere that the groups found in Montana. Matmos and So Percussion have created an album of intricately plotted object studies that Daniel feels approximates the extremes one might encounter on a national journey. The song titles are deceptively narrow—"Water," "Shard," "Swamp"— simple appellations for what are, in fact, deeply complicated compositions that take small sonic ideas and elaborate on them in unfathomable ways. "Needles" is derived from the *Child of Tree* performance, using

**MATMOS**
This electronic duo's career has
been an exercise in lateral thinking,
turning the unlikely and unobvious
into compelling music that satisfies
on both an emotional and an
intellectual level.
*Left to right: M.C. Schmidt, Drew Daniel.*

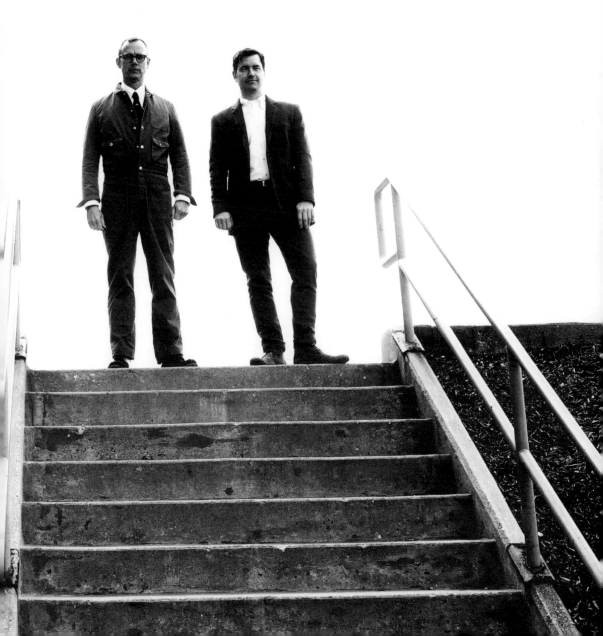

the enhanced cactus to pluck out sharp notes that are simultaneously melodic and rhythmic. "We took the idea from Mr. Cage and made our own song," Schmidt says, "with *beats!*" "Cross" most obviously bears Matmos' stamp; it's a wheezing, thumping piece, croaking and screeching out an impressionis-

kind of brutal—because we've toured and been in the van and been at the airport—there's a willing-ness to lift up the hood on each other's compositions. We had to do that on some of their work, and they definitely did it to some of our work. It was really helpful, but not without some tears."

---

"WHEN YOU'RE COLLABORATING, YOU NEED TO MAKE SURE EVERYBODY'S HONEST. [WITH] THAT FREEDOM TO BE KIND OF BRUTAL, THERE'S A WILLINGNESS TO LIFT UP THE HOOD ON EACH OTHER'S COMPOSITIONS."

---

tic collage of noise and sound effects that coalesce into a grotesque yet beautiful mess. So Percussion's instruments are torn up and repurposed throughout the track, to suit the seedy impulses of Schmidt and Daniel.

"Shard" and "Aluminum" are fragmentary pieces that explore the musical qualities of ceramics and metal, respectively. There's an unsettling quality to these tracks, as if the brokenness of the elements involved has infected the music. They clatter and skitter, their notes bearing an unexpected tonality of hollowness that sounds alien compared to traditional pitch-based instruments. "Flame" uses the rich strum of acoustic guitar as a sonic foundation on which a glittering, major-key uplift is erected, bringing *Treasure State* to a surprisingly warm finish.

"This is a very 50/50 record," Daniel says, stressing that *Treasure State* was a two-way street between Matmos and So Percussion. "When you're collabo-rating, you need to make sure everybody's honest. When you start to write together, there's a comfort level that you have to reach where you can say, 'Look, I think there's three minutes here that are just boring. Maybe you hear them as mellow and medita-tive, but to me, it's dull.' [With] that freedom to be

Though the creations of Matmos and So Percussion may not appear to follow the conventions of music, it is impossible to listen to what they have accom-plished on *Treasure State* and deny that it is musical. Still, Daniel and Schmidt are anxious about calling themselves musicians.

"The word is so fraught," Schmidt says.

"You can't win," Daniel says. "If you call yourself a 'sound artist,' you sound pretentious, and if you call yourself a 'musician,' you feel pretentious, because it's not really the core of your practice. There's a feel-ing of never quite belonging."

"Neither of us went to music school or art school," Schmidt says, "and it's the shit-talky way that we speak about what we do that gets us in trouble. I mean, we got dressed down by [musique concrète pioneer] Bernard Parmegiani at the Groupe de Recherches Musicales. They had invited us to play a concert, and all these heroes of musique concrète come to the show—there's Parmegiani, and Francois Bale, and Pierre Schaffer's wife—and it's terrifying. At one point, Parmegiani walked up to us cold and fixed us with this steely glare and said, '*I make real music.*' And I'm scared now, that I have to clarify

myself every time I speak because some people take this very seriously."

Matmos is following *Treasure State* with its long-awaited *Simultaneous Quodlibet*, an album years in the making that Daniel calls dark, obnoxious, and funny, in the vein of Stephen Stapleton's Nurse With Wound. Named for an obscure musical form that involves the combination and interweaving of distinct, existing melodies and compositional quotations, *Simultaneous Quodlibet* is an aural olio of discreet sonic elements mixed, chopped, and tossed into a surprisingly coherent froth. "It's a much looser-limbed monster than *Treasure State*," says Schmidt, who is quick to credit the contributions of friends and fellow electronic musicians Wobbly (a.k.a. Jon Leidecker) and J Lesser.

*Simultaneous Quodlibet* is utterly Matmos: daring, adventurous, and experimental but tempered with a good-natured sense of humor and whimsy that lures listeners even as the digressions into noise and atonality threaten to push them away. The looseness that Schmidt describes is evident; the record is something of an electronic jam, a long journey through the possibilities of sound where ideas and motifs drift in and out of focus.

Daniel, Schmidt, Leidecker, and Lesser always establish the beat first, with rumba shakers and synthesized percussion pulsing together, leading the way through the foggy mélange of audio detritus. Shards of horns, guitars, and a woman's laughter, as well as a constellation of curious sound effects, spring from nowhere into the unyielding progressive current of the tracks. Words, not lyrics, appear out of context, disembodied, and devoid of meaning. *Simultaneous Quodlibet* is cloaked in spooky atmospherics, assembled in such fine detail that it's hard not to pause and return to a single passage or moment and replay it over and over, trying to discern all the minute elements that blur together to form the impressionistic whole.

As if the pair weren't busy enough with their work

as Matmos, both Schmidt and Daniel reveal that they've been working on side projects. Schmidt's Instant Coffee, which includes bassist Lisle Ellis and ex-Half Japanese avant-musician Jason Willet, has just released its self-titled album on Planam / Alga Marghen. Daniel's much-loved side project, The Soft Pink Truth, has been on hiatus for the past six years, but he admits that he has been practicing and working on new material. It's been difficult, however, as his day job as an assistant professor of English at Baltimore's Johns Hopkins University is demanding a lot of his time.

"At this point," he says, "I've made so much material that's about 80% done. It'd be really fun if I had the time to take it all the way to the finish line—"

"Instead," Schmidt interrupts, "there'll be a book about Renaissance melancholy!"

"Yeah," Daniel admits, "I need to finish my book. That's the real answer. The other problem is [that] I started to do covers, which is like crack. So now I've got this avalanche of covers of Dark Throne and Skinny Puppy and the Virgin Prunes. The question is, 'Do I do another covers album, or is that being completely self-indulgent?'"

Though Daniel and Schmidt talk about their feelings of "not belonging" in terms of anxiety and awkwardness, it's this sense of otherness, of existing outside the conventional, prescribed ideas of what constitutes musicality, that gives their work such power. Though they draw from familiar genres like rock, techno, and avant-garde electronic music, their diverse backgrounds and interests have led them down paths that a group inculcated with formal musical training and concepts may not have discovered. Matmos has created its own sound world, made possible not only by the masterful use of recording and editing techniques but also by an awe-inspiring ability to see the potential for music in things as mundane as a falling book, a ceramic coffee cup, or a resilient bit of desert shrubbery. ◐

# COUGAR

CONNIE HWONG / *PHOTOS BY ELIZABETH WEINBERG*

It's a chilly Sunday afternoon in December, and the members of Cougar are just waking up—in different parts of the country. "It's 1:00 [p.m.] over here," says David Henzie-Skogen, the group's drummer/ percussionist and self-appointed ringleader, conference phoning from Madison. "Is it 1:00 [p.m.] down there?" "Yeah, it's 1:00 [p.m.] down here," guitarist / synth player Aaron Sleator replies from Austin, where he is a student at the University of Texas School of Architecture. Bassist Todd Hill also is on the call from his home in Chicago. Formed in 2003 when all five members lived in Madison, the band members now live in cities spanning thousands of miles; in addition to Henzie-Skogen, Sleator, and Hill, Cougar also includes guitarists Dan Venne, who lives in Brooklyn, and Trent Johnson, now in Milwaukee.

Cougar released its debut album, *Law,* in 2006 on Layered Music, Henzie-Skogen's own imprint, and quickly caught the attention of American and European critics, who noted the band's complex, instrumental melodies. Just don't try calling them the "P word."

"The long and short of it is that we really don't listen to many post-rock bands at all," Henzie-Skogen says while laughing. "People are like, 'Yeah, [Cougar sounds like] late-period Mogwai and Explosions in the Sky,' which we've all heard, and I think that's all we can say about them—we've heard them. All of us personally enjoy stuff that's really different, which I'm sure is why the band sounds like it does. Trent is really a through-and-through pop-music guy—music where the hook is the reason for the music, like Hall & Oates and Hendrix. I grew up playing a lot of Brazilian music, New Orleans music...Todd studied jazz and classical, and everybody else has played in all kinds of bands from reggae to whatever else, so it's hard to say that there are specific influences. But it is easy to say that those influences don't include the post-rock bands that people associate us with, [just] because our music happens to be instrumental music that features guitars."

With *Law,* Cougar cultivated a small but enthusiastic audience across the Midwest and Europe. Three years later, the band members found themselves scattered across the country for work, school, or both. Cougar soon attracted the attention of esteemed London label Ninja Tune, which released its sophomore album, *Patriot,* in September of 2009.

"It's kind of funny that we're doing interviews over a conference call, because it feels like a band meeting," Henzie-Skogen laughs. "For the first record," Hill says, "we were around each other and basically would just meet in the morning. Everyone had pretty easy schedules at that point. But [*Patriot*] basically was almost entirely done as an Internet collaboration, as far as basic ideas of songs. We all have simple recording

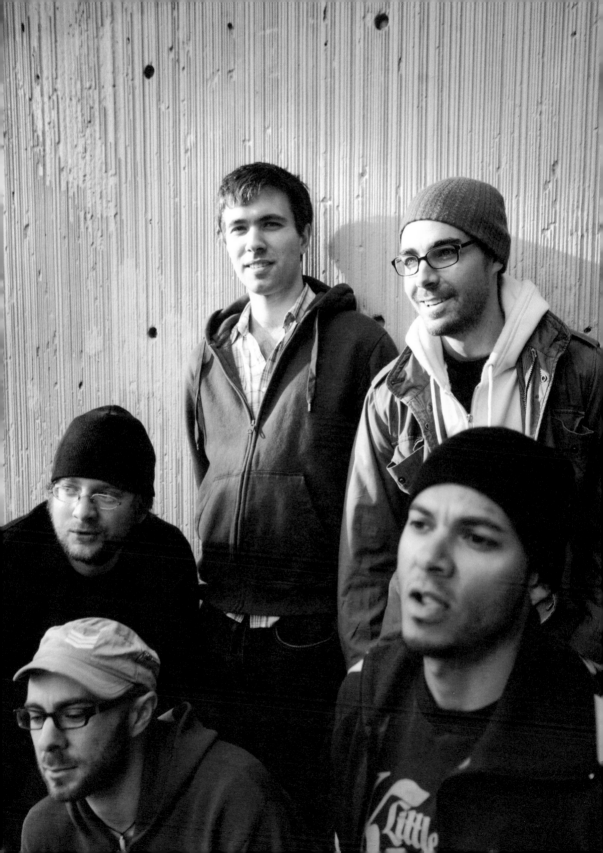

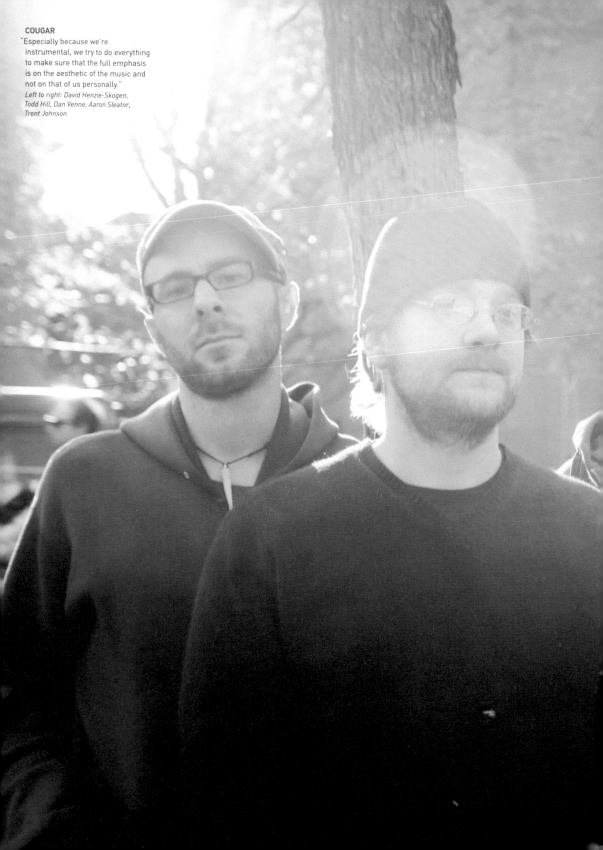

**COUGAR**

"Especially because we're instrumental, we try to do everything to make sure that the full emphasis is on the aesthetic of the music and not on that of us personally."

*Left to right: David Henzie-Skogen, Todd Hill, Dan Venne, Aaron Sleator, Trent Johnson*

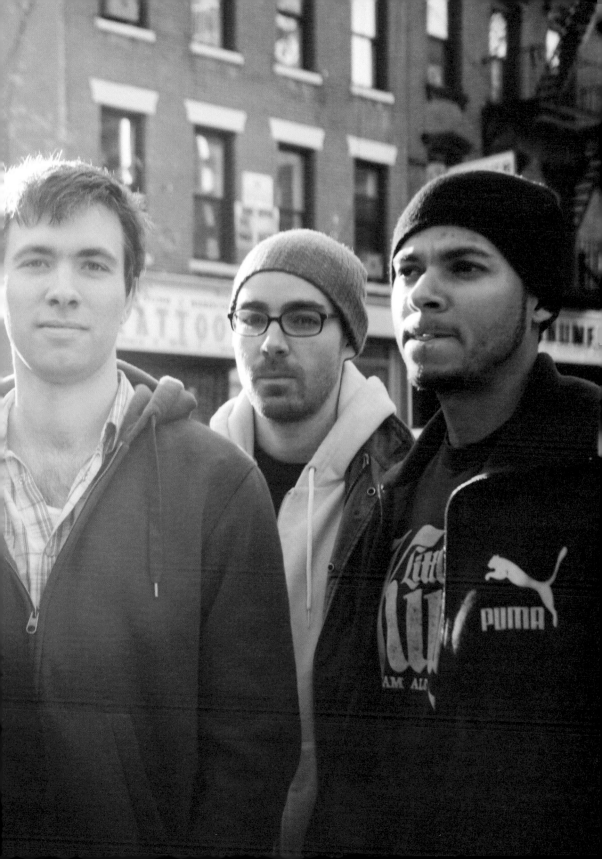

equipment and can record stuff, and Dave acted as the collector. Sometimes the guitar player would fly out to New York to record a guitar part there; it was very piecemeal."

"It's probably one of the things that contributed to making it a different record from the first record," Henzie-Skogen adds. "We started banging our heads together in a room, with the best idea winning out, and we all got to sit there and listen to all these ideas, make all these edits, and argue over thousands of E-mails or occasionally conference calls about what a song should sound like."

Though the entirety of the album was recorded before the band switched labels, the new Ninja Tune pedigree has already had a galvanizing effect on the band. "For me, it's just really exciting to see the Ninja logo on the record," Henzie-Skogen says. "The most refreshing thing about Ninja is that they're really honest. They're not telling us, 'We're gonna make you stars' or whatever. We trust their PR people, we trust what they do, and we like their artists."

In the summer of 2009, Cougar launched a 21-city European tour, providing the rare (albeit temporary) chance for all five band members to live, travel, jam, rehearse, and perform together. "It was the best, most successful tour yet," Henzie-Skogen says. "The band was playing better than we ever played. It was a nice surprise that people would show up at shows and kind of clap and hoot and holler at the beginning of the song that they liked. It was really refreshing that people had heard a little bit of the music before. We were getting used to playing to blank faces supporting larger bands that are nothing like us, like going out with a pop band like Maximo Park and hoping to win over the pop crowd."

In addition to providing Cougar with insight into its growing fan base, the European tour also gave the band a chance to reflect on its image and fashion savvy (or lack thereof). "The first gig of the European tour was in this place in London called the Hoxton right in the heart of this notoriously hip neighborhood," Henzie-Skogen recalls with amusement. "And Todd had one of the best tour quotes ever while talking about all the kids with cool haircuts: 'Their haircuts appear to be backwards.' We've had a number of interesting fan encounters posted on the website. 'If you guys just dressed better or had a singer...' But we've never been a kind of band that focused more on how we present ourselves, or [try to] look like [we] ought to be famous. We're the kind of band that books a gig and gets on stage in the clothes that we wore when we got up at 3:00 a.m. in the morning. Maybe that's a Midwest thing, you know? Why would you change clothes to play music?

"Especially because we're instrumental," Henzie-Slogan adds, "we try to do everything that we can to make sure that the full emphasis is on the aesthetic of the music and not that of us personally. We keep the music feeling naked as far as production is concerned—you hear all the notes that everybody plays, and it's one of the things that makes it a little different from some other things out there, but it also makes it really fun and challenging to perform every night, because it's almost like classical music. When you fuck up, everybody knows you've fucked up. It keeps it exciting for us."

If *Patriot* is any indication, the band's intense focus on complex musical aesthetics, combined with its composition-through-correspondence technique, represents a giant leap forward, facilitating an impressive breadth of songwriting chops and stylistic influences.

"OUR IDEA WHEN WE RECORD IS: DON'T EVER REPEAT SOMETHING. WE ALL AGREED THAT TRYING TO WRITE SOMETHING THAT RECAPTURES THE SAME KIND OF FEELING OR PALETTE IS JUST BASICALLY SECOND GUESSING YOURSELF AND CONSIDERABLY LESS CREATIVE AND AMBITIOUS."

"Stay Famous," the record's epic introductory track, sets a pounding drum line against a wall of wailing, swelling guitars that crescendo into a melodic interlude. "Florida Logic" centers on complex rhythms and syncopation, a nod to Henzie-Skogen's rich background in Brazilian music and jazz, enhanced by the occasional metal-inspired riff. Deeper tracks swerve from a psychedelic prog-metal jam to delicate music-box melodies to a honky-tonk ditty run through a laptop's digital tinkering. Far from being preoccupied with the moody, expansive super-songs that are the hallmark of Explosions in the Sky (a band used by critics as a musical touchstone), *Patriot* instead hints at a vast array of disparate influences, from Ratatat to the Flaming Lips, Battles, Johnny Cash, and even late-1990s drum and bass.

"[People say], 'Oh, they've got too much shit on the record; there's a country song at the end of the record, there's a synth song in the middle of the record, and it starts out with a guitar banger,'" Henzie-Skogen says. "I think that a lot of bands out there find a specific sound, and push that sound as hard as they can as being that band's sound. Our idea when we record is: don't ever repeat something; don't make a song that sounds like a song from the previous record. We all agreed that trying to write something that recaptures the same kind of feeling or palette is just basically second guessing yourself and considerably less creative and ambitious. I just don't want to repeat myself, because when you start doing that, then it's a job."

Despite the challenges of distance, side projects, and other logistical obstacles, Cougar clearly continues to be a labor of love and a vital creative outlet for each of its members. "There are people out there that everybody knows and loves because they're considered benchmarks of creativity," Henzie-Skogen says. "People like Radiohead and Bjork. They try to push their own boundaries every time they make music. To be able to do that and satisfy both people who lust for pop melodies and people who really enjoy experimentation—that's a bit of the inspiration for the band, to get our experimental kicks out but also have band members' moms think something's really pretty. I think we all just try and make music that we want to hear." Ⓐ

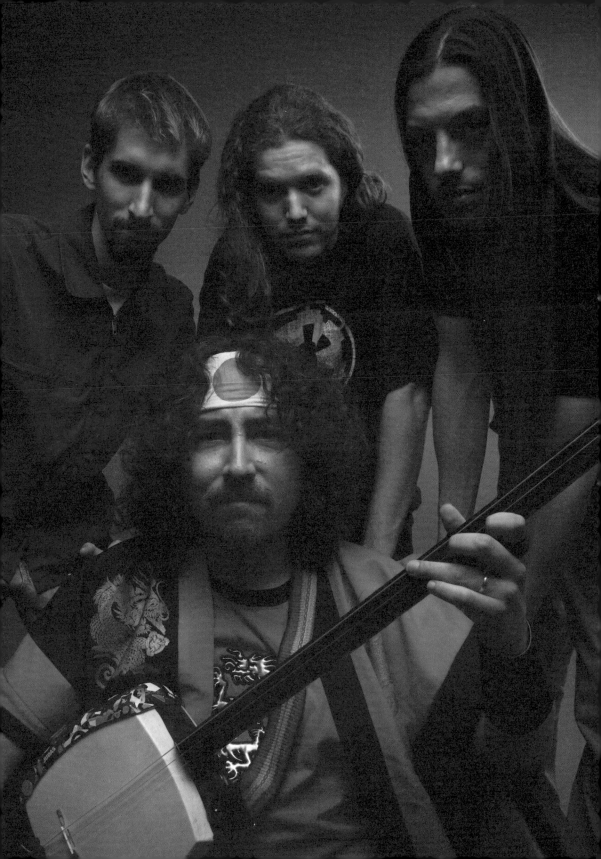

# GOD OF SHAMISEN

MATT FIELDS

Despite a predilection for combining the shamisen—a fretless, three-stringed Japanese lute—with any dissimilar musical style, God of Shamisen's Kevin Kmetz is very much the traditionalist.

Kmetz is a student of Tsugaru-shamisen, a striking, percussive style of performance developed during the late 1800s and early 1900s in the northern region of Honshu (the largest island of Japan). Evolved in part by players such as Takahashi Chikuzan, who contributed to the "Tsugaru boom" of the 1950s, Tsugaru-shamisen eventually adopted long improvisations and began to reflect American influences such as the burgeoning free-jazz movement.

The name Tsugaru-shamisen, however, didn't gain popularity until the '50s and '60s, an era when America again declared itself protector to Japan. Military bases had sprouted up in the region, and with them came American music suddenly filtering through the radio. Influences of jazz, blues, and rock 'n' roll were added to the Tsugaru repertoire, and just as quickly, the shamisen community named the folk-infused improvisations as the true tradition of Tsugaru-shamisen—a tradition that must stay rigid, according to some.

It is particularly apt, then, for an outsider who spent his youth in the 1980s going to school on an Ameri-can military base in Japan to advocate a tradition of change inherent in the beginnings of Tsugaru-shamisen.

Kmetz had a desire to play the shamisen during his early teens—something that he says was impossible for a gaijin, an outsider, to do at the time. "There was no way I could have gone into a shamisen school," he says. "It was just closed off to foreigners. You just wouldn't see a gaijin going to a shamisen master and learning. I had to wait until I was an adult to go into shamisen."

Since picking up the instrument, Kmetz has become the first foreigner to win the honorary Daijo Kazuo Award in 2005, as well as finish as a runner-up in 2006 and in second place in 2007—honors that he hopes to surpass by becoming the first foreigner to win first place in a Tsugaru-shamisen tournament. Apart from the tournaments, however, Kmetz leads God of Shamisen, a conduit for the change that he sees as paramount to Tsugaru-shamisen's continuity. *Dragon String Attack*, the band's 2008 debut, deftly weaves metal, funk, ambient electronic, and even a sense of the 8-bit-music renaissance into an effluent, funny, intelligent mess of Eastern and Western influences. The album, including contributions from Trey Spruance of Secret Chiefs 3, fellow shamisen player Masahiro Nitta, and bansuri maestro Deepak Ram,

has at its center the shamisen—with a rhythmic, buzzing, and tonally striking sound that is never out of place yet always surprising in its context.

For Kmetz, the band's changes in style—from blast beats to reggae jams to Turkish folk—are a natural progression for Tsugaru-shamisen.

"I feel there's a duty to keep adding to it," Kmetz says, "because that's what it was originally about. People

drummer Lee Smith—a fellow alumnus, along with Kmetz, of genre annihilators Estradasphere—resides in Seattle, where some of the recording for *Smoke Monster Attack* was completed.

Produced by Thornton and Billy Anderson, a name very familiar to metal heads, *Smoke Monster Attack* continues to blend the shamisen's unique sound with Western music. Anderson has produced for the likes of Sleep, Secret Chiefs 3, and Mr. Bungle, and

---

## "I FEEL LIKE IF YOU'RE PISSING PEOPLE OFF, YOU'RE MAKING AN IMPACT."

---

forgot that you could add a phrase and still call it Tsugaru-shamisen. You're going to make people mad, but that's really what it's supposed to say. To me, that's the only way to keep a tradition alive." Those whom God of Shamisen are angering, surprisingly, are not the Japanese masters—a group, Kevin admits, that is not the most vocal in its true opinions. The most outspoken individuals come from the USA. "I'm thrilled to report I've actually been making a lot of fellow American shamisen players quite upset," Kmetz says. "I'm really taking huge authorities with the instrument, which is one of the major complaints I'm getting from a lot of fellow American players. They're saying, 'You can't really call yourself Tsugaru-shamisen, because you're not sticking to the language.' It's been sort of a satisfactory moment for me, because I feel like if you're pissing people off, you're making an impact. Finally, I'm considered worthy enough to get upset about."

It's been two years since the release of *Dragon String Attack*, and despite the distance between players, God of Shamisen has released a follow-up digital album titled *Smoke Monster Attack*. Kmetz, after spending most of his adult life in the States, has moved back to Japan to study under the current masters of the shamisen. Bassist/producer Mark Thornton and guitarist Karl Schnaitter reside in California, and

he brings to Kmetz's instrument a frantic immediacy that hits at every note. The rhythmic, acoustic strikes somehow fit right in with heavy riffs and video-game covers. The metal influences heard on the first album take center stage with Anderson's production, and *Smoke Monster Attack* is less likely to bound from one genre to another. The music loses none of its spontaneity or humor, and if anything, it feels like a stronger, more cohesive release than the first.

Within the time between albums, God of Shamisen has been as active as a band can be with its members spanning the globe, playing Japanese-American festivals, dive bars, and concert halls. The band plans, however, to accomplish one elusive goal: to tour Japan. "We've never done that, and that's always been weird," Kmetz says. "It's like, 'Wow, you're doing this thing that's mixing Japanese culture with American culture, and you've never gone to Japan and showed that to anyone.'"

This means that Japan has something wholly original coming, derived from the best that American and Japanese culture could birth, flitting between two worlds despite the tendency for stagnation in the name of tradition. As Kmetz so rightly says, tradition is about keeping things alive enough to change. ⓐ

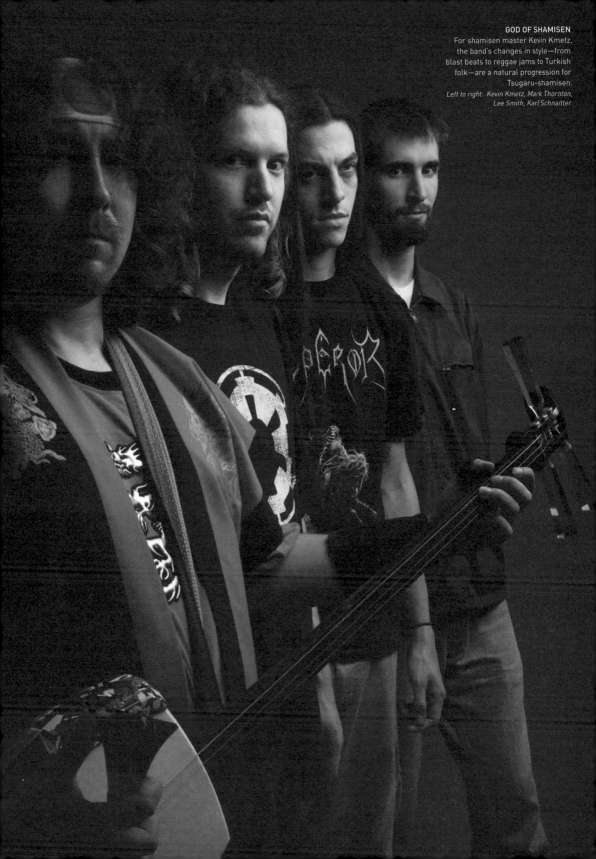

**GOD OF SHAMISEN**
For shamisen master Kevin Kmetz,
the band's changes in style—from
blast beats to reggae jams to Turkish
folk—are a natural progression for
Tsugaru-shamisen.
*Left to right:  Kevin Kmetz, Mark Thornton,
Lee Smith, Karl Schnaitter*

# KENAN BELL

JEFF TERICH / *PHOTOS BY BRYAN SHEFFIELD*

Hip hop has a long and proud academic tradition. Some of its noblest icons include Large Professor, Dr. Dre, and the Poor Righteous Teachers. East Coast outfit Main Source successfully executed *Breaking Atoms* in 1991, and countless emcees have been known to drop science. Yet few, if any, such lyricists actually built up experience instructing a grade-school classroom.

Los Angeles rapper Kenan Bell likewise has an intellectual, slightly nerdy approach to his atypical hip-hop fusion, melding high-minded lyrics with a live-band, indie-rock-leaning sound on his debut album, *Until the Future*. As one of Bell's own lyrics sums it up, "picture a bookworm carrying a ghet-toblaster." But with an atypical sound comes an atypical résumé. More than just schooled in the ways of beats and rhymes, Bell actually drafted up lesson plans in math and language arts as a Montessori schoolteacher. According to Bell, his neighbors ran a private school, where he did ROP training while tak-ing classes, which ultimately led to student teaching after college. He was offered a position as a teacher shortly thereafter, a turn of events that he describes as "almost like a divine opportunity."

In fact, teaching was something that Bell pursued long before deciding to make the leap into being a full-time performer. However, balancing the two ulti-mately would be difficult to maintain, and ultimately, he chose music.

"I just recently resigned, and it's still a fresh wound," Bell says. "It's something I loved to do and have a passion for. But there was a shift. I'd have shows at 12:30 [a.m.] and have to be in class at 8 the next morning. It was crazy stuff, just having to balance that. But it's something I always had a heart for."

Though Bell hadn't always envisioned himself as a rapper, music has long been a passion of his, having grown up listening to his brother's Arrested Develop-ment albums, vinyl that a cousin of his in New Jersey pressed, and an extensive list of rap legends. "I was into Kool Moe Dee, Kurtis Blow, Hammer, Nas, any of the cats that were doing it in the '90s...before my mom took my rap tapes away, after she found out about some of the messages in them," he says.

Even at an early age, however, Bell took to writing journal entries, which evolved into lyrics over time. Still, Bell contends that until a few years ago, it was mostly in the interest of having fun.

"Conceptually, at a very young age—about 3rd grade—I started writing," he says. "Not even from a lyrical, rap standpoint—they were just journal entries. It was more stream of consciousness. I would incorporate

**KENAN BELL**
This LA rapper takes an intellectual, slightly nerdy approach to his atypical hip-hop fusion, melding high-minded lyrics with a live-band, indie-rock-leaning sound.

some Snoop Dogg lyrics, but without some of the content that wasn't appropriate for that age. In high school, junior or senior year, I started writing raps in class, when I was supposed to be taking notes, and I'd record some stuff with my friends. We wouldn't record anything seriously—Christmas albums and things like that. It was never really a professional pursuit."

As a lyricist, Bell has a playfully verbose and witty flow, but as a writer, he's methodical and focused. Whereas some rappers are all too eager to point out their freestyle skills, Bell spends a lot of time with the music to bring out his best work, sometimes keeping a song on an endless loop before he's finished with his verses.

## "I DON'T KNOW IF [TEACHING] IS SOMETHING I'LL RETURN TO, BUT I HAVE A NEW PLATFORM, AND NEW PARAMETERS TO MY CLASSROOM."

Bell has only recently been indoctrinated in contracts, management, and other aspects of the industry's business side. But perhaps more surprising is that he hadn't even performed live until 2008. Part of his reluctance to take the stage came from shyness, but Bell also is very humble about his role as a performer, staying genuinely excited about the idea of being part of a greater whole than seeking the limelight.

"I had never really performed ever," Bell says. "Having friends in the band performing with me, and not so much having to be the sole act, did release some of the tension. It's a learning experience every step of the way. It's kind of like an adolescent going through puberty. I'm glad I got over it early on.

"I'm a reserved type, a private dude," he adds. "It was a change in lifestyle, from being in the classroom from 9 to 5 to being on tour. You just have to adjust and use that platform for what you want it to be— more like you're part of something."

"I definitely do take my time and methodically construct the rhymes," he says. "I write to a tempo. I can write in rhymes to any beat on the radio. I wrote probably eight verses to a Smiths song, 'This Night Has Opened My Eyes.' Some songs I don't, but I like to sit with the music for a while and vibe with it. I like to be...not tired or delirious, but I like the wee hours of the morning—maybe fall asleep with it. I'm always writing, conceptualizing, and memorizing. I try to place puzzle pieces in proper form and fashion."

Kenan Bell may have packed up his chalk and yardstick, but as he ponders where his career takes him, he muses that he's merely addressing a larger pool of pupils.

"I don't know if it's something I'll return to, but I have a new platform, and new parameters to my classroom," he says. "I just want my art to shed some light on my experience." Ⓐ

# TRENTEMØLLER

ARTHUR PASCALE

Among the challenges of music criticism and consumption is the genre dilemma. How do we explain how something sounds without pigeonholing? Whether we cognitively recognize it or not, every genre carries with it a set of expectations and emotions that distort the way we hear music. Of course, some tags have a stronger gravitational pull negatively or positively than others, depending on personal taste, and any given genre may have dozens of subcategories.

Electronic music has quite a few subcategories of its own: house, techno, downtempo, dubstep, grime, wonky, jungle, rave, nu-rave, minimal, glitch, IDM, drum 'n' bass, trip hop, etc. And as soon as someone picks up a drum machine, he or she is herded into one of the categories. This isn't necessarily bad; it makes it easier to group likeminded artists together and helps expose people to new music that they might enjoy simply by association. But it's not necessarily good either, because we subsequently create expectations for artists and how their art will sound.

Danish production guru Trentemøller is particularly struck by this problem. "I don't see myself as either an electronic musician or a rock musician," he says. "I'm so tired of the boxes people always want to put music into." For him, making music is not about putting a few contrasting genres head to head in a heavyweight title fight; it's about calling upon whatever elements fit any given composition at any given time.

Anders Trentemøller has been building his name in the Danish electronic scene since 2003. After remixing some high-profile artists (Röyksopp, The Knife, Robyn, and Moby to name a few), he decided to expand his production talents to a full-length album. The year 2006 saw the release of *The Last Resort*, an ambitious double-disc collection that showed off his ability to split the difference between headphone-friendly grooves and dance-floor burners. The record garnered praise from the electronically oriented online community and catapulted him to global attention. Due to the success of The Last Resort, he was able to quit his day job, and he earned a headlining spot at the 2009 Roskilde Festival as well as a chance to remix Pet Shop Boys.

His new album, *Into the Great Wide Yonder*, is a dramatic departure from his previous work. Whereas *The Last Resort* excelled in its ability to cut away the fat and muscle of dance music and show us its frail skeleton, *Into the Great Wide Yonder* proves that electronic music can be powerful and dense. The songs are more complex and heavier than his previous album, with layer upon layer of robust orchestration that includes mandolins, Theremins, vibraphones, strings, synths, and acoustic and electronic drums playing a game of king of the hill. But

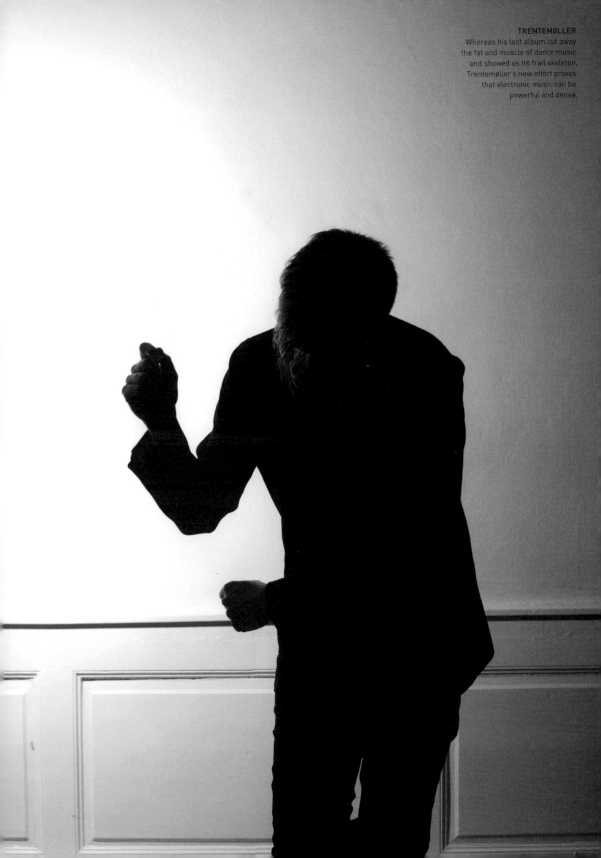

**TRENTEMØLLER**
Whereas his last album cut away
the fat and muscle of dance music
and showed us its frail skeleton,
Trentemøller's new effort proves
that electronic music can be
powerful and dense.

those instruments, most of which were performed by Trentemøller, fall to the wayside when confronted by the tremolo-swollen and overdriven guitar riffs. The guitar work, again performed by Trentemøller, sounds like surf rock during a hurricane, dark and immensely powerful, with the shudder of the whammy bar sending trembles through the music.

This stylistic change likely occurred because of Trentemøller's spontaneous writing process. "I never make a plan for my music before I start composing," he says. "I love it when the music itself takes me somewhere I'm not really in control of." For *Into the Great Wide Yonder*, he pushed his own limits

and used them more rhythmically than melodically. On "Sycamore Feeling," the new album's first single, Trentemøller lets guest vocalist Marie Fisker's smoky voice run free across his placid guitar strumming. The track marries the heartbeat of minimal techno with the meditations of an acoustic guitarist, creating a full band sound that hasn't been heard in his music before. English singer Fyfe Dangerfield (Guillemots) and Danish singers Josephine Philip (Darkness Falls) and Solveig Sandnes also add enrapturing vocals on a few other tracks, and the result is no less stunning.

"I wrote the songs with their voices in mind," Trentemøller says. "They contributed lyrics and melodies.

## "I LOVE IT WHEN THE MUSIC ITSELF TAKES ME SOMEWHERE I'M NOT REALLY IN CONTROL OF."

creatively and tried different ways of recording. He switched to a more manual style of recording, by turning his monitor off so that he couldn't "see" the music, and laid down much of the music on analog tape before using the computer as a recorder and mixer instead of an instrument. This style of aural-based composing is apparent on the album. Tracks grow and mutate in a much less sequenced manner than his previous work. You can't count 16 beats on this record and expect something to change. It creates its own rules for transformation. The best example of this would be the opening track, "The Mash and the Fury," which billows its way into existence with a minute-long ambient wash. Soft blips accent the tonal floodplain created by Trentemøller's synths in a manner not constrained by tight rhythms or measures. Over the course of the song, new elements are added until the whole piece slides into a rhythmic order, but not with the icy perfection that characterized his last effort. It is a song that represents the dynamics of the album as a whole. Songs mutate and grow with a subtlety akin to Brian Eno's landmark *Ambient 1: Music for Airports*.

Additionally, *Into the Great Wide Yonder* is much more vocal-centric than *The Last Resort*, which featured a few distorted and chopped vocal tracks

It's inspiring to have another artist to work with. The singer's input gives the whole album a special vibe that I could not come up with alone."

No matter how much a song meanders in the beginning, it always finds a home in a groove, the musical reference point that gently guides a track to a crescendo and subsequent resolution. The album gives structure to ambience and life to electronics, two things that make it extremely difficult to push Trentemøller into any genre. It challenges what we expect to hear when we listen to an electronic record, and it forces us to wonder where a producer becomes a musician. Trentemøller plans to tour on this album across America and Europe, and it seems impossible for him to play these songs alone. This could be the start of a shift in Trentemøller's identity, from solitary composer to lauded bandleader.

We will never grow out of our need to categorize what we hear. There is simply so much music that it's impossible to sift through it without some sort of organizational system. But artists like Trentemøller will always be looking to expand our idea of what an electronic album—or any album, for that matter—can be. ◉

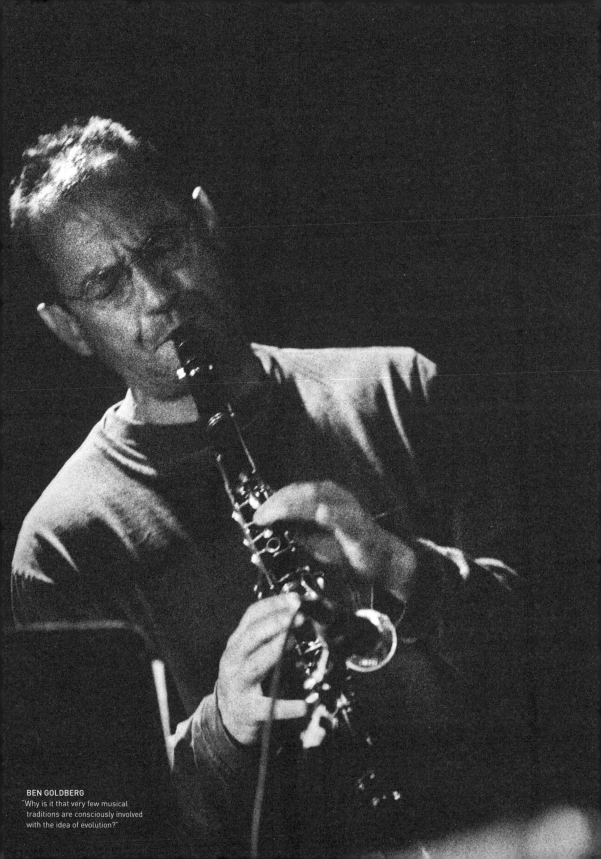

**BEN GOLDBERG**
"Why is it that very few musical
traditions are consciously involved
with the idea of evolution?"

# BEN GOLDBERG

SABY REYES-KULKARNI

The first time that Ben Goldberg heard a clarinet being played, he was struck by an unfathomable quality that he still hears to this day, even after spending decades playing the instrument.

"I don't know if other people hear it this way," he says, "but to me, a clarinet has no end. It's like it just disappears into..." Goldberg trails off as he attempts to find words to describe the sensation that the sound of a clarinet gives him.

"It's very deep," he continues. "It has no bottom to it. And it always strikes me this way, no matter who's playing it: that there's something down in there that you just can't *reach*. When you find something like that, you just start wandering towards it."

One of the principal forerunners of a musical movement that John Zorn dubbed "radical Jewish culture," Goldberg blazed a new trail in the late '80s by blending traditional Jewish folk music with avant-garde jazz, and he also has found new shades of expression for the clarinet in a jazz and experimental context. When he founded the New Klezmer Trio in Berkeley, California in 1987, Goldberg experienced what he refers to as the "musical big bang" of his career. At that time, Goldberg had already studied klezmer music for years in college and was heavily steeped in its tradition thanks to a rigorous itinerary of bar mitzvahs, weddings, and various social events.

"I honed my style," he laughs, "playing a thousand bar mitzvahs."

Those types of gigs, Goldberg soon discovered, came with a hefty reward of instant social approval. "My choice to study it definitely had something to do with identity," he explains. "Plus, you get a lot of praise. If you're Jewish and you start playing klezmer at weddings, it's like you're an automatically esteemed member of the Jewish cognoscenti or something! They really treat you that way, like, 'You're doing such a good thing for the Jewish people.' And that pleased me."

But, despite the cultural affinity, Goldberg started to feel an acute sense of disconnection—a kind of generation gap, if you will—between klezmer's old-world underpinnings and his own life experience.

"Sounding authentic was beginning to feel pretty inauthentic to me," he writes in his essay *New Klezmer Trio and the Origins of "Radical Jewish Culture."*

A lifelong jazz afficionado, Goldberg wondered why klezmer hadn't evolved and branched out into a variety of modern permutations along the same lines as jazz had—and he wondered how it still could. Simultaneously, Goldberg wanted to use the clarinet as a vehicle for jazz. (If it's a mystery as to why klezmer, itself a vibrant polyglot fusion of music from several

different parts of the world, hadn't continued to develop once it was transplanted into an American setting, it is perhaps an even more compelling mystery that the clarinet still hasn't achieved the same visibility in jazz as, say, the saxophone or trumpet.) So, after reaching a high degree of fluency brought on by year after year of intensive practice and analysis, he set about looking for ways to reinterpret Jewish folk music so that it might sound truer to himself and speak to contemporary sensibilities. One of his solutions was to apply the improvisation of jazz to klezmer's heavily codified rules and parameters. Another was to, in a sense, crack the music open by attempting to dig deeper into the rich bedrock of Eastern European rhythms and uncover an essence that could be used as a *living* musical style.

Revisiting how he felt back then, Goldberg wonders aloud: "Why is it that very few musical traditions are consciously involved with the idea of evolution?"

It's a rhetorical question, but Goldberg is less concerned with finding the answer these days, and he no longer feels as pressed to invent new languages as he once did. In a poetic twist to a career that spans work with individualist visionaries like John Zorn, Nels Cline, Bill Frisell, and Trevor Dunn as well as several of his own groups, Goldberg became a full-fledged member of Tin Hat in 2005. The brainchild of violinist Carla Kihlstedt (Sleepytime Gorilla Museum, 2 Foot Yard) and guitarist Mark Orton, Tin Hat (originally named Tin Hat Trio before the group reconfigured with the inclusion of Goldberg) weaves together chamber music, jazz, Gypsy folk, experimentalism, and pop into a sound that gives Goldberg

room to feel at ease, at least in terms of the ethical considerations of his creative decisions. In a sense, Tin Hat, which released its live album *Foreign Legion* this spring on Goldberg's own label BAG Production, represents the fruit of all the time that Goldberg spent questioning the integrity of his innovations.

"In some ways," Goldberg muses, "Tin Hat fits like an old glove. But when I first started playing with them as a guest in 1997, there's something that really impressed me about them and, at first, even confused me a little bit: they didn't have an axe to grind. I'm a little bit older than those guys, and when I first started playing with them, they really showed me something. I realized that I had come up in a world where there *was* an axe to grind. That was an essential part of New Klezmer Trio: 'God damn it, we can do this in an avant-garde way; watch this!' There was a sense of 'look out, everybody, we're really going to fuck with this song.' Mark and Carla were another generation. They just found the beauty in all this different music—whether it was avant garde, traditional, this style or that style. If you listen to 'Waltz of the Skyscraper' on the live record, it starts off as a waltz. And then all kinds of strange things start happening and it turns into—I don't know what you'd describe it as—new music or free improvisation or a free-for-all, but it sounds like all those things are what belong there. It doesn't at all sound polemical. In a way, it's taking the next step. It's saying, 'Look, these musical ingredients that seemed antithetical to each other can live together happily!' But it's no less a concerted and well-considered and brave musical statement to make *that* step. Different generations have to take different steps."

Goldberg stresses, however, that Tin Hat's uncanny ability to craft accessible music out of what are often presented as highbrow forms belies the group's musical sophistication and depth.

"It totally kicked my ass joining that band," he says. "They have a *very* high standard of composition. In

cases Goldberg in a decidedly more groove-oriented setting. Despite the fact that it has the word "home" in the title, the album represents anything but a final destination or resting place for Goldberg's art. *Go Home* follows 2009 release *Speech Communication*, a new album on Zorn's Tzadik label from a reactivated New Klezmer Trio. Yet having let go of the

## "I REALIZED THAT I HAD COME UP IN A WORLD WHERE THERE WAS AN AXE TO GRIND. THAT WAS AN ESSENTIAL PART OF NEW KLEZMER TRIO: 'GOD DAMN IT, WE CAN DO THIS IN AN AVANT-GARDE WAY; WATCH THIS!'"

their world, it's not just the idea of writing a tune. Partly because of the instrumentation—there's no drummer or bass player—the emphasis is on compositional thoroughness. And I feel like my own ability to write had to be stepped up a notch or two. That had a huge effect on me—the way that I think about what a song is, and also orchestration, form, what's required, and what a piece of music can be."

In addition to the new Tin Hat live album (which consists of performances from 2005 and 2008), Goldberg also recently released an album as a leader, *Go Home*, again on his BAG Production imprint. *Go Home* features guitarist Charlie Hunter and show-

"mission" that New Klezmer Trio once represented for him, Goldberg feels free to venture well outside the very paradigm that he helped create. And as he continues to cover more disparate territory, Goldberg is proving himself to be a rare musician—one who hits a comfort zone while simultaneously stoking his inspiration. Ⓐ

# BEHIND THE MASK

# BEHIND THE MASK

JAMIE LUDWIG

**WHETHER A MASK IS USED TO EMPHASIZE A POINT OF VIEW, TO ENHANCE THE SPECTACLE OF THE STAGE SHOW, OR PURELY FOR THE SAKE OF FUN, IT'S CLEAR THAT IN TODAY'S CONTEMPORARY MUSIC SCENE, THE REASONS BEHIND USING MASKS AND COSTUMES ARE AS VARIED AS THE ARTISTS THAT WEAR THEM.**

"It adds an element," says Justin Pearson, bassist /vocalist for San Diego sci-fi grind-punk four-piece The Locust, a band that dons hooded, skintight, full-body uniforms. "It's hard to say how you feel when you do it; you're walking on stage with three other people with absurd outfits. We're part of the show, and part of the live performance is the energy, negative or positive. It adds a level of intensity."

"It's all about using your imagination," says Tom Fec, who performs under the name Tobacco as a solo artist and as a member of dreamy psych-hop outfit Black Moth Super Rainbow. He employs masks as tools to obscure his persona, rather than The Locust's edgy, over-the-top approach. "I think that's a really important piece to making an impact," he says. "When you know everything about a person, then it's like watching someone you know up there, and it becomes something else completely. The more you know, the less you care about knowing."

RJ Krohn, better known as soulful hip-hop artist RJD2, is a performer who has experimented with masks and costumes on stage as much for his own amusement as for the audiences at his concert. "I have always felt that theatrics," he says, "or at least dressing up, was an obvious way to say, 'At least I'm trying here, folks,' to a crowd. Just walking on stage in a T-shirt and jeans is cool if you are a genius. I, however, have questionable talent, which needs to be deep fried, slathered in a tasty barbecue sauce, and dressed up like *real* talent."

Krohn's first experiment with costumes was as an alter ego that he named "Mo' Buttons," in a costume decked out with tons of buttons with a sampler strapped to his chest, in order to highlight that on stage, he plays the device like a keyboard or drum machine rather than simply pressing "play." The sampler proved to be too heavy to wear comfortably every night, but when Krohn discovered that he could incorporate a MIDI controller to run the equipment rather than the entire unit, he took the premise and his sense of comedy to the next level, introducing crowds to his latest persona. "When I had [the equipment techniques] down, I realized that it needed a way to differentiate itself from the rest of the show," he says. "A guy just putting on and taking off a wireless spinning MIDI controller is just dumb. So the alter ego became 'Commissioner Crotchbuttons,'

# "WE LOOK RIDICULOUS, BUT WE'RE TOTALLY SERIOUS. MAYBE IT'S HARD FOR A BAND TO ACHIEVE THAT?"

**JUSTIN PEARSON, THE LOCUST**

because I had built the thing into a belt that spins (à la ZZ Top), and when you have a musical instrument planted on your crotch, the jokes just write themselves."

Like Krohn, The Locust's uniforms are rooted in a sense of humor but also an equally strong sense of rebellion. Formed in 1994, The Locust began wearing costumes by the late '90s as a reaction to what it felt was unusual backlash from the underground press, which focused more on the band's clothes than its music. "We were just wearing our street clothes," Pearson says. "We were poor punk kids. Somehow that became the topic of the conversation instead of our music. It was sort of a pointless round-table discussion, and people seemed really agitated with us. We weren't a racist band. We weren't fighting people. We were playing music, and for whatever reason, they criticized us beyond the music."

Its first costumes, fuzzy vests and goggles, were created to be tongue in cheek. Surprisingly, as The Locust developed as a band, the costume concept stuck. "We never really thought about it," Pearson says. "We wrote music and we played music—jagged, funny, quirky parts. We started figuring out things to do musically that coincided with us doing a visual element. It happened by chance, and then it evolved. We look ridiculous, but we're totally serious. Maybe it's hard for a band to achieve that? It became very honest. We're not fucking around or being influenced by this other thing. It wasn't self-conscious."

In turn, the uniform concept has affected The Locust's performance style, which Pearson says also plays off the rambunctious stage antics and overt masculinity of many of its peers in the hardcore scene. "We found ourselves with this borderline homoerotic, nerdy, sci-fi thing," he says. "We look like robots; we move jaggedly. We don't have breakdown parts. We're stationary, and you can't run or jump. It was very technical and confined to a spot. We decided, 'Let's do the complete opposite [of many tour mates] and stand there and not move. And we'll stop and be completely still.' There is a physical edginess to it beyond the fact that we looked like these science-fiction creatures."

Though The Locust has grown an overall aesthetic from both its musical and visual components, and Krohn is happy to poke fun at himself for the sake of the show, the reality for many musicians is that a costume or mask is a form of armor, granting them space from the watchful eye of the crowd. Take San Antonio DJ Ernest Gonzales. Under his own name, Gonzales creates music that is chilled and collected, often combining elements of indie rock, pop, and hip hop. When he began toying with a more bass-heavy dance sound, he opted to present it under a different name. He created an alter ego that he called Mexicans with Guns, topping off

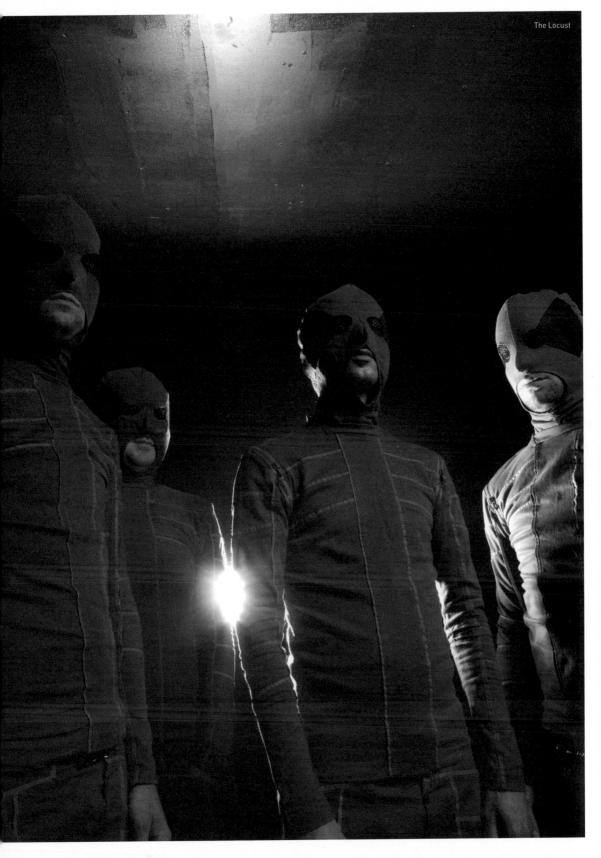

## "A MASK ENABLES YOU TO BE WHATEVER YOU WANT TO BE ON STAGE...LIKE GETTING DRUNK WITHOUT HAVING TO DRINK."

**ERNEST GONZALES, A.K.A. MEXICANS WITH GUNS**

the character with a Mexican wrestling mask. "It's branding, in a sense," Gonzales says. "If I've been doing a different sound, then coming out of left field with a different sound could be positive, or it could be negative. For me, it felt like two separate projects and sounds. The sounds are so different; I realized [that] I'd be playing to different venues and crowds."

Having an alter ego enabled Gonzales to overcome his apprehensions about testing new musical waters, and specifically, wearing a mask allowed the introverted Gonzales to bring out a different side of his personality. "When I'm on stage and I have the mask, I'm able to be more loose," he says. "I'm an introverted kind of person. A mask enables you to be whatever you want to be on stage...like getting drunk without having to drink.

"With the mask, it could be anybody up there," he adds. "Also, the idea of the mask is very important to Mexican culture. El Santo (Mexican wrestler Rodolfo Guzmán Huerta) has been in 80-plus films. The wrestlers come out and they never reveal their face. It's very political too; I wanted to bring out the mask and build up [the character] as a hero."

Like Gonzales, others create cultural discourse by tying themselves to an era. For LA DJ Alfred Darlington, who plays under the name Daedelus and dons full Victorian suits on stage, the decision to perform in costume had its origins in the philosophy of his music. "I have a big interest in invention," he says. "I felt that the Victorian period was a period of great invention. Now I'm pretty committed to it, and it feels more appropriate to me than wearing my street clothes."

In Darlington's meticulously constructed electronic music, every sound is deliberate; there are no improvisations and no room for extraneous noise. Sonically, it could be seen as an answer to Dandyism, a philosophy that Darlington finds particularly inspiring. "Beau Brummell was the prototypical dandy," he says. "He was the first person to adopt attire as a full-time religion. Performance art didn't exist at the time, so this was revolutionary. I liked the idea that that everything he did was deliberate. It took him four hours a day to get ready because every gesture he made was artistic. Philosophically, I related in the sense that in my music, every sound is planned. Dressing up like that helps me get into the mindset."

Darlington describes the dedication to his costumes as "masochistic" in some ways. "I'm committed to my music and my art, and it does feel like I've taken on the burdens of the role," he says. "I sweat through my clothes, but the idea of stripping it down seems ludicrous." The Locust's Pearson echoes his thoughts, saying,

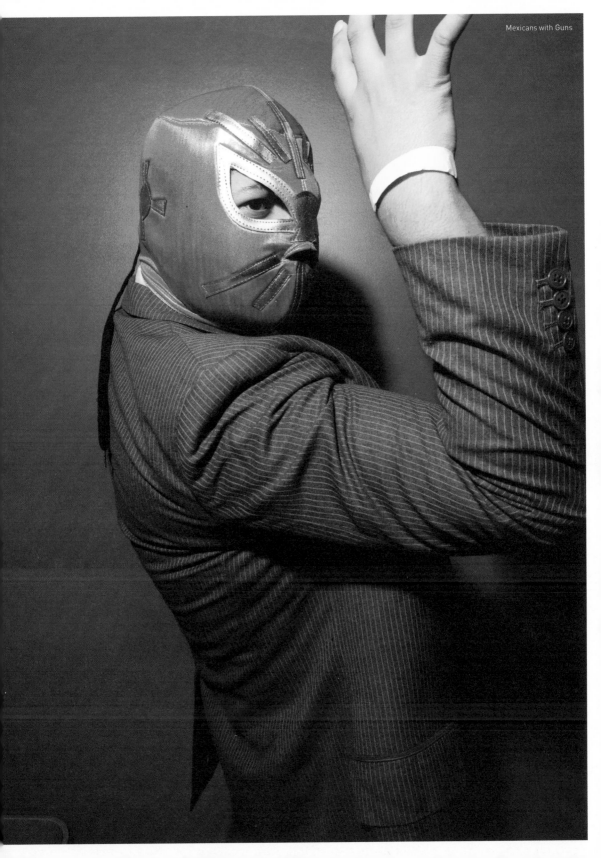

# "IT'S ALL ABOUT USING YOUR IMAGINATION. THE MORE YOU KNOW, THE LESS YOU CARE ABOUT KNOWING."

**TOM FEC, TOBACCO**

"There have been times when you're like, 'This is so stupid.' Sometimes it's been pretty brutal—mainly your face, because some of the masks haven't had a mouth opening and were attached to our shirts. You could drink through it, but you couldn't spit. One time I was sick on tour and threw up in the mask and had to swallow it. [Our drummer] Gabe [Serbian] has flipped his mask up, and he'd throw up if he'd overexerted himself. Sometimes with singing, I'll get vertigo or tunnel vision if I hold the note until the end of the measure."

Darlington doesn't wear an actual mask, but wearing the 19th Century attire accomplishes the same goal for him. The same can be said for hip-hop artist Javocca Davis, a.k.a. Vockah Redu, a prominent figure in New Orleans' bounce community. Davis incorporates face paint, theatrical costumes, and lavish sets into a subgenre of hip hop that is notorious for its energy, overtly sexual dancers, "triggerman" beats, and party-like atmosphere.

"I have a big imagination, and I bring that to the stage," he says. "I don't just want to be a rapper on stage with a chain. This is the theater part of me. I love to paint my face; it goes with my music. Why wear a T-shirt when I can demand the stage?"

Davis studied theater and performance arts at the New Orleans Center for Creative Arts, but until the past year or so, he kept his two passions separate. "I wasn't being open minded," he says. "I thought a rapper was supposed to look this way or that way. It was limiting. Now I'm more mature. I'm representing me as a person."

As Vockah Redu, Davis follows a tradition of artists such as Michael Jackson, Prince, and Madonna—as well as contemporaries like Saul Williams—who have toyed with sexuality and larger-than-life stage personas. Others like Tom Fec, however, are content to let their legends grow from speculation. This includes atmospheric electro-pop trio Castratii, an Australian act that only performs in a mask of complete darkness to become anonymous or even invisible. Convention often dictates that having the right look to accompany one's music is a key factor in launching a successful career in the entertainment business. Ironically for Fec and Castratii, *not* having an image has resulted in more attention from the press and music lovers. "People are definitely more interested in not knowing right now, in particular as everything is so easily found online," Castratii's Jonathan Wilson says. "We like to make our own judgment on artists or musicians. We don't need them to be real. We prefer the myth of the artist."

"The usual stuff that comes along with being in music seems irrelevant to me," says Fec, who gives few interviews and fewer (and often obscured) photo shoots, and who uses effects on his vocal recordings. "If I

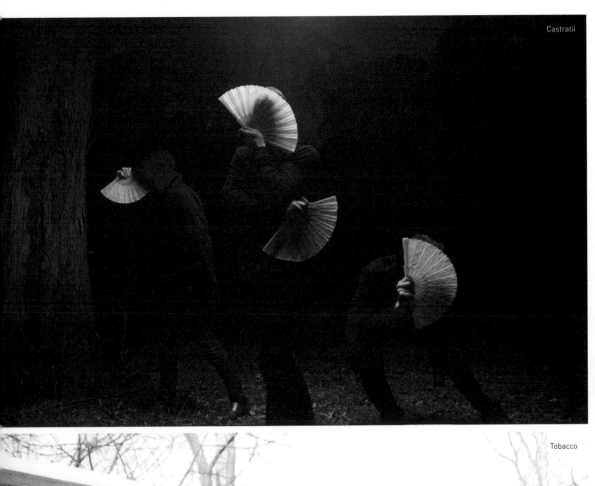

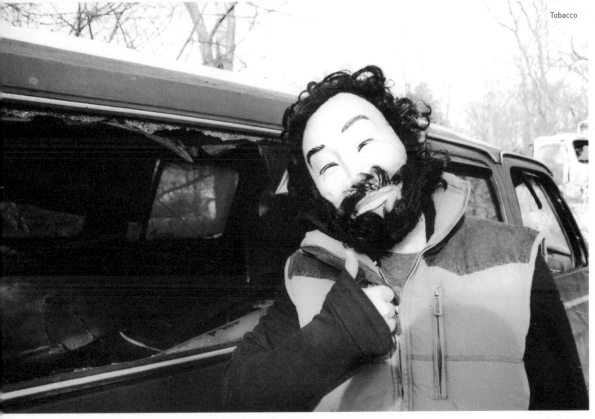

# "JUST WALKING ON STAGE IN A T-SHIRT AND JEANS IS COOL IF YOU'RE A GENIUS. [MY TALENT] NEEDS TO BE DEEP FRIED, SLATHERED IN TASTY BARBECUE SAUCE, AND DRESSED UP LIKE *REAL* TALENT."

**RJ KROHN, RJD2**

was a guy with a guitar singing about my life, it might make sense, but I have this fucked-up world that I want people to interpret for themselves. It really shouldn't be about me."

Recently, Fec has invited a mask-wearing friend to join him on stage, and due to this lack of a visual public persona, audience members often walk away thinking that the masked figure is Fec. "I've always liked confusing people," Fec says. "It makes everything more fun when you're not sure what's going on. If they mistake him for me, then I've done my job." At first glance, Fec's approach may appear as if he is having fun at the expense of his audience, but he maintains that his anonymity has given his listeners more room to interpret the music.

The members of Castratii, meanwhile, have found creative satisfaction in complete darkness—despite their visual-arts backgrounds in sculpture and installation. "Darkness is so much better for many things," Wilson says. "It can be creepy and frightening or soft and sensual. It encompasses so many different good and evil connotations. We also like the idea that we can barely see each other while we play. Our only link is the music."

Without the ability to actually "watch" the band, Castratii's audience leaves its shows with a unique experience. "We find that the sound can consume a person in a completely new way if the performer is left in the dark," Wilson says. "It becomes about the sonic and not how it is made. When seeing a rock show or even a classical performance, most people walk away with an idea [that] they were closer to that performer as a person. They may also have an insight as to how those particular sounds are made. This is something we want to keep to ourselves—our sounds and our persons. This way it can retain a little mystery."

Darlington, who believes that costumes and masks also can be protective forces, adds, "We live in an era where people regurgitate media. You are under this possible gaze, and it goes up on Flickr; it goes up on YouTube. Everybody has a part and takes a role in forming your media presence. You always have to be prepared to be scrutinized."

Although music as an art form is first and foremost for the ears, the fact that so many artists take on the additional task of elaborate visual schemes, whether masked, costumed, or otherwise disguised, is telling of its multi-sensory qualities. Perhaps thinking of music and art as separate forms is erroneous. "It tells a story," Davis says. "Every show tells a story." Ⓐ

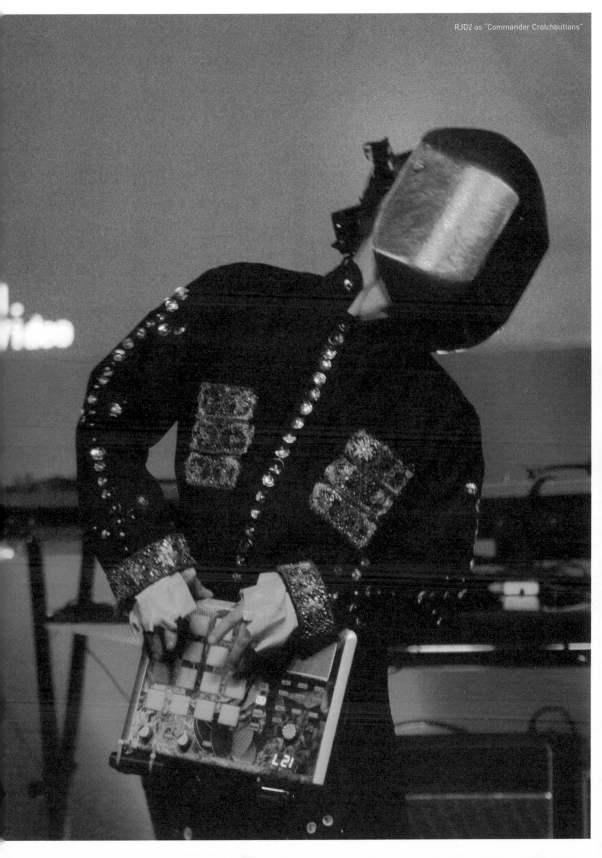

# UNTOLD STORIES

TRANS AM

HELEN MONEY

SCOUT NIBLETT

KAP BAMBINO

RITA J.

MAMMOTH GRINDER

PIERCED ARROWS

PHANTOGRAM

KRALLICE

LIARS

JESSE MORRIS

CORY ALLEN

RICHARD COLMAN

# TRANS AM

OAKLAND L. CHILDERS / *PHOTOS BY STEVE GONG*

Sebastian Thomson is a man without a country or, depending on how you look at it, a man with two homes. Either way, Thomson has worn out his welcome in London, England, where he has lived for the past four years. Despite a lucrative career jetting between Europe's party places as a one-man electro-funk concoction called Publicist, Thomson can't escape his roots. He's an American, despite his British address, and has to return to the United States in order to keep his green card.

"It is a bummer," Thomson says, not sounding terribly put off by the situation. "Publicist is pretty popular, and now I have to move back to the US. I'll still be able to play in Europe, just not as much. It's been a bizarre life, and it's only going to get weirder."

There is also the small matter of his other band, Trans Am, for which he has played drums and a myriad of electronic gadgetry for the past 20 or so years. Trans Am, a hard-to-pigeonhole outfit that wraps the past, present, and future of rock, funk, and dance music into a surprisingly cohesive, synth-fueled fun fest, got its start in Washington, DC in the early '90s. Despite popularity and success in the underground

music scene, Trans Am's members (Thomson, bassist Nathan Means, and guitarist Philip Manley) became restless. Despite having lived in the same town for most of their adult lives, often together under the same roof, even the prospect of making wonderful, fulfilling music couldn't keep them in the same place.

Still, malaise couldn't destroy the band either, and Trans Am has managed to thrive under geographic pressures that could destroy even the strongest relationships. It's the kind of odd but increasingly necessary modern situation that many bands find themselves in. The world is getting smaller, and musicians have adapted.

"When I left America, Nate was in New Zealand and Phil was in San Francisco," Thomson says. "We had started playing together when we were 16 or 17 and started playing as Trans Am when we were 23, so we've been doing this a long time. I think it got to be a bit much."

Living entire oceans apart has its drawback to be sure. Manley says that the move, while necessary for Trans Am's collective sanity, fundamentally changed

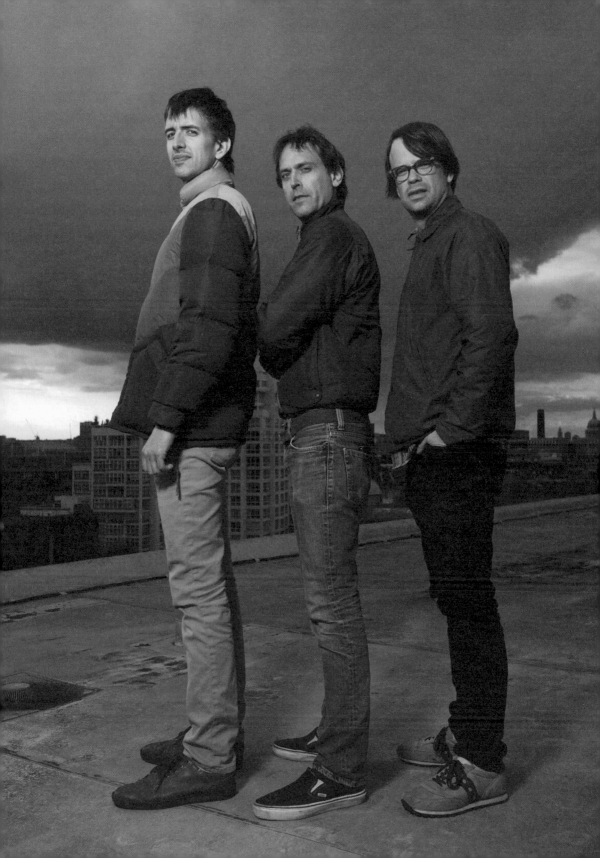

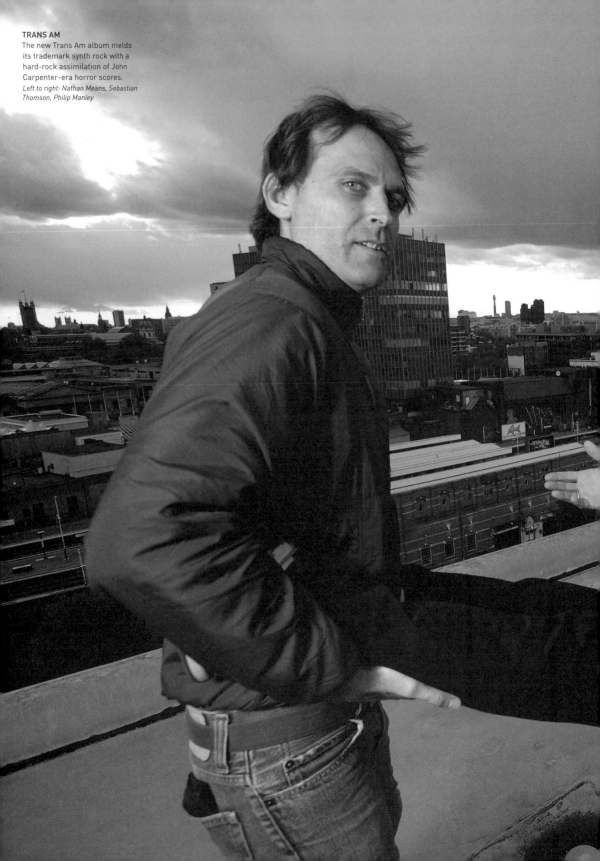

**TRANS AM**
The new Trans Am album melds
its trademark synth rock with a
hard-rock assimilation of John
Carpenter-era horror scores.
*Left to right: Nathan Means, Sebastian
Thomson, Philip Manley*

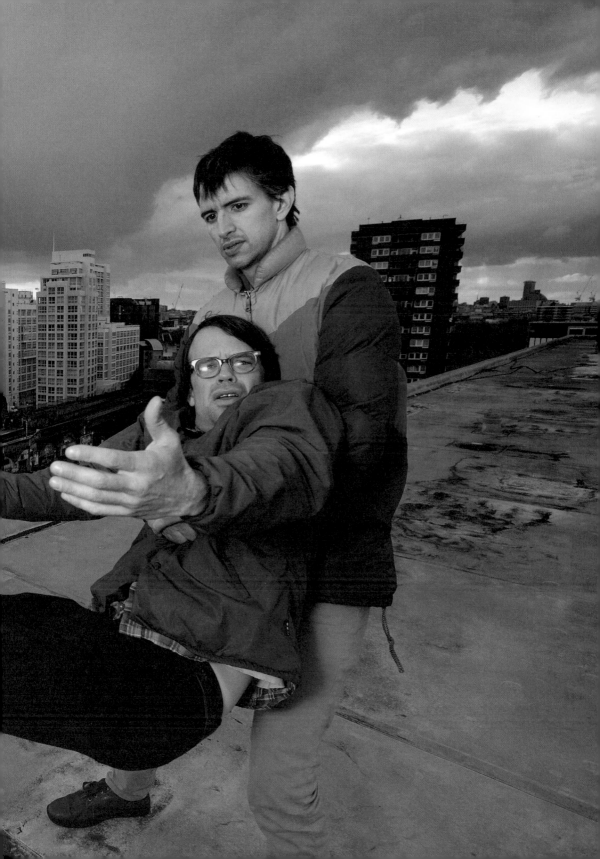

the dynamics of the band. "Because of the physical distance between us, we don't play as often as we used to," he says. "There's too much about being in a band, at least for us, that is three people in a room creating something together. Not even the Internet can change that. There are subtle nuances of how people work and play music together that are lost when you're not standing next to someone."

Difficult or not, living apart was better than the other option. "We had started to move apart," Means says. "I think we eventually would have gotten completely sick of it and stopped playing together."

"Living in different cities helped us continue playing together as a band," Manley says. "We needed the physical space to lead our own lives. Trans Am was a full-time thing for many years. It consumed all of us. Now we have lives outside the band, which is a much healthier way to be. We just get together a few times a year to record and play some shows. It's fun!"

Bringing fun back into the equation seems to have been just the spark that Trans Am needed. Despite splintering in 2003, the band has since produced a number of records, some of the best material in its career: *Liberation* (2004), *Sex Change* (2007), a live album titled *What Day is it Tonight?* (2009), and now a concept album titled *Thing*.

"For better or worse, it has sharpened us," says Means, who has returned to the United States, taking up residence in Portland, Oregon. "With *Sex Change*, we recorded half of that album in a week, took a week off, then had another week of recording."

Thomson agrees. Living apart, he says, makes the band's time together productive and something that they take more seriously. "It's more exciting when we see each other," Thomson says. "It forces some of us to bring more written material. We're forced to be a little more prepared."

Though the band may walk into the studio bubbling

with ideas that were concocted in its members' very separate lives, it's still what happens when everyone is together in one room that makes Trans Am the band that it is. "We get into our own band biosphere," Means says. "Certain things are going to grow in there, and certain things aren't. I can't say being apart has made a huge amount of difference in that sense."

Monotony may have driven the members of Trans Am to separate continents, but it has also played a key role in its development as a band.

"A big part of everything we do comes from getting bored easily," Means says. "When we first started playing, we had drums, guitars, and bass. Those are still the instruments we're best at, but we've accumulated synths and stuff over the years."

Much of the forward movement in Trans Am's sound can be attributed to Thomson's curiosity for new sounds. He scours the Internet, seeking out old and peculiar analog synthesizers, and spends his off hours trying to make them work with computers.

"It's a pretty democratic band," Means says. "There's not a dominant presence, but Seb is the most technically gifted musician out of any of us, so he definitely has a larger role than most drummers do. If you watch our band and watch other bands, it's a lot more likely that what you'll see him doing, it's three people doing it in another band."

"We had always thought," Thomson explains, "that Trans Am on stage and Trans Am in the studio are nothing alike. The way I play drums in the studio, for example, is way different than how I play on stage. I'm much more measured when we are recording."

And it's not just the band that feels that way. "A lot of our friends think we're better live," Means says. "And when we toured with Tool, we talked to a lot of Tool fans that had bought our albums and didn't like them but loved us live."

Embracing that difference, Trans Am decided to release the aforementioned live album, which was culled from years of soundboard tapes, home recordings of practices, and even video footage. Unlike a lot of live records that are simply pushed out by bands trying to fulfill a contractual obligation to their labels, *What Day Is It Tonight?* sounds like a band trying to build a road between its live show and its recorded material. "The tape was running for a lot of stuff, starting from the very beginning," Means says. "We had a mountain of tapes of live shows sitting around that we knew we'd do nothing with unless we had a deadline."

music for the project anyhow. "It's dark and heavy and has a somewhat cinematic quality to it, hopefully," Manley says. "Instrumental music lends itself well to motion pictures because it's pretty ambiguous—totally nondescript and inaccessible."

And though the album's intended counterpart never came to fruition, *Thing* stands alone as an exemplary effort—possibly the band's best to date. The trio's spacey synth rock is at its most dynamic and dramatic, but it never loses its head-banging MO or dance potential. Throughout *Thing*, Thomson acts as a no-nonsense beat machine that drives squiggly and

## "THERE ARE SUBTLE NUANCES OF HOW PEOPLE WORK AND PLAY MUSIC TOGETHER THAT ARE LOST WHEN YOU'RE NOT STANDING NEXT TO SOMEONE."

Thomson says that a live album may have been inevitable simply because of Trans Am's musical upbringing. Growing up as they did in the 1970s and '80s, the music of that time played a huge role in the band members' musical growth. "The concept of a live album, it's kind of antiquated," Thomson says. "It's very '70s. We might be inspired by Kraftwerk or DC hardcore, but we grew up listening to classic rock. You can be into all sorts of new and interesting music, but you can't erase your youth."

*Thing*, the band's new album released this April, melds these influences while presenting a hard-rock assimilation of John Carpenter-era horror scores. The project was, in fact, begun when Trans Am was commissioned to write the soundtrack for a science-fiction/horror/thriller film. The film lost its financial backing and was scrapped only a few months into writing and recording, but the band carried on writing

sinister sounds, while Manley and Means use their assorted gear to serve as conduits to otherworldly vibes. It's an exciting and new representation of Trans Am's sound, a milestone that hopefully portents sounds to come.

But no matter whether the three are improvising ten-minute solos on stage or spending hours in the studio adding layer after layer, Means says that it's all Trans Am—regardless of how little one version may sound like another. "It's hard for us to get outside of what Trans Am does for us," he says. "I'm not worried about playing anything really sloppy. You have to be willing to be cheesy, atonal, and just bad before you can get anywhere interesting. It ends up sounding like Trans Am most of the time." Ⓐ

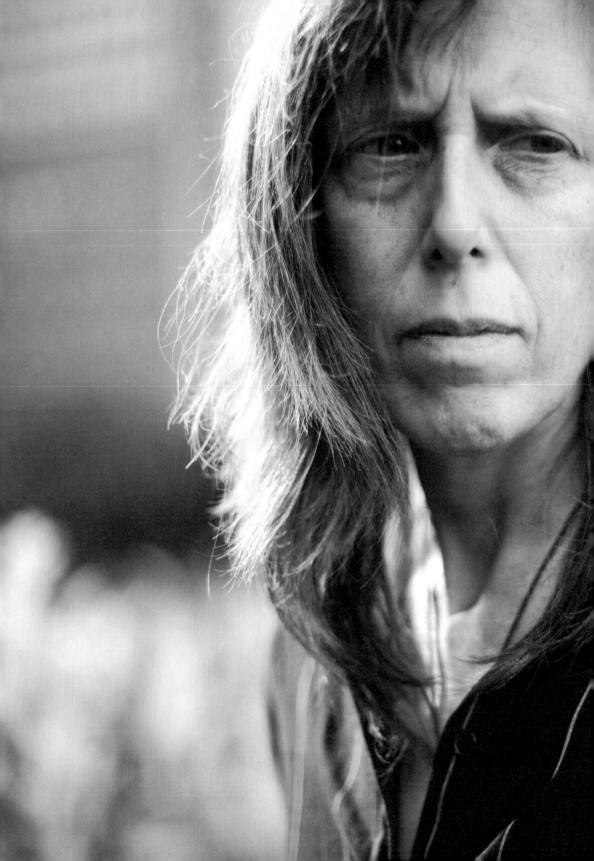

# HELEN MONEY

CHRIS CATANIA /
PHOTOS BY ELIZABETH WEINBERG

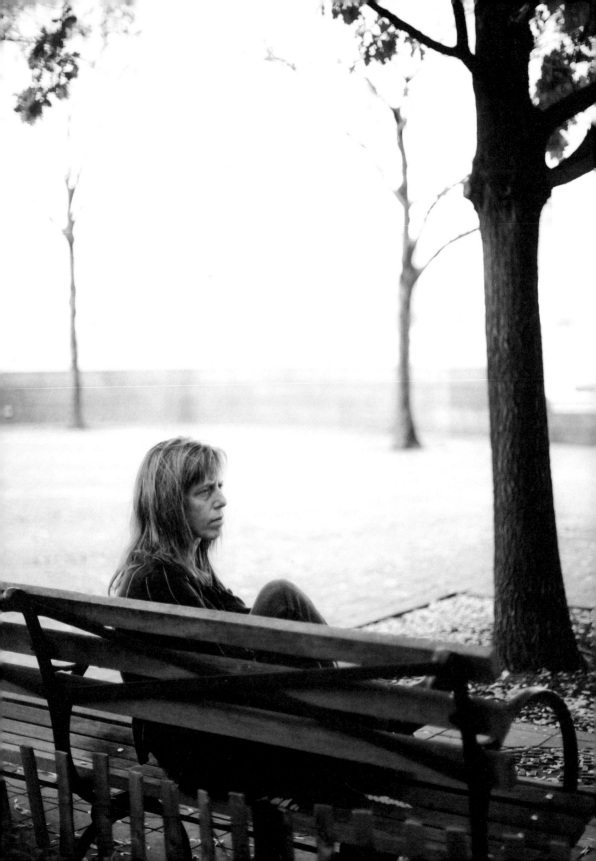

**A**S HELEN MONEY, CHICAGO-BASED CELLIST ALLISON CHESLEY TRANS-FORMS A COMMONLY KNOWN CLASSICAL INSTRUMENT INTO A MIGHTY WEAPON FOR COMPOSING AND ARRANGING FURIOUS ONE-WOMAN ROCK CONCERTOS.

But unlike the explosive and menacing songs on her second album, *In Tune*, Chesley is unassuming in person, speaking softly in the basement chill-out room at the Empty Bottle in Chicago before performing later that evening. The subterranean location seems fitting, considering Chesley's ability to push the sonic boundaries of the cello and journey to the depths of the heart and mind. "I want to make the cello sound like anything but a cello," she says. "I'm looking for that one feeling, and then I dig in and see what I can discover. I love that dark sound and going to a serious place where I can work with darker emotions. I have to feel what I'm playing."

Born and raised in Los Angeles, Chesley became a cellist serendipitously. "In grade school, I had to pick an instrument for a part of a public-school music program," she says. "I can't remember exactly why, but I ended up picking the cello. Then I remember my dad buying me Antonin Dvorak's *Cello Concerto in B Minor*. That's probably one of the best cello pieces ever written, and I still don't know how he knew to pick that out. I listened to that Dvorak recording over and over. Eventually, I came to love the midrange sound of the cello, and it's unique from all instruments because it's most similar to human voice. It hits you right in the chest."

As she grew up, Chesley continued to mix in varied musical influences like the music of pop star Shaun Cassidy. But it was the epic rock of The Who and SST punk bands such as The Minutemen (which she covers on *In Tune* with "A Political Song for Michael Jackson to Sing") that formed the nucleus for the

style of aggressive rock-based and minimalist cello that she wanted to play.

In 1994, Chesley came to Chicago to study for her master's in cello performance at Northwestern University. She met fellow musician Jason Narducy, with whom she eventually formed alternative-rock band Verbow. After recording two albums with Verbow, Chesley left the band in 2001 to embark on a solo career. In addition to Helen Money, Chesley works as a composer, arranger, and instructor for Chicago's Old Town School of Folk Music. "I love teaching at the Old Town School of Folk Music," she says. "I had a student with multiple sclerosis who wanted to learn to play cello, and it was inspiring to see that type of determination from a student, because it makes me appreciate my gift and think back to when I was a kid and I used to hide in the backyard when I didn't want to practice my cello."

Chesley also composes for theater and film productions and has leant her talents to bands including Disturbed, Anthrax, Mono, and Russian Circles. Chesley says that creating music for other projects is "more about the dance," where she focuses on complementing, enhancing, or responding to visual elements like actors or sets in theater or film.

The challenges change when it comes to her own music, where it's up to her to decide where she takes the mood of a piece. "As Helen Money, I try to present an idea, tell a complete story, and have structure," she says. "When I left Verbow, I wasn't really interested in playing pretty cello. I didn't want to be just a string player in a band. I had gotten to the point where I didn't want to play with anyone because I was really curious to see if I could write and perform on my own. I also wanted to challenge myself to see if I could create a whole cohesive piece."

The first Helen Money record, a self-titled album that she released in 2007, was about discovery. "I was thinking more along the lines of Bob Mould's *Workbook*," Chesley says. "So over time I added effects pedals and took the aggressive cello I was playing with Verbow to a different level."

As for her sophomore album, Chesley says that she pushed herself to develop an idea. "I recorded my first album live, but when I started recording *In Tune*,

I had just started working with Pro Tools," she says. "I wanted to see if I could get away from relying on my loop stations' pedals and worry about how to pull it off live later."

For In Tune, Chesley took a different approach to recording. Working with engineer Greg Norman (Pelican, Russian Circles, Neurosis), she was presented with new challenges in the studio. "Once of the things I was cautious of when recording on tape was to figure out how to play things from beginning to end," she says. "Learning that was difficult. When I screwed something up, I wasn't sure if I could do that again. But Greg helped by telling me to just get one good take, not four or five. Working like that in the studio was hard, but it allowed me to learn to be okay with mistakes, and I'm glad I did it that way." That edge and struggle can be felt on the album. Her placements of percussive plucks

Chesley wrestled with artistic uncertainty during the recording of In Tune and as she prepared to tour. "There's so much music out there now that it's easy to ask yourself ask yourself, 'Why am I doing this? Why would anyone listen to my music?'" she says. "There are so many good musicians today that you really have to believe in yourself and be confident even when you have doubt. For me, I realized that if I'm not playing my cello or writing, then I'm not really happy and I get depressed. Being aware of this makes me realize that I should be making music even when I'm struggling with the fear that nobody will want to hear my music. Sometimes I play cello just for my own emotional health or to sort things out."

Listening to Chesley work out her struggles and express herself on record is only part of the equation. Experiencing Helen Money live adds completeness to

---

"I CAME TO LOVE THE MIDRANGE SOUND OF THE CELLO, AND IT'S UNIQUE FROM ALL INSTRUMENTS BECAUSE IT'S MOST SIMILAR TO HUMAN VOICE. IT HITS YOU RIGHT IN THE CHEST."

---

and violent pushes and pulls of the bow back and forth across the strings immerse the listener in songs that are rigid and gritty, sleek and graceful. It's a jagged juxtaposition of metal textures and rock rhythms that's terrifying as much as it is tender and vulnerable.

For example, as inspiration for her song "Untilted," Chesley explains, "I was listening to John Coltrane's 'Alabama.' I knew that song was about the girls who died in a bombing during the civil-rights struggle in the '60s. I love that song because it's so naked. Coltrane evoked a strong feeling. I wanted to do the same thing in the middle section of 'Untitled.' On all my songs, I'm searching for a feeling or a sound more than melody because I'm not very good at writing melody.

"And that feeling is usually dark," Chesley adds, "because I'm not scared to explore the darker emotions. I don't mind being in a dark places. I don't know why that is. For some reason, I don't like music that you have to think about to appreciate. I'm hesitant to listen to albums like that. I like the rawness and immediacy of music that hits you quickly."

her albums. But after two years of performing on her own, Chesley feels that she is coming to the limits of what she can do on stage solo. "I feel self-contained when I'm on stage," she says. "I don't move around a lot. It feels sparse. I like that I'm intimately connecting with the audience, but I'm hoping to make it a bit more epic. I'd like to play and share the stage with other musicians too. It's a lot to deal with everything yourself, like driving to the venue, dealing with other bands when someone tries to move me up on the bill, and when things like my effects pedals don't work right. At times like those, I really need to rely on another band member."

Even so, Chesley's solo performance that evening at the Empty Bottle erupted with power and strength, filling the venue with an undeniable force. Chesley's performance was raw, naked, and revealing, and it provides inspiration by showing how a cello can rock, roar, and growl gorgeously when in the hands of Helen Money. Ⓐ

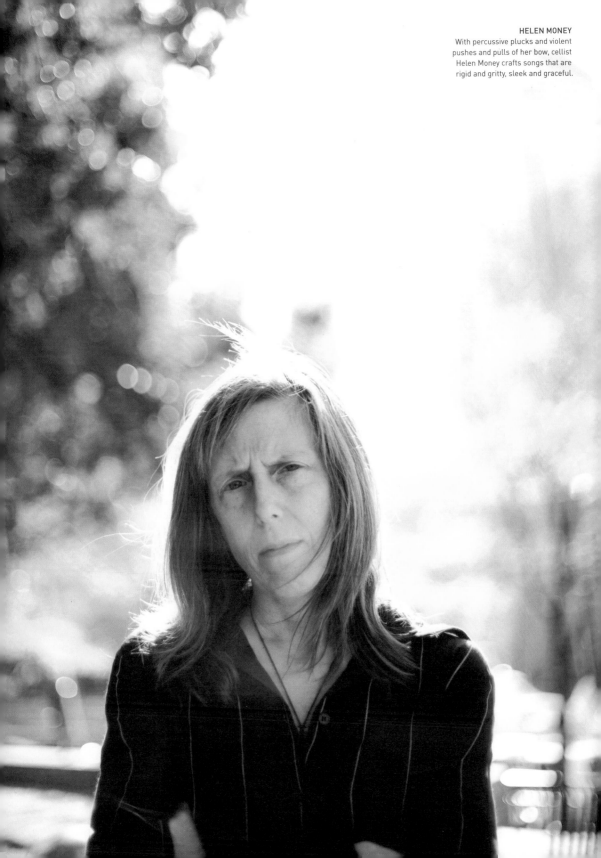

**HELEN MONEY**
With percussive plucks and violent
pushes and pulls of her bow, cellist
Helen Money crafts songs that are
rigid and gritty, sleek and graceful.

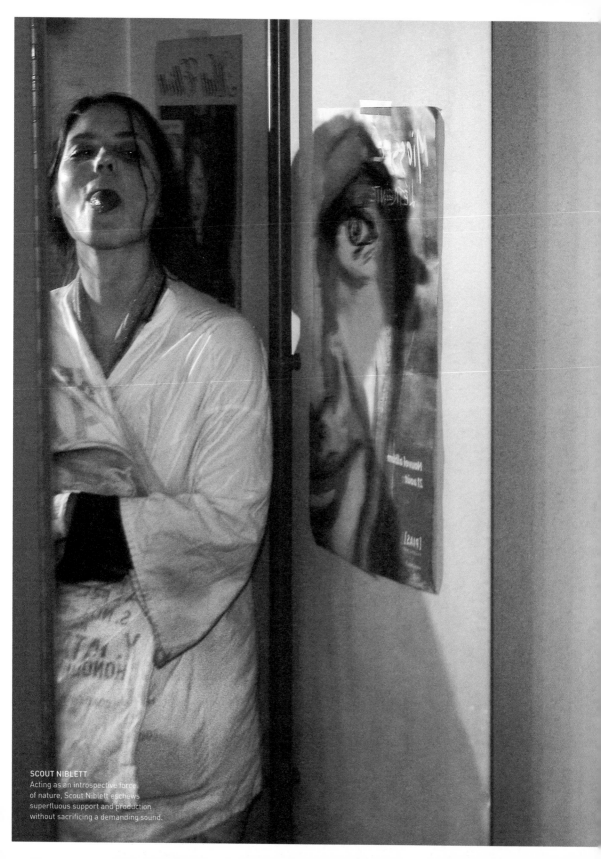

**SCOUT NIBLETT**
Acting as an introspective force
of nature, Scout Niblett eschews
superfluous support and production
without sacrificing a demanding sound.

# SCOUT NIBLETT

CHARLIE SWANSON

Crossing the lines of minimalist performer and powerhouse artist, Scout Niblett is easily one of the strongest voices to emerge in recent years. With each successive album, Niblett emboldens her material with a hypnotic and stirring display of honest emotion and inspired will. Acting as an introspective one-woman force of nature, she eschews superfluous support and production without sacrificing an already demanding sound.

Born in Staffordshire County, near the city of Birmingham in central England, Emma Louise Niblett grew up within the duality of the rural and industrial state. At a young age, she was trained on the piano and violin, and raised on music from the Top 40 countdown, from which she regularly taped her favorites to listen to over and over again. Her artistic roots and an English tradition of emotional repression clashed within her. Though Niblett had begun writing songs on her classically trained instruments, they never acted as an emotional or creative outlet.

When the grunge movement reached English shores, a 17-year-old Niblett discovered acts like Nirvana and Sonic Youth. Kurt Cobain's powerful voice and raw emotion especially captured her attention, compelling her to move to guitar and becoming a major influence in her burgeoning songwriting. As soon

as she got that guitar, she learned a few chords and immediately began writing material. With a stockpile of ideas from her youth on the piano, Niblett began building with simple melodies and heart-pounding vocals.

In college in Nottingham, Niblett split her time between music and performance art. She first took to a stage, but not to sing. Her performance art included multimedia monologues and an almost Cabaret-style exploration of music and images. However, it would not be long before she shared her songwriting with the intimate audiences. "I didn't want to do anything else," she says of her advent into performing. "I was pretty stubborn about it."

For her stage name, Niblett turned to the Jean Louise "Scout" Finch, the spunky narrator from *To Kill a Mockingbird*. "The character almost reminded me of myself, but a very free version of myself as a child," she says. "I didn't really express myself the in the way that she did. I didn't do that. And I felt that I should have, like that was a part of me that I really repressed. I think music is a way of expressing myself fully."

From the beginning, Niblett was a solo artist. "I've never had a band," she says. "I never learned other people's songs. That didn't interest me." But that's not to say that she's an isolationist. She has contributed to a broad range of friendly collaborations and the odd duet, only to remain a predominantly lone figure throughout her work. Niblett released her debut LP, *Sweet Heart Fever*, on Secretly Canadian in 2001, introducing listeners to her minimalist yet powerful and resonant songs. The album also introduced Scout Niblett the percussionist, as some songs were just her stark voice over a rumbling beat. This too would become a signature aesthetic.

Turning an ironic ear to her material, Niblett kept up an irreverent and enigmatic front. In her early shows, the musician would act out in odd yet comforting ways, like donning a blonde wig or engaging in morbid sing-a-longs. After building a reputation as a bold live presence, Niblett began touring Europe. She soon decided to pick up and move to the United States, where her music was being discovered by fans of PJ Harvey and Cat Power. Her constant touring led to a restless lifestyle, as she explored the country while living in places like Chicago, Philadelphia, and Oakland before landing in Portland.

The year 2002 saw the release of the *I Conjure Series* EP, where again Niblett played the entire album and captured a sparse, moving atmosphere often with only guitars and vocals. Her subsequent releases, starting with *I Am* in 2003 and *Kidnapped by Neptune* in 2005, feature the songwriter working with producer Steve Albini, after they met during recording on a mutual friend's album.

In 2007, Niblett opened her world slightly by experimenting with folk and country lines and even inviting Will Oldham to collaborate on the album *This Fool Can Die Now*. By this time, Niblett also had gotten into the habit of bringing a drummer on tour with her, rather than flying solo. The new dynamic didn't change the intimacy of the performance, nor did it lighten the brooding, raw emotion lying at the center,

but it did allow the songwriter to focus on bringing a more refined and contemplative approach to her music, one that has expanded her creative outlet.

The latest offering from the artist is her most challenging and heavy work yet. *The Calcination of Scout Niblett* poses tough questions to our protagonist. The process of calcination is the first step in turning lead

something will emerge that wasn't there when I started. I can't say I want to write a song about this and do it."

She admits that the messages are not always so clear. Sometimes a song written years ago will suddenly become relevant, immediate even. Such is the case with "Pluto." Written initially over a decade ago, this

## "I DIDN'T REALLY EXPRESS MYSELF IN THE WAY THAT [*TO KILL A MOCKINGBIRD*'S 'SCOUT' FINCH] DID. AND I FELT THAT I SHOULD HAVE, LIKE THAT WAS A PART OF ME THAT I REALLY REPRESSED."

into gold, a metaphor that suits the album well. A cathartic and reflective journey, *The Calcination...* carries an unbelievable weight with strained resolve that explores many of the all-too-often taken-for-granted moments and memories. From the blazing opening seconds, and throughout the intensely personal record, Niblett's energy never falters.

As always, Niblett's inner voice speaks and informs her songwriting. A dedicated astrologer as well, she takes subconscious mysteries and lures them right to the surface. "To me, songs really are kind of messages from my subconscious," she says. "I don't sit down and try and write something with a concept. I can't really do that. I just start playing, and then

track only now is featured on her newest album, observed in new light, with new purpose. And it's not the only one. Niblett hints at scores of works remaining perhaps as live performance only, or even kept further out of reach, until their meanings becomes clear.

Niblett's raw torrent of emotion is anchored in her deeply sensitive and mature outlook. A dedicated astrologer as well, she takes subconscious mysteries and lures them right to the surface. Looking straight at what most people spend years ignoring, the depth that Niblett's songwriting taps into is matched only by her staggering resilience, offering respite for the rest of us. ◐

# KAP BAMBINO

JAMIE LUDWIG / *PHOTOS BY JUCO*

Today Caroline Martial and Orion Bouvier, of Bordeaux, France, are in Los Angeles. Tomorrow they play a one-off in San Francisco as electro-rock duo Kap Bambino. Their handful of US tour dates will be followed by one-offs in Mexico, Colombia, and more, which is a pretty sweet tour itinerary for a band that has yet to record outside its own bedrooms. "We are so lucky because we never expected to move like this," Martial says. "It's really cool every time we have the chance to do things like this."

Kap Bambino is a prime example of the adage "do what you love and the rest will follow." A chance meeting at a party first led Martial, a quirky pop vocalist who performed under the name Kima France, to Bouvier, a multi-instrumentalist who was growing bored with the limitations of traditional rock. After realizing they had much in common, the two agreed to start their own label, Wwilko. "Wwilko releases music from non-commercial artists—indie freaky music," Martial says. "Now we have 20 releases. We do everything by ourselves—the artwork, the drawings, everything." In 2003, they began Kap Bambino, their first joint venture as musicians. Since then, they have self-released a handful of EPs and two full-lengths, and have independently toured the world. Their third album, *Blacklist*, was released in Europe at the tail end of 2009, finally making a splash stateside in the spring of 2010.

Kap Bambino's worldwide fan base may be on the upswing, but the band is bent on maintaining its regular DIY operations. "No one controls what we do," Martial says. "We want to do everything ourselves, and [our label] was up for that. If we start tomorrow to have someone else control our artwork, or our image, or recording, it's not going to be Kap Bambino. We record in the bedroom. We've never been at the studio. We want to try to go to the studio sometime, but we really want to keep the texture that we already have and the artwork. Kap is not just music; it's a lot of things."

In today's underground climate, few styles of music remain as polarizing as electronic dance music. In recent years, artists have blended styles in increasingly new ways, resulting in hybrids such as acoustic folk with backbeats, hip hop infused with Brit pop, and frat rock with African-influenced rhythms. Though some artists softly introduce listeners to new sounds in subtle ways with variations on already familiar formats, Kap Bambino's blend is a more aggressive and unwieldy. *Blacklist*'s title track, for instance, finds Martial's voice manipulated until it is as sharp as razorblades, creating a piercing sound over pulverizing, heavy synth beats. This brutality is balanced elsewhere on the album with an unassuming quirkiness, distinct pop sensibilities, and Martial's naturally girlish French accent making it easy to imagine tunes

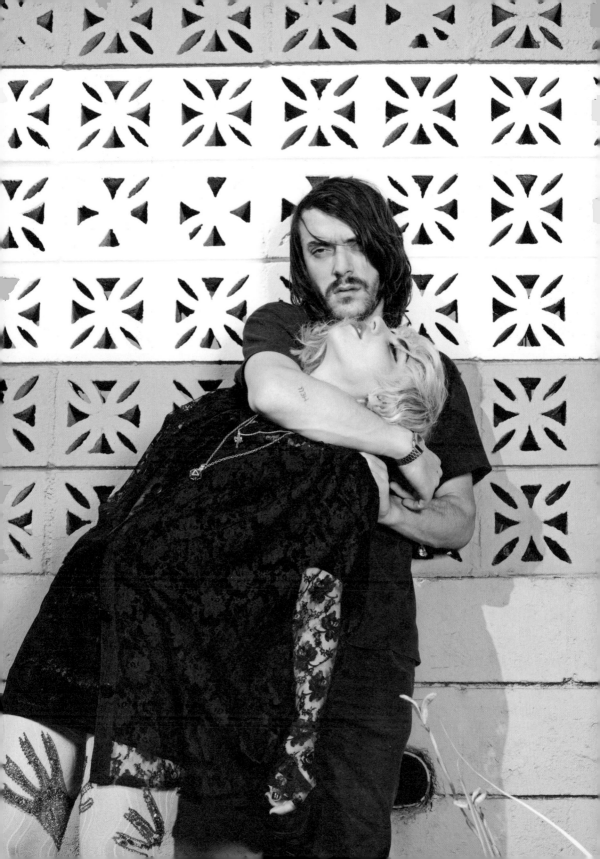

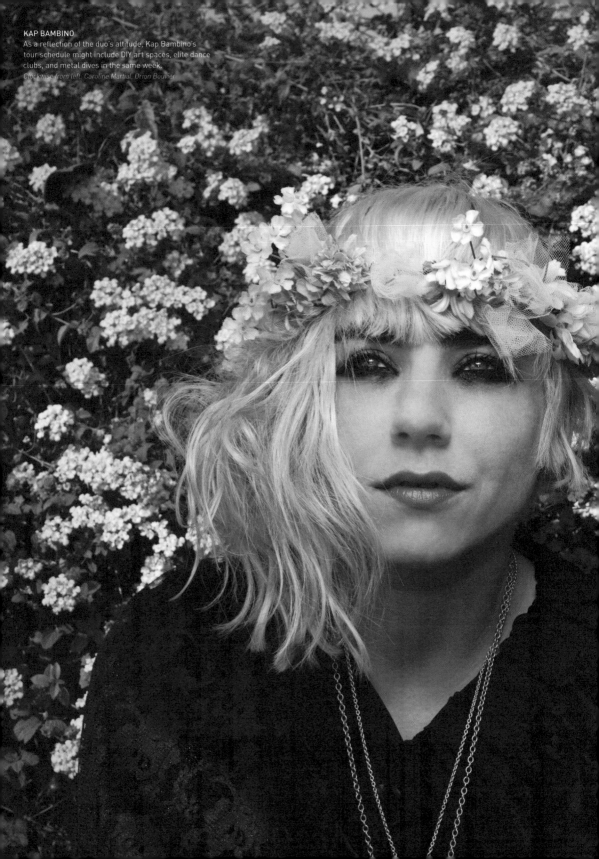

**KAP BAMBINO**
As a reflection of the duo's attitude, Kap Bambino's
tour schedule might include DIY art spaces, elite dance
clubs, and metal dives in the same week.
*Clockwise from left: Caroline Martial, Orion Bouvier*

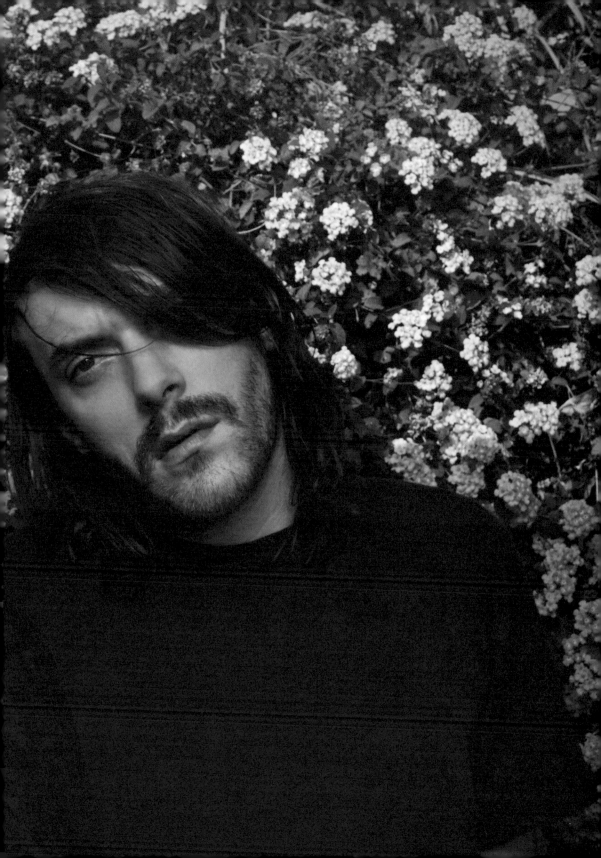

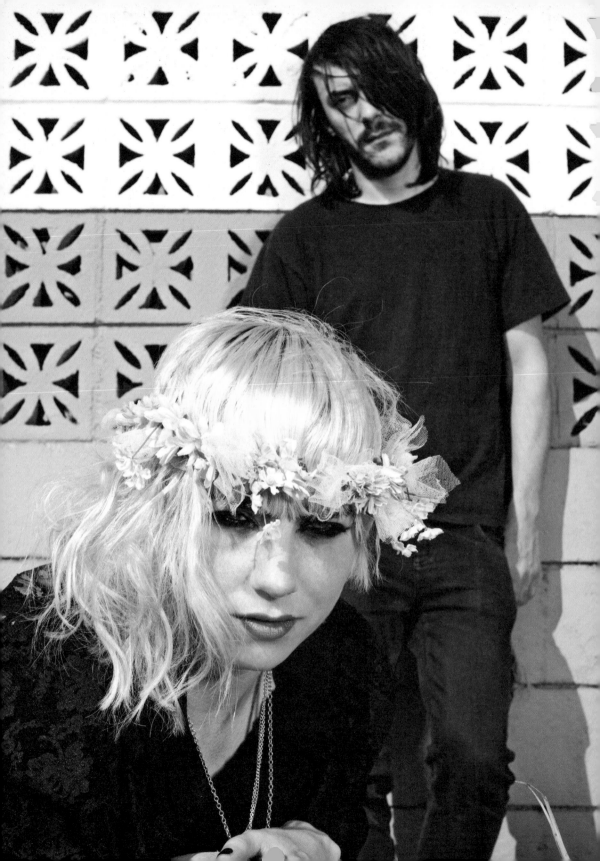

like "Batcaves" and "Dead Lazers" appearing on commercial radio. Due to this versatility, the duo has drawn listeners across what often are very strong fan lines.

"We just want to do what we like," Martial explains. "Of course, that breaks the rules of electro-rock. It's bizarre that in our crowd, we have guys from the rock scene, electro scene, metal—it's a big mix. It's what we like because that's what we are. We try our best

a T-shirt and leggings), may appear over the top, but Martial insists that both of these elements are merely an outpouring of her inner self. "When we first started Kap Bambino, I was really young, and for maybe the first 20 gigs, I was really dressed up. I finally realized that people were just talking about my outfit, like, 'Look at that girl; she's wearing a wedding dress,' and I said, 'Oh, my god, no!' I just want people to listen to my stuff. I decide to chill and just concentrate on the music. I'm always wearing my little jacket, but

---

## "WE REALLY WANT TO ARRIVE ON STAGE LIKE A COMPUTER BUT GIVE IT A HUMAN ROCK SIDE, LIKE ROCK AND PUNK. [MULTI-INSTRUMENTALIST] ORION [BOUVIER] IS THE MACHINE; I AM THE HUMAN."

---

to stay in the middle of things. We don't want to have a stamp; [we] just want to create music." As a reflection of this attitude, the duo's tour schedule might include dates at DIY art spaces, elite dance clubs, and metal dives in the same week.

Even if the music isn't enough to reach new fans, Kap Bambino's live shows could win over any skeptic. Martial mesmerizes the crowd as she climbs gear, writhes around the stage, and, in true punk-rock fashion, breaks the fourth wall between artist and listener while Bouvier, hair in his face, stands collectedly at his electronics. "We really want to arrive on stage like a computer but give it a human rock side, like rock and punk. Orion is the machine; I am the human," Martial laughs.

The antics, as well as Martial's bold clothing choices (she's as likely to sport a gold lamé bathing suit as

that's the way I am in life. I can't stay pretty. Sometimes I try to do good makeup, but after two songs, everything falls down and I just look like a zombie."

Martial remarks that with all things considered, Kap Bambino isn't necessarily doing anything that hasn't been done before. "We are not original," she says. "Yesterday, I jumped in the crowd four or five times, but I'm not the first one." Even so, the duo's sincerity and fuck-it-all attitude harkens back to a time when punk was fresh and daring and anything could happen. "I don't come from art school; I come from the street," Martial adds. "It's very simple. No bullshit. I think Orion's music gives me a trance, and maybe that is the reason Kap Bambino is how it is. I hope so, because I don't understand myself." Ⓐ

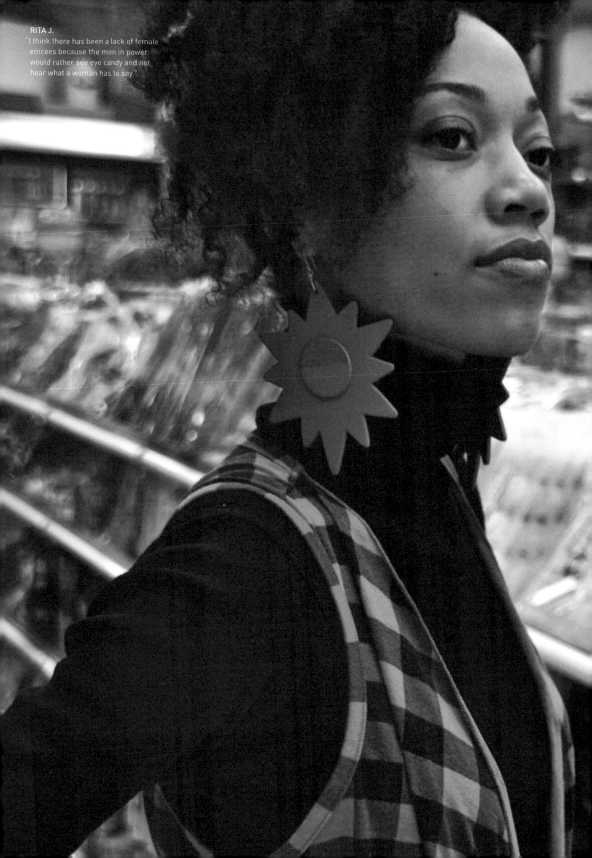

RITA J.
"I think there has been a lack of female emcees because the men in power would rather see eye candy and not hear what a woman has to say."

# RITA J.

JEFF MIN /
*PHOTO BY ROPER*

# CHAPTER 05

I t's hard to argue against the fact that hip hop always has been a man's world. Despite the fact that pioneering artists such as MC Lyte, Queen Latifah, Roxanne Shante, and Monie Love set a bold precedent, many female emcees found themselves faced with two rather limiting options: either to match the bravado of their male peers with over-the-top aggressiveness, or complement it with a hyper-sexual image. Within that polarization, unique voices have often gone unheard.

Trailblazers of the 1990s like Ladybug Mecca, Lauryn Hill, and Erykah Badu, and contemporaries including Jean Grae, Psalm One, and Georgia Anne Muldrow, have shown a more realistic perspective that highlights the artist's individuality. This progression has provided fertile ground for a new crop of lyricists, and one of the most exciting talents to emerge from that scene is Atlanta emcee Rita Jackson, a.k.a. Rita J.

"I think there has been a lack of female emcees because the men in power would rather see eye candy and not hear what a woman has to say, so they don't give females an opportunity to expose their music," Jackson says. "Women keep getting overlooked and shelved because they don't fit into the desired mold. Women [in hip hop] either have to be portrayed extremely sexy or tomboyish, and there is no middle ground, when most females that I know are somewhere in the middle. There needs to be more balance in hip hop. I just want to showcase a different face, a different character—one that is not being represented right now. I am the change that I wish to see."

Jackson first discovered her knack for writing while she was a student at Southern Illinois University. She spent hours at a time in her dorm room ritualistically hammering out lyrics. As she developed her craft, she discovered a sense of empowerment. "Education is knowledge, and knowledge is power," Jackson says. "If you educate yourself, you can go far in life and accomplish great things."

Her confidence and style quickly caught the attention of Chicago emcee Iomos Marad, who had been working with Chicago independent label All Natural, Inc. Marad then introduced Jackson to label head Anthony Fields, a.k.a. Tone B. Nimble. "Our first impression of Rita was that she rapped extremely clear, had smooth flow, and had a sweet voice," Fields says. "We also discovered she had a vibe that would fit with All Natural Inc., which is basically to be creative and say a little something."

Jackson soon found herself laying down heady verses for the Family Tree on the *Tree House Rock* project (2003). The album gave Jackson the final push that she needed to move forward and pursue a solo project.

Her debut album *Artist Workshop* was supposed to be released sometime in late 2007 (that year saw a Japan-only edition), but technological and circumstantial mishaps continuously delayed the process. Fields says that Jackson's move to Miami and then Atlanta slowed the recording process. After recording in several different studios, the music files that she had on an external hard drive were accidentally

174    ALARM 38

destroyed. When everything was recovered, Jackson and Tone tweaked the album, updating, replacing, and remixing select beats. The final hurdle came when All Natural's distributor, Touch & Go, shut down its distribution branch, forcing them to seek a different distribution route.

four female emcees who come together and gel and it's all love." In other words, it's art imitating life.

Through Jackson's music, she strives to connect the dots of real life and lay to rest all the unrealistic ideals that have compartmentalized female emcees for far

---

"WOMEN [IN HIP HOP] EITHER HAVE TO BE PORTRAYED EXTREMELY SEXY OR TOMBOYISH, AND THERE IS NO MIDDLE GROUND. I JUST WANT TO SHOWCASE A DIFFERENT FACE, A DIFFERENT CHARACTER—ONE THAT IS NOT BEING REPRESENTED RIGHT NOW. I AM THE CHANGE I WISH TO SEE."

---

"It was so frustrating," Jackson says. "Whenever you put time and effort and energy into something, you want to see it live. If it's an album, you want to see it do well and hear people's feedback. You want to perform it. And [the delays] held me back from doing that for a couple years.

"I'm working on a project now entitled *She The Hard Way*," she continues. "It's myself and four other young ladies (Boog Brown, Sa-Roc, Stahhr, and Khalilah Ali) who are from all different parts of the United States, and they come here to Atlanta. It's produced by DJ Sol Messiah, and it's a project about

too long. It's a mission that any hip-hop head can appreciate, regardless of gender. Her solo album can be seen as her first attempt to balance the scales, and as she settles into different projects, it's almost certain that it won't be her last.

"It seems like for a minute, [women] weren't being taken seriously," Jackson says. "But that's over now." ⓐ

# MAMMOTH GRINDER

LUC RODGERS / *PHOTOS BY JONATHAN ALLEN*

"My goal as a band is to make enough money to afford a practice space where, in the summer months, we wouldn't have to play in our underwear."

Chris Ulsh, singer/guitarist for Austin metal trio Mammoth Grinder, is being completely serious, what with the summer temperatures not only topping but *remaining* over 100 degrees for days at a time. With a stoic disposition and fly-on-the-wall demeanor, Ulsh could easily be mistaken for any other quiet 22-year-old college student studying mathematics.

"I've been listening to metal since grade school," he says. "As far as the new stuff, I really don't know much about it. It just seems like the whole idea of metal has been bastardized and dumbed down over the years. I mean, now we have shit like *Metalocalypse* selling out clubs across the country. I just don't understand it."

Though the Adult Swim cartoon's popularity has illuminated the masses on the intricate musicianship and talent needed to play metal, Ulsh's views are not singular in their distaste, especially from the viewpoint of an underground metal band working its ass off trying to get its art to a respected position. Metal musicians have often been pigeonholed as simpletons screaming about unimportant subjects, from the very beginnings of the genre, when bands like Black Sabbath rattled the world with an ungodly,

magnificent racket. Although the stereotype has been an obstacle for some, it has also fueled the metal underground to be *that* much noisier and *that* much more unstoppable; Mammoth Grinder, in its infancy, is the perfect example of the power of this movement and its unstoppable contributions to music, both new and old.

Initially released on vinyl via Austin's Cyclopean Records with a CD version released by Relapse Records in early 2010, *Extinction of Humanity*, the band's second full-length, brings the simple brutality of death metal with a hardcore rawness that is heard less and less in this age of digital recording programs, overdubs, and pitch correctors.

With a sprightly leap over the banister of the porch where we are enjoying a pitcher of Lone Star beer, drummer Brian Boeckman joins the discussion. Boeckman and Ulsh have a long musical history together. "We met in Houston a long time ago because of our shared interest in metal," Ulsh says. "It was inevitable that we would begin to play together and then become best friends." The two-piece eventually grew into the current three-piece with the addition of bassist James Hammontree.

In Austin, one has to only venture outside to witness everything from impromptu tight-rope walking to a Mariachi band performing in a downtown alley for

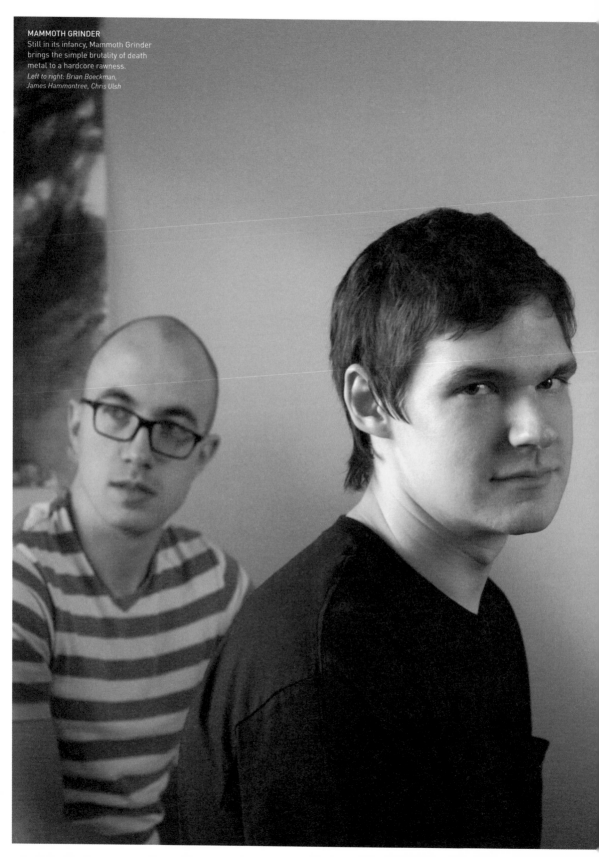

**MAMMOTH GRINDER**
Still in its infancy, Mammoth Grinder brings the simple brutality of death metal to a hardcore rawness.
*Left to right: Brian Boeckman, James Hammontree, Chris Ulsh*

"IN A TOWN LIKE [AUSTIN], THERE ARE SHOWS EVERYWHERE, ALL THE TIME. THE PUNK-ROCK SCENE IS MUCH STRONGER HERE THAN METAL, BUT THEY REALLY GO HAND IN HAND. THERE IS A DEEP RESPECT FOR EACH OTHER, WHICH ISN'T ALWAYS THE CASE ANYWHERE ELSE."

the simple pleasure of sharing music. "In a town like this, there are shows everywhere, all the time. The punk-rock scene is much stronger here than metal, but they really go hand in hand. There is a deep respect for each other, which isn't always the case anywhere else."

Armed with a strong work ethic, a DIY aesthetic, and growing support from the underground metal community, Mammoth Grinder is on the precipice of something large—and well deserved. After all, it is musicians like Ulsh and Boeckman, who care more for art and sound than fame and notoriety, that have kept the metal genre alive and relevant for generations past, present, and future. ⓐ

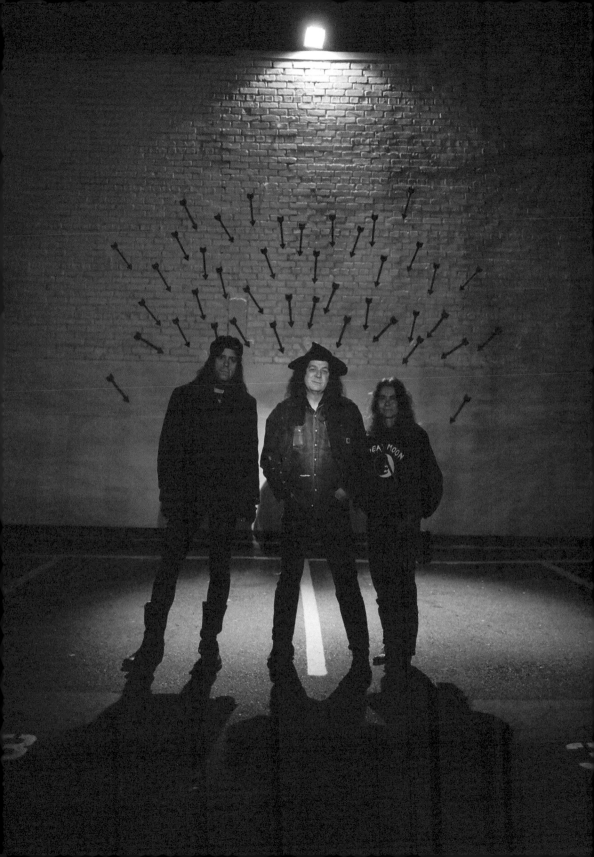

# PIERCED ARROWS

JAMIE LUDWIG / PHOTOS BY ANDREW WAITS

**I**T'S TUESDAY NIGHT IN PORTLAND, OREGON, AND MUSIC MILLENIUM, ONE OF THE TOWN'S MANY AMAZING INDEPENDENT RECORD STORES, IS FILLED WITH MUSIC LOVERS WAITING FOR LOCAL TRIO PIERCED ARROWS TO BEGIN AN ACOUSTIC SET CELEBRATING THE RELEASE OF ITS LATEST RECORD, *DESCENDING SHADOWS*.

"THANKS FOR COMING TONIGHT," BASSIST TOODY COLE SAYS TO WELCOME THE CROWD BEFORE ADDING, IN REFERENCE TO THE ACOUSTIC GUITARS AND STRIPPED-DOWN DRUM KIT, "THIS IS A FIRST FOR US, AND WE'RE REALLY NERVOUS."

This confession stands out because even though *Descending Shadows* may be the band's sophomore release, Toody, guitarist/vocalist Fred Cole (her husband), and drummer Kelly Halliburton are hardly new faces in the music scene. Over beers after the performance—a 20-minute set of minimal, hook-laden garage rock—the bandmates estimate that between the three of them, their collective discography looms in the triple digits. Despite their pre-show jitters, and the fact that one of Fred's two hearing aides has gone missing, they agree that their acoustic in-store debut went rather well. It's clear that for Pierced Arrows, new challenges are always welcome challenges.

This adventuresome spirit has long served the members of Pierced Arrows well. Fred began his recording career as a teenager in 1964, playing in myriad bands over the years that followed. Eventually, he became enamored with the sounds of punk rock and, in 1987, started Dead Moon with Toody on bass and vocals and with drummer Andrew Loomis. The trio blended elements of punk and country into its stripped-down, classically Northwest rock-'n'-roll sound. Thanks largely to word of mouth and relentless touring, Dead Moon grew a rabid underground following throughout the world. Its members became veritable icons to the underground set, with Fred and Toody regarded by some as the ultimate couple in independent rock. They recorded and pressed many of their own records (on the very lathe that was used to cut the The Kingsmen's "Louie Louie"), built their own home, and in their time off the road, worked side by side as proprietors of the Tombstone Record Label, Tombstone Music Store, and Tombstone General Store in Clackamas, Oregon. Their lifestyle and career path were so captivating that they became the subjects of *Unknown Passage*, a 2004 documentary about Dead Moon.

When the Coles parted ways with Loomis in 2006, they formed Pierced Arrows with Halliburton, a seasoned musician who plays bass in long-running Portland punk bands Defiance and Severed Heads of State (and whose father played in a band named Albatross with Fred during the 1970s). The group released its debut album *Straight from the Heart* in 2008.

Their stories are plentiful, but their attitude remains optimistic and fresh rather than road worn and jaded. They admire good musicianship and professionalism in working musicians regardless of experience level, and are always up for a good adventure. On any given night, they may play for a modest audience hearing their music for the first time, or a crowd of hundreds singing along with every word. "Every band sees the gauntlet," Toody says. "I don't care how big or small you are; it's part of what keeps it exciting because you never know."

Their individualism and hard-working philosophies are evident in their music as well. Fred is a songwriter's songwriter, and bands from all over the globe have paid tribute with covers (most famously, Pearl Jam's rendition of Dead Moon's "It's Ok"). Taking the shape of poignant love ballads, riff-driven political diatribes, or hard-rock anthems, each song rings sincere, straightforward, and sheds light on some universal truth. "Fred's a complicated man," Toody says. "He writes in a lot of different themes that touch everybody, whether it's anger, frustration, whatever—they all come into play. And I'm a fan. I love the way he writes too." The chemistry between the couple, now grandparents, is undeniable. On recordings, their vocals, whether solos or as duets, often create the feeling of being a fly on a wall, privy to thoughts meant only for each other's ears.

Their particular combination of unforgettable songs, personality, and DIY ethos has meant that the Coles' reputation often precedes them. Fred and Toody acknowledge their cult status among many of their listeners and take it in stride. "We've been around so long, and that's unusual," Toody acknowledges.

Still, they dismiss the notion of being "legends" of independent rock. "I consider a legend to be something that is over," Fred says. "I don't consider myself a legend because I'm not done yet. I'm an old, alive musician. I'm still doing new stuff. A legend is someone who's done everything they're going to do, and they're just playing their hits from 40 years ago."

For the members of Pierced Arrows, waxing nostalgic is boring. Focusing their energy on developing material and keeping their eyes open to new opportunities keeps things interesting. "If I was just playing along to Dead Moon songs, and these guys were just rehashing old stuff, then that would be pathetic," Halliburton says.

The Coles agree. "Performing the same material over and over again for X amount of years, you lose that particular thing," Toody says. "At some point, all you're doing is pleasing the audience because for them, it's just one night, and for you, it's thousands upon thousands of gigs."

"I would hate to be a one-hit wonder, where there was one song you have to play every night," Fred says. "Pierced Arrows has played almost three hundred gigs, and we've been together almost three years. Once we get our catalog up to date, we start getting rid of different things. If nothing else, it gives bands like us incentives to make new material, so you can lose the things you've played."

Fortunately, the songs keep coming naturally. "I can't try to write," Fred says. "I can start thinking about it, and ideas start to formulate, but I just have to wait around for it to come. If I sit down and stare at a piece of paper, everything I write sucks."

Even with new material, though, Pierced Arrows has been faced with the task of convincing some listeners

Despite Halliburton's expressive drumming, and the band's more aggressive approach, the Coles' primal, heartfelt style is unmistakable. And that's a good thing. The most differentiating characteristic between the old band and the new may lie in the band members' mindset. "There was never any other drummer in Dead Moon other than Andrew," Fred says. "There was never another drummer in Pierced Arrows

---

## "I CONSIDER A LEGEND TO BE SOMETHING THAT IS OVER. I DON'T CONSIDER MYSELF A LEGEND BECAUSE I'M NOT DONE YET. I'M AN OLD, ALIVE MUSICIAN."

---

that it is not just a continuation of Dead Moon. This can be particularly annoying for Halliburton, who, despite two albums and nearly three years playing with the Coles, is often referred to as "the new drummer."

"There are some people that definitely don't [understand the difference between the bands], and some people that don't *want* to, like people that grew up listening to Dead Moon that don't want to acknowledge that this is something new," says Halliburton, who, despite his frustrations, remains largely sympathetic. "I'm a fan of music. There are a lot of bands where if I'd been listening to them for 20 years, and then they took an abrupt turn and a lineup change, it would take some getting used to, so I can empathize with people. I can understand where they're coming from, but they've got to understand where we're coming from."

Listening to Pierced Arrows and Dead Moon side by side, it's easy to see where the confusion lies.

other than Kelly." *Descending Shadows* reflects this carpe-diem attitude from its first moments with aptly titled opener "This is the Day." Though the album is explicably rooted in a long rock-'n'-roll tradition, tracks like the snarling "You Don't Wanna Know" and the anthemic "Paranoia" prove it to be a solid, vibrant offering that maintains an energy based firmly in the present.

As of the release of *Descending Shadows* in early 2010, the future for Pierced Arrows seems to be shaping up nicely. While beer glasses are drained, designs for new T-shirts are passed around, and the band talks of plans for even more new recordings and upcoming tours. "I have a good feeling that we'll play Japan and South America [in support of *Descending Shadows*]," Fred predicts.

"It's cool for all of us, for as long as we've been at it, to have something to look forward to," Toody says. "Makes it worth the ride, you know?" Ⓐ

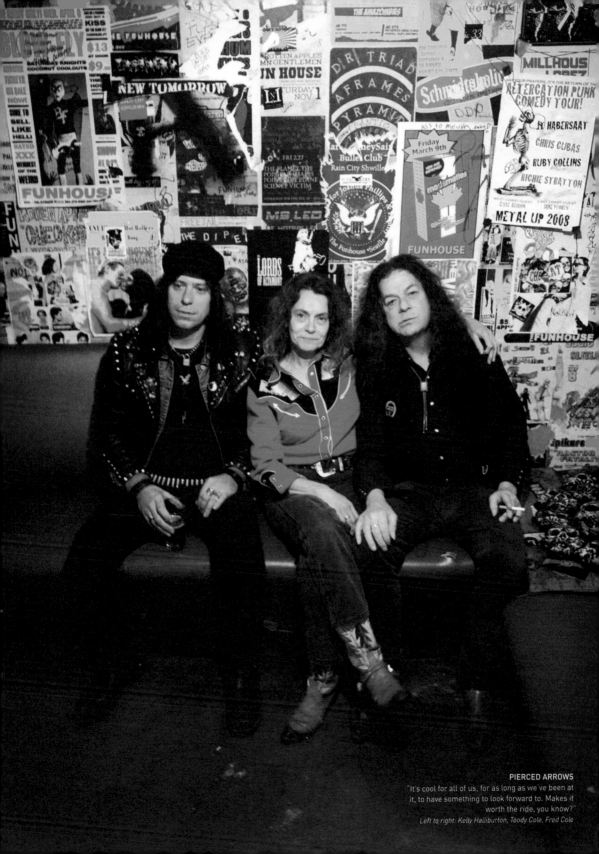

**PIERCED ARROWS**
"It's cool for all of us, for as long as we've been at it, to have something to look forward to. Makes it worth the ride, you know?"
*Left to right: Kelly Halliburton, Toody Cole, Fred Cole*

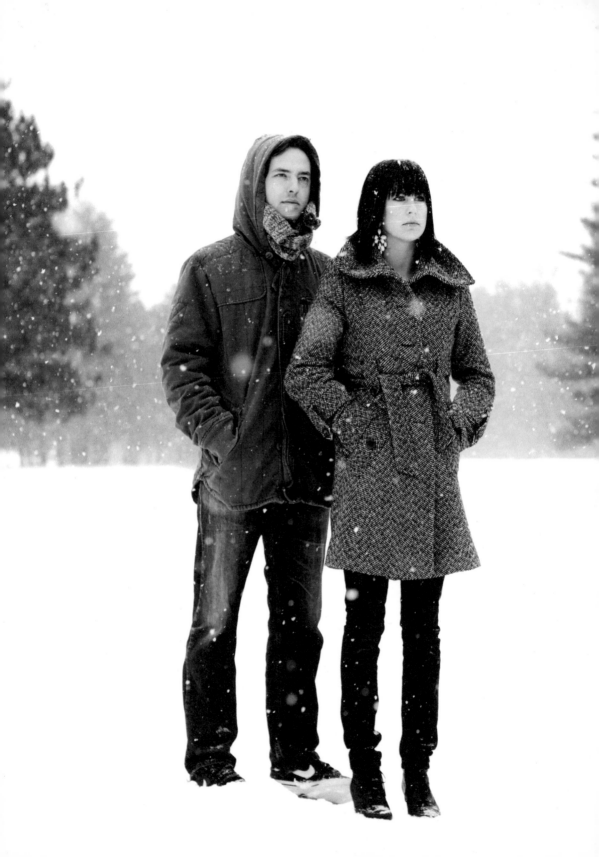

# PHANTOGRAM

CHARLIE SWANSON /
*PHOTOS BY NOAH KALINA*

A PHANTOGRAM IS, BY DEFINITION, AN OPTICAL ILLUSION. IT GOES LIKE THIS: TWO SEPARATE BUT IDENTICAL IMAGES ARE SHOWN IN 2D. PUTTING THEM TOGETHER CREATES THE LOOK OF A SINGLE IMAGE, AND A THREE-DIMENSIONAL LOOK APPEARS AT THE ILLUSION'S "SWEET SPOT." THIS TECHNIQUE IS THE BASIS FOR 3D MOVIES, A MAJOR PART IN THE WAY WE PERCEIVE EACH OTHER, AND A MOST APPROPRIATE DESCRIPTION OF GUITARIST JOSH CARTER AND KEYBOARDIST SARAH BARTHEL'S MUSIC.

The duo is in the middle of its first European tour when we get the chance to talk. "It's just us out here," Carter responds when asked about tour mates. "Yeah, we're going to be touring for the rest of our lives," Barthel adds. Already, the duo has shared the stage with established acts such as Ra Ra Riot and Brazilian Girls. Phantogram's talent is clear even before its debut record hit shelves. In its well-polished live show, the duo really earns its moniker.

While Carter moves about freely, wielding his guitar and stomping on a plethora of pedals, Barthel is stationed behind the keys, a massive rack consisting of all the electronic flourishes that fill out the corners—almost invisible at times, repetitive and foundational at others. In the stage show, the two combine into a single vision. When that new dimension opens up and our perception changes, they not only complement but complete the outfit. On record, Phantogram sounds like five people; on stage, the two act as one.

Phantogram began where many bands do, in a small hometown. For Carter and Barthel, it was in Saratoga Springs, in upstate New York. The two were neighborhood friends growing up in nearby Greenwich. After high school, they parted briefly, but a chance reunion led them to form a band.

For Carter, it was an unexpected surprise. The songwriter had recently returned to Saratoga Springs from New York City after his band Grand Habit, an experimental outfit that he founded with his brother, went belly up.

For Barthel, playing music was a new experience. Before playing with Carter, Barthel had studied visual arts. In the summer of '07, she returned home as well, dissatisfied with the degree and trying to take a break. After she and Carter discovered a mutual love of underground hip hop, the two began collaborating on music together.

The two friends began driving 45 minutes one way to a barn in the middle of nowhere. They retrofitted the space into a proper studio and dubbed their lair the Harmony Lodge. It's there that they spend most of their time, working out songs that combine their diverse influences and explore greater creative expanses. In an increasingly crowded and cramped world, the open and isolated space provided by

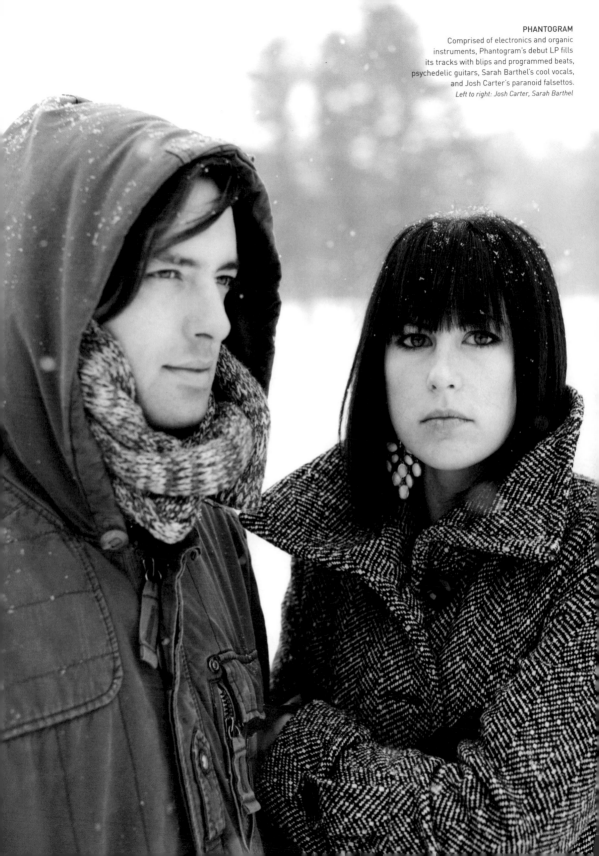

**PHANTOGRAM**

Comprised of electronics and organic instruments, Phantogram's debut LP fills its tracks with blips and programmed beats, psychedelic guitars, Sarah Barthel's cool vocals, and Josh Carter's paranoid falsettos.

*Left to right: Josh Carter, Sarah Barthel*

"WE WOULD COME UP WITH IMAGINARY SCENARIOS AND WRITE AROUND A CERTAIN IDEA AND JUST SEE WHAT HAPPENED."

Phantogram's debut LP, *Eyelid Movies* (Barsuk), is a swirling, beat-propelled gem of dreamy, texture-driven indie pop. Filled with a combination of electronics and organic instruments, the record is a blend of elements that include drum machines, samples, live instruments, and the occasional vinyl crackle. "We really wanted to capture a certain sound on the record," Carter says. "We've been experimenting a lot with weird samples. Whether homemade or in the studio, we just keep looking." He adds, "[The album] eventually shaped itself the way it did naturally. We didn't think too hard about it." Instead of constraining themselves to capture their vision simplistically, the two experimented fully to achieve the exact feel that they sought. The experimentation and sampling only heightened their musical sweet spot.

At moments, the pair can sound jaded, even cynical. But its best comes from its sleepier side, the dreamy and explored sounds. After all, what are eyelid movies if not dreams? Phantogram, if nothing else, makes us long for that moment in our own eyelid movie, reveling in our own illusions, before clocks and whistles command our attention.

Citing influences from early hip hop to Serge Gainsbourg, Phantogram isn't about mashing up tastes and seeing what works. The pair has had many nights in the dead of winter, searching for and building up a seamless blend, the perfect cocktail of sounds—mixed and chilled, contemplative and complementary. Working off each other, the two create music with a darkly mirrored edge. Phantogram pulls back just enough yet fills its tracks with all manner of blips and programmed beats, psychedelic guitars, Barthel's cool vocals, and Carter's paranoid falsettos.

Harmony Lodge allows the pair to create without restrictions. "Most of our music is made at night, in the middle of winter, out in the barn," Carter says. "We would come up with imaginary scenarios and write around a certain idea and just see what happened. A lot of the lyrics might tend to be on the bleaker side of things, but it was the dead of winter."

At home and on the road, the two friends are just discovering the possibilities of their talents. Each single that they release is more sophisticated and more complete than the last. In time, Phantogram could well become the vision that it has set forth with *Eyelid Movies*, a great introduction to a new sound. Ⓐ

# KRALLICE

LUC RODGERS / *PHOTOS BY JUSTINA VILLANUEVA*

Queens, New York was at one time the epicenter of jazz in America. While Louis Armstrong and Ella Fitzgerald could be heard blaring the new sounds of America, young Sonny Rollins and Thelonious Monk were busy ingesting all they could so that one day, unbeknownst to them, they too could put their stamp on a rebellious sound that was purely American.

Fast-forward to present day Queens and one will find that not much has *really* changed. Yes, the shops and styles may be different. The roads are wider and the air is dirtier. The "cacophony of rebellion," as it was described in the 1940s, still looms in the air, albeit often without brass and woodwinds.

"I am not so knowledgeable about the world of jazz," admits Colin Marston, guitarist for the black-metal band Krallice. "I grew up listening to King Crimson a lot." Despite the lack of fervor for the music of old Queens, Marston—along with bandmates Mick Barr (vocals/guitar), Nick McMaster (bass), and Lev Weinstein (drums)—has sure-footed knowledge about where the band's singular sounds have originated. "Classical music, especially 20th Century, which is another influence on how I think about music. A lot of ambient music, especially ambient guitar music, has been important to me."

Krallice's self-titled debut album quickly shot the band to the apex of what has become the US black-

metal sound, combining classic blast beats with ethereal atmospherics. This wildfire can be mostly attributed to word of mouth, a staple in the metal world via messages and music trading. For Krallice, this was especially important because the band rarely tours or plays shows outside the New York area. "[We put] less of an emphasis on playing out and touring than most other bands. It is just not a priority for Krallice. We are playing a few shows for the record… five days or something, all around New York."

But a question undoubtedly comes to the foreground. With the members' roots and influences in non-black-metal bands (members are and have been in such acts as math-metal trio Dysrhythmia, punk-jazz act The Flying Luttenbachers, progressive death-metal band Astomatous, and melodic death-metal group Solecism), was the self-titled debut a one-off? Something to do for the hell of it? With the band's second full-length, *Dimensional Bleedthrough* (Profound Lore, 2009), any and all doubts have been put to rest.

*Dimensional Bleedthrough* takes the power and atmosphere of Krallice's debut and pushes it further, louder, and longer. The opening title track lays the foundation for this sprawling, violent collection with its unflinching power and sweeping crescendos from movement to movement. Barr's vocals are at times in your face and other times seemingly part of the entire atmosphere.

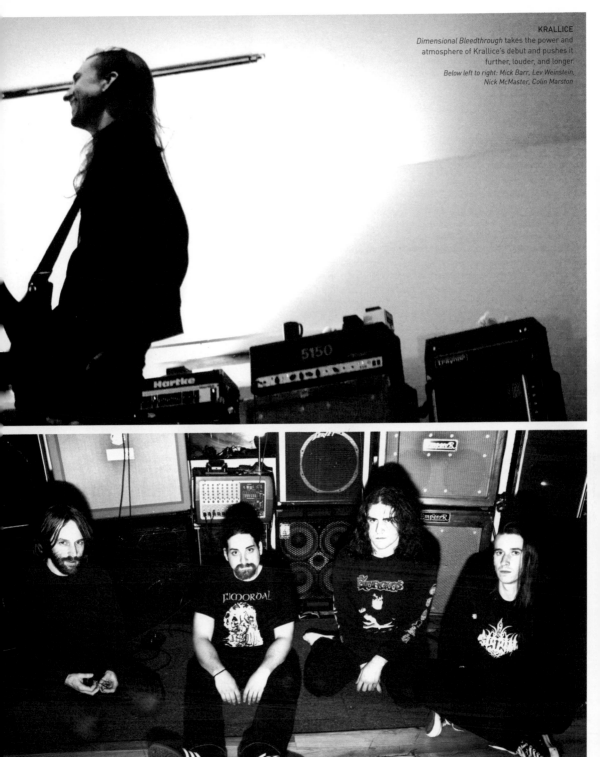

**KRALLICE**
*Dimensional Bleedthrough* takes the power and
atmosphere of Krallice's debut and pushes it
further, louder, and longer.
*Below left to right: Mick Barr, Lev Weinstein,
Nick McMaster, Colin Marston*

The production, both a seamless blend of clarity and a blinding fog of rage, can be attributed to Marston's *other* endeavor: he owns and operates the Thousand Caves recording studio in Queens. Along with Krallice, Marston has recorded electro-grind masters Genghis Tron, avant-garde artist Jarboe, and the scarier-than-hell, now-defunct Khanate.

Though New York City accepts all kinds of art, both outsider and mainstream, Marston feels that the city is not a metal town. "I've gone through periods where I think that New York has a decent metal community," he says. "I go back and forth, though. I mean there are some pretty influential death-metal bands like Suffocation and Immolation, but they're really from Yonkers and Long Island, I believe. As far as from Manhattan, Brooklyn, Queens, and so on, there aren't that many that I can think of. There is a lot of experimental music here, which can be exciting even though it is not in the traditional sense [for] a metal band. But, really, I can't think of a single American city where there are five awesome bands coming out at the same time. When I think of a scene, I always think of the [1980s] Bay Area thrash scene where a lot of bands came from this one area all at once."

Even though the reemergence of black metal has generated a buzz, just as when any genre becomes more popular, an underground still lurks away from the Internet. Marston says, "I'm not sure I'm convinced of any more interest in extreme metal now than there has been in the past. It seems to me that that just happens every now and then [when] there's a band from a more extreme-metal background that ends up on a major label. That's fairly common."

Safe in the spoken-word world of friends and critics alike, Krallice has achieved a notable following around the world based solely on its two-album catalog. Krallice may very well, and unintentionally, bring the American style of black metal to a wider audience and continue the legacy that the jazz greats of yesteryear did before them without big money or big business and only with a big heart for what its members love to do: play music. Ⓐ

# LIARS

MICHAEL PATRICK BRADY /
PHOTOS BY DUSDIN CONDREN

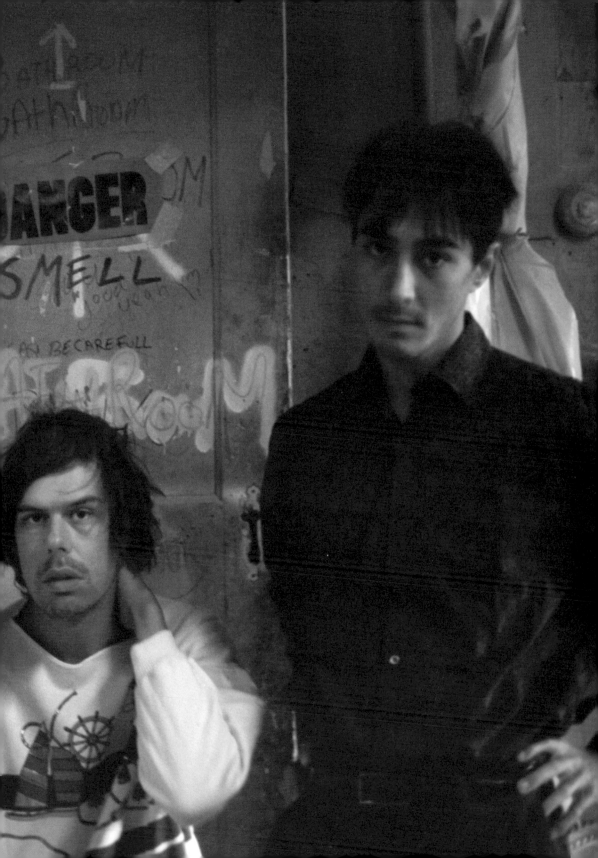

I N THE LAST DECADE, THERE HAVE BEEN FEW BANDS MORE SURPRISING OR COMPELLING THAN LIARS. RUTHLESSLY INNOVATIVE AND COMMITTED TO CONSTANT EVOLUTION, ITS DEFIANT ATTITUDE TOWARD THE EXPECTATIONS OF ITS AUDIENCE AND THE PREVAILING TRENDS IN INDEPENDENT ROCK HAS SET IT APART IN A BIG WAY. IN AN ERA WHEN UNDERGROUND MUSIC FLIRTS WITH THE MAINSTREAM AND BANDS ARE OFTEN THRUST INTO THE HARSH SPOTLIGHT TOO SOON, THEN DISCARDED BEFORE THEY CAN FULLY MATURE, LIARS HAS BLAZED ITS OWN TRAIL AND HASN'T WORRIED ABOUT WHETHER OR NOT PEOPLE WOULD FOLLOW. THOSE WHO DID WERE NOT DISAPPOINTED.

Liars' 2001 debut, *They Threw Us All In a Trench and Stuck a Monument on Top*, was an album that was noisy and abrasive but grounded in the dance-punk zeitgeist that dominated turn-of-the-century New York City. Listeners mistook the album for an introduction when, in reality, it was a farewell, a coda to a scene that had already exhausted itself. Bassist Pat Noecker and drummer Ron Albertson, the rhythm section that had an immense presence on those early recordings, soon departed the band, leaving Angus Andrew, Aaron Hemphill, and new member Julian Gross to discover a new sound. The band's sophomore effort, the confrontational, conceptually minded *They Were Wrong So We Drowned*, was a polarizing work.

Feeling hampered by the claustrophobic New York scene, Liars escaped to Berlin for a three-year stint and recorded its third release, *Drum's Not Dead*, a droning, atmospheric masterpiece that further established its reputation as creative visionaries. The follow-up, the self-titled *Liars*, demonstrated that the group's penchant for thematic concepts had not dulled its ability to write sharp, rousing rock songs.

Although that album received a warm reception, frontman Angus Andrew says, "We felt like we lost a sense of adventure." Without a unifying theme as it had on *Drowned* and *Drum's*, Liars lost some of the joy that it had in developing the earlier records. "We have to get together and agree on a certain mood, to make something that's more complete than just a bunch of random songs. Part of the fun of making a record is giving it this extra life."

The band's fifth and most recent album, *Sisterworld*, is a bold burst of intensity, with a loose concept inspired by the band's recent residency in Los Angeles and its encounters with the city's darker, unseen elements, ones that challenge postcard narratives of LA

as a place of opportunity and optimism. "When I first moved here," Andrew says with a wry laugh, "I decided that the best way to get in touch with LA would be to not drive a car." That's not an easy proposition in a city known for its pedestrian unfriendliness. Andrew was living in La Brea, home to the famous La Brea Tar Pits, one of what he calls LA's overlooked sections. "The city is so huge, and people spend their time in cars, going from A to B and never taking into account the places they're passing in between. This was one of those places—a constant barrage of crime and homeless people. The non-recognition of that by the people driving through can be really frustrating."

Despite its frustrations, relocating to Los Angeles had its benefits as well. "I really wanted to get isolated and shut off from a lot of things," Andrew says of his time in Germany, "and it was great for that. But in terms of getting things done, it was much more difficult getting a group of musicians together to play on the record. Coming to LA was like coming back to our parents' house. Julian and Aaron are both from here; there's a huge network of friends and family for us. The environment in Berlin, where it's cold and where we didn't speak the language, it was kind of freaky, in a good way, but it's amazing to realize what an uphill battle that was." This extra support enabled Liars to introduce sounds and ideas onto *Sisterworld* that it hadn't felt it could properly execute with its previously limited resources. The difference can be heard on the album's opening track, "Scissor," which features some delicate, mournful strings as an emotive counterpoint to Andrew's signature falsetto. It's but a prelude to the searing rush of noise that Hemphill and Gross are waiting to release in a torrent, mercilessly scouring any evidence of tenderness from the song.

The thematic core of *Sisterworld* is elusive, conveyed more in implication and feeling than in any overt

way. "What drove us to this idea was being here in a city like Los Angeles," Andrew says, "which gives off this image of Hollywood glamour or perfection when the genuine story of LA is people coming here to get into the movie business and 90 percent of them being rejected. LA is this large pool of rejection. But it maintains this glittering outward appearance."

Those who don't succeed in Hollywood often fade into the shadows, seeking out some obscure niche in which they can ensconce themselves. *Sisterworld* plumbs those depths, shedding light on an underworld of a superficial city and the people who inhabit it. "They find places," Andrew says. One of those places happened to be adjacent to his downtown dwelling. "There was this place next to me, an after-hours club where these underground characters would come late at night to party, and I found myself witness to these people who came to LA but didn't necessarily fit in. They found their own environments. *Sisterworld* is us creating our own space, where you can define on your own terms and feel as if you can be the one who determines the laws and the way things are run. It's somewhere you can escape to."

Andrew's encounters with the darker side of his new home were not all positive, however. When a business he lived over was robbed, he became a witness to a murder as the store's security guard was shot to death. It was a troubling event, one that engendered a strange mix of conflicted feelings in the singer. "I was there, basically, watching him die on the pavement while the police took off his clothes," Andrew recalls. "It was a weird scenario." The violence and severity of this event greatly affected him, by making real the harsh struggle of urban living that he had never truly experienced in his own life. "So often it's a glimpse on the news that someone died here, but to have it happen in your face is a real strong reminder of what's going on in all these places that are

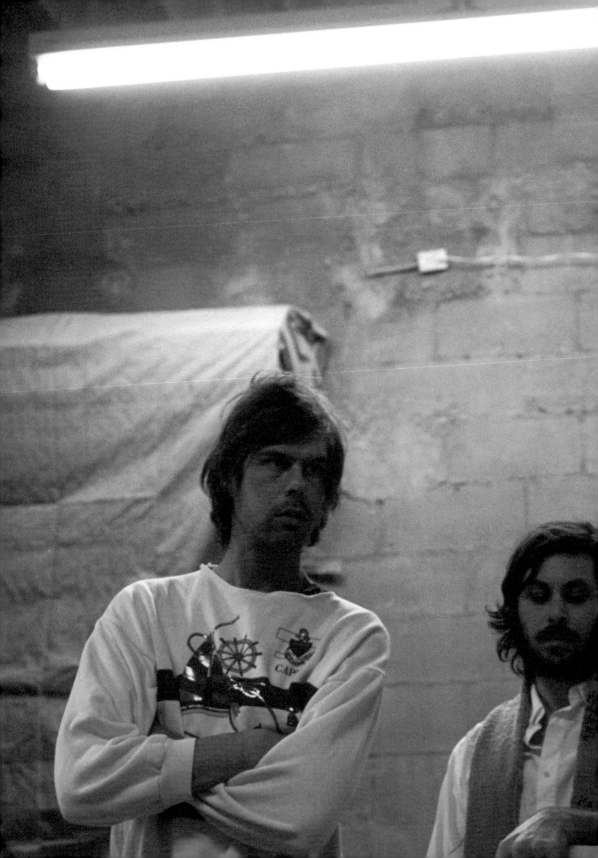

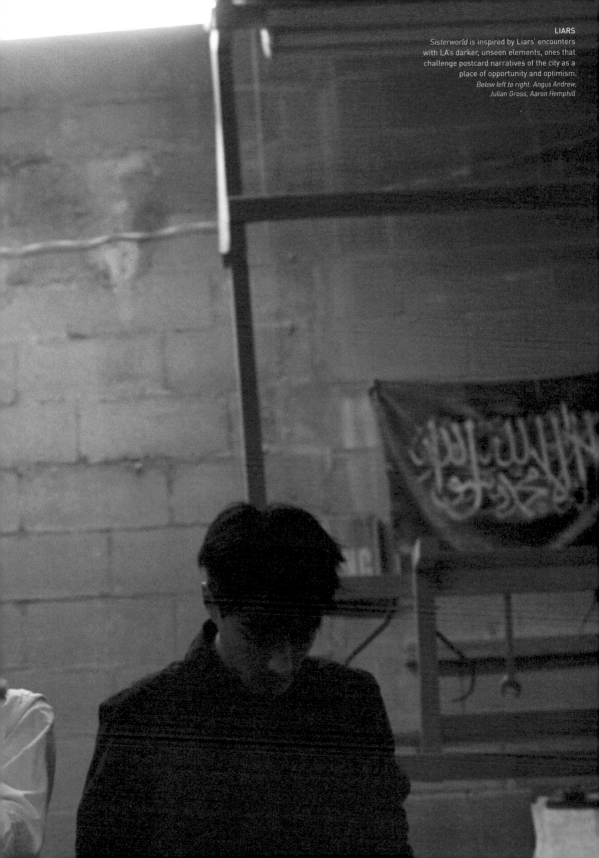

**LIARS**

*Sisterworld* is inspired by Liars' encounters
with LA's darker, unseen elements, ones that
challenge postcard narratives of the city as a
place of opportunity and optimism.
*Below left to right: Angus Andrew,
Julian Gross, Aaron Hemphill*

forgotten about." He confesses that amid the feelings of fear, uncertainty, and shock, he felt an unusual and troubling thrill. "I was shocked at myself," he says, "that I was so…giddy." The act of violence served as an inspiration for the most arresting and emotional track on *Sisterworld*, "Scarecrows on a Killer Slant," which storms with a cathartic wail. The raging guitar tears up sheets of sound that crash back and forth in righteous anger, culminating in a chorus that tips over into frenzied, vigilante madness.

The song is an adrenaline shot, and the true emotion and passion that drive the song give the track added gravity.

by a complement of strings and horns that help bring the song to a boil. "Using the horns and strings is something that I'm proud we were able to do. We felt comfortable saying, 'Okay, let's take on that extra layer of sound.' We've never been in that position before, where that kind of idea could come to fruition." The track proves that there still are boundaries for Liars to push, horizons for it to reach and to make its own.

After nearly a decade of Liars' existence, Andrew seems content with the band's place in the world and what it has accomplished. But after a moment of consideration, he laughs and says that if he had the chance, he'd advise his younger self to be more

---

## "SO OFTEN IT'S A GLIMPSE ON THE NEWS THAT SOMEONE DIED HERE, BUT TO HAVE IT HAPPEN IN YOUR FACE IS A REAL STRONG REMINDER OF WHAT'S GOING ON IN ALL THESE PLACES THAT ARE FORGOTTEN ABOUT."

---

The album isn't all weighty social commentary. The lighthearted, satirical track "The Overachievers" is a snarky look at the mellow lifestyle of young, bio-car-driving Angelenos as they settle down and commune with nature. It's also the first clearly narrative song in Liars' repertoire, a slice-of-life short story that abandons the band's abstract tendencies for an external perspective that Andrew compares to the work of Bret Easton Ellis. The chanted refrain of "Hey! Hey! Hey! Hey!" sounds vaudevillian—a big, broad, knowing grin to the crowd that'll clap for more.

Apart from those two up-tempo tracks, the album is largely sedate and meditative.

The penultimate track, "Goodnight Everything," is the one that most impressed Andrew. "That song is a good example of a song that was really large and seemed difficult to put together at first," he says, "but we were able to do it." It's a complicated, densely layered arrangement. Faint mechanical twitches flutter in the background before the band kicks in, augmented

mindful of money. "For a long time," he says, "we were just completely ignorant of how the business side of things worked. We refused any idea of cashing in on things, you know? But I think eventually you realize that if you want to keep doing this and get by, certain things have to give. It seemed like, at the start, we were intent on basically smashing everything that we could achieve. And that was fine and good, but it seems like if I look back on it now, maybe there were some opportunities that would've made life easier if we hadn't been so, dare I say, arrogant."

Despite the choices that Liars made in its past, they have led the band to this present, and for that, we can be thankful. It continues to be a potent and provocative band that defies and subverts expectations. It embraces the unexpected and seeks new methods of expression that keep listeners on their toes. Complacency is never an issue. Adventurousness is assured. Nowhere is that more apparent than in the turbulent rumble of *Sisterworld*. Ⓐ

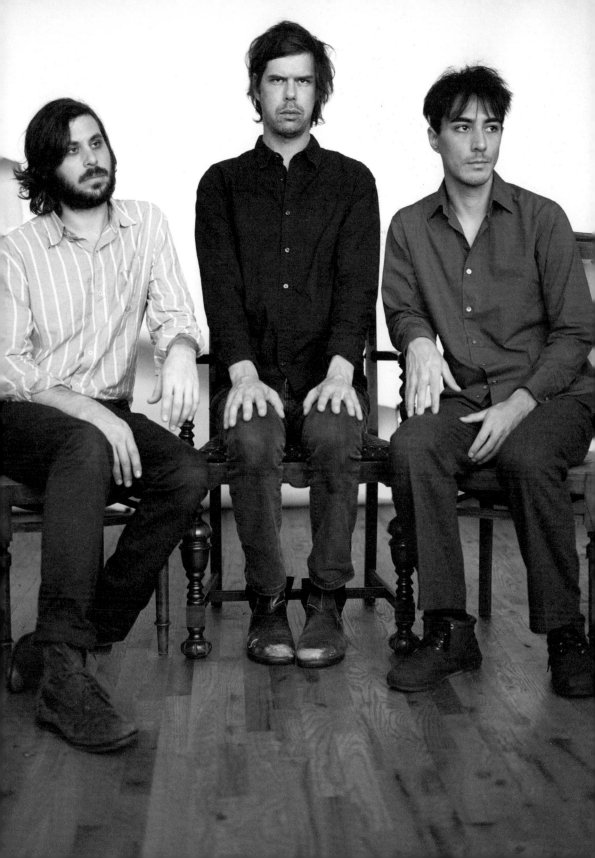

# JESSE MORRIS

BUCK AUSTIN / *PHOTOS BY CECILIA AUSTIN*

The east entrance of the 24th Street rapid-transit station in San Francisco is almost perpetually caked in pigeon shit. The grime-patina floor and supposed-to-be-shiny metal subway turnstiles are mottled with the splatterings, creating a slimy/crusty minefield for commuters to navigate. On that stained floor, care-fully wedged between the landmines, is a worn black guitar case with some loose change and a couple of bills staring up forlornly from a plush field of forest green. Commuters descending the escalator toward this entrance see the case first as they approach. Then they hear the voice. And if it is their first time hearing it, their eyes grow wide. Or they wrinkle their brow. They ask themselves, "Is that a recording? Is there some kind of commercial being shot here?" It just sounds too real—too much like *him*. As they descend the escalator further, they see the source of that voice, and things get even more confus-ing. Because that sound—how could it be coming from *that* person?

The only thing more striking than how much Jesse Morris sounds like Johnny Cash is how little he looks like him. He is a man in black, yes, but his black is a scruffy leather jacket and jeans with patches of bands like Flipper, The Last Resort, and Toxic Reasons. It's not exactly Grand Ole Opry attire. Peaking out from beneath the sleeves of said jacket is a tattooed coat of many colors that Cash would definitely have bypassed. And instead of that iconic slicked-back

pompadour, Morris rocks a stubbled dome and unruly mutton chops. But none of these things stop Morris' rich but weathered baritone from sounding hauntingly like that of Cash. It's the centerpiece of Morris' spare-change revue, which also includes tunes penned by the likes of Hank Williams (any and all of them), David Allan Coe, Merle Haggard, and Morris himself. To bring his talents of imitation and permutation to his peripatetic customers, Morris gets up at an hour when the outlaw-country crowd was usually just get-ting to bed. Once at the station, he sings and strums until he has made enough money or his voice goes out. That can mean anywhere from 40–50 ditties in the course of a morning.

Ten years ago it was unlikely that Morris would even have sat through a song by any of those country artists, much less learn to perform one. As a teenager living in the beachside hamlet of Pacifica, California, Morris says that he thought of "the music of pain" as "old country-bumpkin" junk. And then at age 15, in a move that would lay the concrete for his life path, Morris was simultaneously introduced to the music of both G.G. Allin and Johnny Cash. At the time, he was in an alternative high school for kids with mental disorders, having been diagnosed with major depressive disorder as a young person. From that first exposure, country and punk would form intertwining strands in a rope that Morris says saved his life. Cash especially left an impression. "I've always wanted

**JESSE MORRIS**
The only thing more striking than how much
Jesse Morris sounds like Johnny Cash is how
little he looks like him.

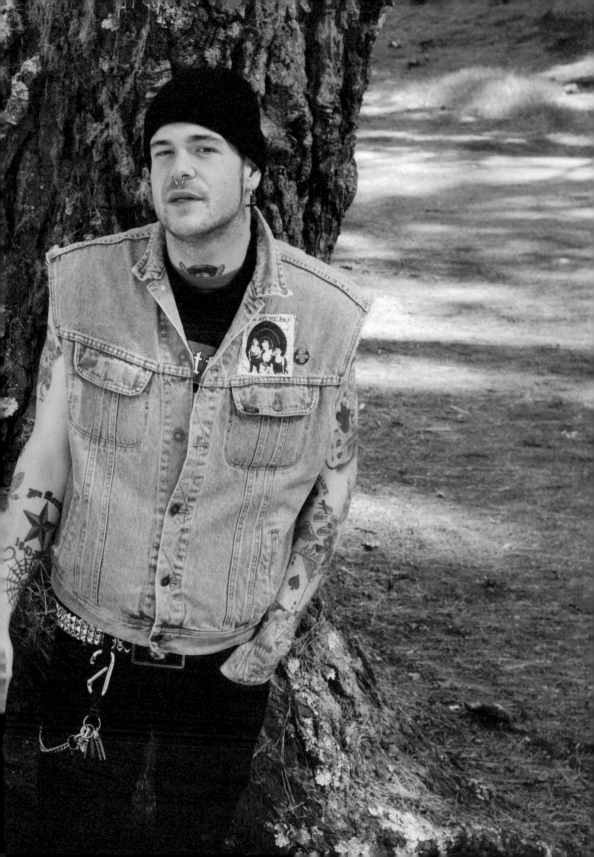

to belong but never did," he says. "It seems like he speaks to people like that." Morris soon began teaching himself Cash's songs.

A few years and several hundred practice hours later, Morris tried out the songs he had learned for the other kids in Job Corps, a vocational education program for young people located on Treasure Island in San Francisco Bay. The response was positive enough that Morris began to think about expanding his audience. With his only spending money coming from a $12/week stipend and whatever he could hustle up as a cigarette dealer to the other kids, he had a definite monetary motivation for taking his act under the road. According to Morris, the first time he played in the subway system—aged all of 18 years—was like walking into a supermarket naked. But he soon learned that being timid wasn't going to make him any money. "You've gotta give 'em your all or they're not gonna give you nuthin'," Morris says. "They don't wanna see some shoe-gazin' fuckhead up there." Morris connected with his initial audience enough to cover his coffee and cigarette expenses for the day. "The first time, I made 10 or 12 bucks, and I thought I was rich," Morris says with a grin. "'Wow! That's more than minimum wage!'"

The Bay Area Rapid Transit (BART) system doesn't require that buskers get permits to play in its stations. In fact, the only time that Morris has been hassled was when he was having a bad day and played a G.G. Allin song that even he admits probably wasn't appropriate for the venue. The laissez-faire attitude toward BART performers has allowed Morris to play over 1,000 "shows" in various subway stations in the city over the past seven years. At an average of two hours per show, that may mean Morris has had more time on stage, such as it is, than any other musician his age in the Bay Area. He has developed his craft to the point that not only is he able to support himself largely through his playing, but he also was recognized by San Francisco Weekly as "Best BART Musician" in 2008. As a part of a campaign to make commuting not seem like such a soul-destroying

experience, BART hailed Morris' talents in a feature story on its website, noting how he had gained a reputation as the "punk-rock Johnny Cash" of the subway system. "Mom was proud," Morris says, laughing. "Her son's the most famous panhandler in San Francisco!"

As strange as it may sound, banging out odes for sleepy train riders, most of them barely there, has brought stability to Morris' life. He still has to work nights as a bouncer, but at least he doesn't have to work at Denny's or Starbucks anymore. "I can't do a straight nine-to-five," Morris says. "I've tried that. I just want to blow my brains out when I do."

Music might be a moonlighting gig for some, but for Morris, it's a dawn gig, a daylight gig, a dusk gig, and every-other-kind-of-light gig. It is this way because it has to be. Beyond the economic security from his subway income, the almost constant access to an open venue has brought Morris an increased emotional clarity as well. "When I don't play music, I feel crazy as fuck," Morris says. "It's kind of a weird meditation. In a way, it shuts my head off." When you talk to Morris for any meaningful amount of time, you understand how "on" his head can be. Between pictures at a recent photo shoot, with a guitar in his hands, Morris segued rapidly between personas: an exuberant ska bandleader, a spacey new-age guru, a La Cage Aux Folles-style diva, a bitter old blues musician. It may come off as a nervous habit at first, but it quickly becomes clear that it is more integral than that. Morris, who describes his personality as that of "an Elvis impersonator with multiple-personality disorder," has a lot going on inside that close-shaven noggin.

Not too long ago, Morris decided that the medications he'd been on for bipolar characteristics since age 12 had outlasted their usefulness. His doctor told him that if he wanted to kick the anti-depressants, he needed to find another way to get his endorphin levels up. He recommended that Morris adopt an exercise regiment. At the time, Morris weighed 380

pounds, a result of self-medicating himself with "piz-za, burgers, donuts, dope, and beer." Now, a couple of years later, Morris is below 200 pounds, having dropped a couple of Iggy Pops through a regiment of gym workouts and riding around San Francisco on a '70s Huffy that he found abandoned in a park. "I've done enough self-destruction," Morris says of his new lifestyle.

Getting cleaner, along with canceling his cable TV, has made him a better songwriter, Morris says. But he admits that he wouldn't have as much material to draw from if it weren't for all those bad times. "If

country and one-quarter punk, but the music itself feels more seamless than that division, like a rambling hayride down St. Mark's Place. The band's live performances don't let up on the tractor throttle either, with Morris variously sneering and goofing his way through raw tales. Morris doesn't see it as out of place for his band to ham it up while performing a song about offering a cigarette to a recent suicide vic-tim. "We joke around constantly," he says. "It's really the only way to stay sane. Too much of life is serious, you know? I might annoy people by joking around all the time, but if they don't like it, fuck 'em. Fuck those serious bands. We're serious about our *music*."

## "THEY BETTER HAVE A HOCK SHOP IN HEAVEN, BECAUSE I OWE JOHNNY CASH A LOT OF MONEY."

you don't get kicked in the ass, you don't really go anywhere," Morris says. "That's why there's so much horrible pop music out there. They're not suffer-ing enough. They're not getting their emotional ass beaten by the dominatrix of life." But it's not enough to suffer, Morris says. You have to do something about it. When life hammers him, he strikes back on any paper that he can find. "Write your ass off," Mor-ris says. "Write every night. Even if the songs suck, write 'til they don't suck anymore."

Veteran San Francisco musicians Joe Dean, Thom Rockwell, and Barry Spry were impressed enough with Morris' songwriting and performing that they teamed up with him to form the band that today is known as Jesse Morris and the Man Cougars. After upwards of 30 gigs at bars and clubs in the Bay Area, they have released their raucous self-titled debut LP, which Morris says is "coming to a merch table near you." He describes the album as three-quarters

For as much "bat-shit loco" brashness as Morris might put out, he is, at his core, still a very apprecia-tive man, humbled by the journey on which his mu-sic has taken him. He describes playing with punk bands like Fang, Verbal Abuse, and the Dwarves as "an honor." His voice fills with gratitude at the mention of having his band's debut mixed and mastered at Mr. Toad's in San Francisco, where so many of the bands that he admires had their releases processed. And Morris never loses sight of the fellow musician who has helped him the most in his career. "Man, when I die, that dude's going to come collecting," Mor-ris says. "They better have a hock shop in heaven, because I owe Johnny Cash a lot of money." Ⓐ

# CORY ALLEN

SABY REYES-KULKARNI / *PHOTO BY MEREDITH MAPLES*

It's rare to think of tranquil music as "unlistenable," but Austin, Texas ambient musician Cory Allen's latest album, *Hearing Is Forgetting the Name of the Thing One Hears*, arguably challenges the listener's concentration *because* it is so easy to listen to. If you were to try mapping out this music, it would require intense concentration—way more, perhaps, than the hypnotic, brain-twisting work of minimalist icons like Steve Reich and Philip Glass—but it would most likely subdue you first!

"Probably," laughs Allen, who also is co-owner/curator of Austin-based independent label Quiet Design (along with founder and fellow ambient artist Mike Vernusky).

Most easily described as a sequence of softly rippling, algorithm-based tones that sound a lot like a computer rendition of wind chimes, *Hearing is Forgetting…* was in fact inspired by the wind chimes outside of Allen's bedroom window. Unsurprisingly, the album lends itself to quiet reflection and inner calm, but it differs in some fundamental ways from music that we might typically identify as "meditative." Whereas other ambient artists—and even Allen's previous work—tend toward inducing heightened awareness in the listener, *Hearing is Forgetting…* instills a distinct sense of *non*-awareness, non-being even, and was in a sense designed to evaporate when we turn our attention to it.

"If you can get your ears and mind somewhere between listening to this music and ignoring it," he offers, "it really will reveal itself." At least, he admits with a chuckle, he *hopes* so.

Heavily influenced by the writings of Zen philosopher Alan Watts, Allen often applies Zen and Taoist principles to his music and uses his music as a vehicle to explore a longstanding preoccupation with the nature of perception itself.

"The area between the objective and subjective universe is really what interests me," he explains. "What's happening outside of our skin, what's happening inside of our skin and in our minds, and then the dissonance and lost-in-translation kind of thing that happens in the act of perception—all of my work deals with that. All of it's about manipulating perception."

Nonetheless, *Hearing* represents a dramatic step forward from its predecessors and arguably marks the first time that Allen has succeeded in penetrating the realm of meta-perception with sound. For the most part, despite sharp distinctions between them, his other albums—*Gesemi Tropisms* (2005), *Observing a Warmth* (2006), *Satori in Atlantis* (2007), and *The Fourth Way* (2008)—all strike an impressive, almost paradoxical balance between sedate and gripping. But in all of these cases, the listener is able to

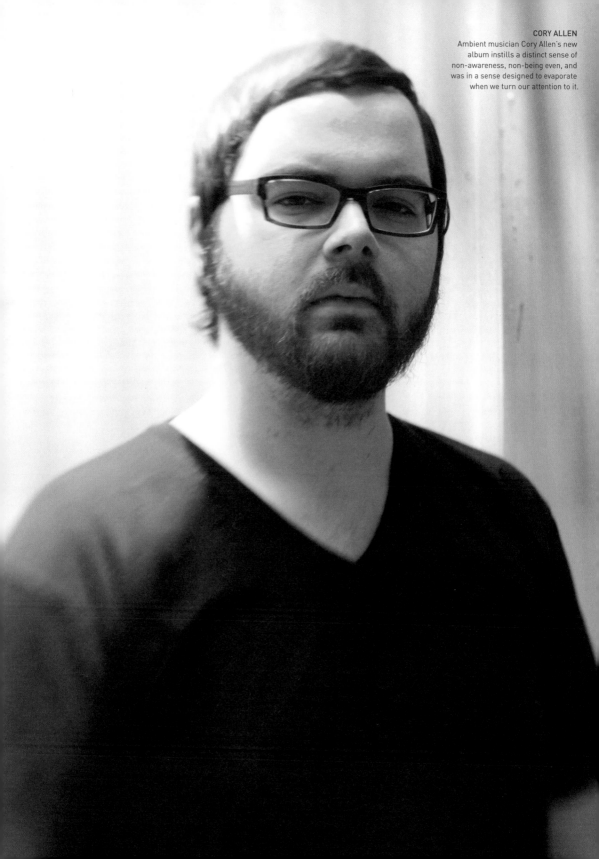

CORY ALLEN
Ambient musician Cory Allen's new
album instills a distinct sense of
non-awareness, non-being even, and
was in a sense designed to evaporate
when we turn our attention to it.

"follow" the music from beginning to end. You might get carried away, but you never fully lose yourself, or your sense that the music exists as something solid and tangible.

"All of my previous work had been pretty linear," Allen says, "in the sense that it definitely goes somewhere

three-dimensional effect where you can't tell where the piece ends and the room begins. They're actually hard to identify. Irwin was so interested in the way that light and color affected each other, and affected everything around them, that he would go into the installation space and paint away shadows and paint all the walls and ceiling and floor an identical

---

# "IF YOU CAN GET YOUR EARS AND MIND SOMEWHERE BETWEEN LISTENING TO THIS MUSIC AND IGNORING IT, IT REALLY WILL REVEAL ITSELF."

---

from beginning to end. There are trajectories and different compositional gestures and sections that take you different places. I wanted to get away from that."

Enter the work of installation artist and light sculptor Robert Irwin, whose use of shadow and light to remove the boundary between sculpture and the space surrounding it inspired the conceptual framework for the music on *Hearing*. (The album title is a take-off on author Lawrence Weschler's 1982 biography on Irwin, *Seeing Is Forgetting the Name of the Thing One Sees*.) When Allen happened upon one of Irwin's "light disc" pieces at the Hirshhorn Museum in Washington, DC, he saw an opportunity to take his music a step further by translating some of Irwin's ideas into sound.

"The discs are about three or four feet in diameter," Allen explains. "Looking at one of them, it casts this

color. So that way, there was no possible intrusion on the work."
Irwin eventually took this approach to its logical conclusion, which appealed to Allen.

"At a certain point," Allen says, "he abandoned the notion of there being an actual focus on a piece. He stopped working on canvas because it dictated such a harsh edge for where a piece stops. So I started thinking, 'Okay, I need to make something that has no boundaries.' I thought, 'It doesn't need to be defined; it doesn't need to have an edge.'"

Newly inspired, Allen still had to figure how this all was going to work.

"What's funny," he recalls, "is that I thought about this for months, but right outside my bedroom, my neighbor has a wind chime. It's just so beautiful, par-

ticularly if there's rain or something like that going on at the same time. A wind chime is infinite; it's a set pattern of notes, but somehow, it's always different. It's got an essence, more than a composition does, that's just happening. And it's delightful to listen to."

Not to mention, it's easy to listen to. Part of the reason that Allen didn't initially look to the wind chime was that he often listened to it passively, barely noticing that it was there—much, he says, like being in a state somewhere between listening and ignoring.

"I thought, 'Man, there it is!'" he says. "I wanted to remove the template of sound and creation and space and time, remove all of that from the music and just have this pure sensation. As soon as that clicked, I started doing the work immediately."

Like all of Allen's albums, *Hearing* is, sonically speaking, quite distinct from the rest.

"Everything on there," he explains, "is made from complex sine tones that I created with my computer that all have overtones drawn out in a very specific way. Whenever they interact with each other, the overtones of each frequency collide and create these meta-frequencies."

Hence the harmonic "rippling" effect that mimics a wind chime.

"It was important," Allen says, "for me to make something that was musical but was also static, just kind of suspended there."

If that sounds like a conceptual conceit, the way the tones hang in space—"just kind of suspended there"—actually mirrors Allen's way of life.

"As I grow older," he says, "I want to dissolve myself as much as possible. I do my best to keep myself in a state of non-existence. I've removed my self from the situation, where living becomes 'such-ness.' By removing the identity and removing any attempt to impact, your brain doesn't get in its own way. And whenever you stop trying, things just grow out of you."

Certainly, full-length albums seem to "just grow out of" Allen, at a rate of one per year. In listening to any one of them, one gets a clear sense that the music *resolves*, that it reaches a kind of natural conclusion. But Allen compares his work to the way a school of fish moves. As far as he is concerned, there is nothing driving those movements other than movement for its own sake. There's no way to gauge, then, what Allen might put out next.

Just this year, he took an unexpected detour when he released *Dimensions of Tomorrow*, an album of sample-based hip-hop instrumentals under the name Datalove. Datalove manifests a beat-bumping (if still somewhat esoteric) side of Allen that has yet to emerge in the music he puts out under his own name. As a musical alter-ego, Datalove provides not only a refreshing, 180-degree change of pace but also some possible clues as to what Allen might accomplish when his muse inevitably swings back in the direction of formlessness. Even then, though, *Hearing is Forgetting…* will likely still stand as the challenging, rewardingly impenetrable work that it is. Ⓐ

# RICHARD COLMAN

KATIE FANUKO

When looking at the paintings and illustrations of California-based artist Richard Colman, it's clear that his electric-hued, intricately detailed images are influenced by everything from Byzantine-era iconography to geometric abstractions. Less obvious, however, is that the Washington, DC native started out as a graffiti artist. "Graffiti had nothing to do with what I would be doing when I was older," Colman says. "That stuff was just very in the moment." Yet even though his current aesthetic hardly shows a trace of his graffiti past, those early experiences have stayed with him throughout his career and have informed his identity in the fine-art realm.

As a teenager growing up in the suburbs of DC, he was cognizant of the city's role as the nation's political pulse but also of its less publicized underbelly. Colman was completely drawn to the capital's grittier side, so when his peers introduced him to graffiti art when he was 13 years old, it wasn't long before Colman would start sneaking into the city with a couple of spray cans in tow. "I grew up doing graffiti and that sort of stuff," he says, "so naturally, you're sort of drawn to the seedier sides of the city, and you're kind of lurking around in the middle of the night. It was really just a fun way to cause trouble when you're a kid."

By the time Colman was ready to attend Boston's School of the Museum of Fine Arts in 1998, he was ready to leave tagging back in DC. Aside from a side gig creating murals for Coca Cola while he was in college, Colman essentially had put his graffiti work on the backburner in his early 20s. "Even now, I'll do it occasionally if I meet up with friends, but I pretty much left it behind when I went to art school," he says. "I saw it as two different things, because I had been doing [graffiti] for so long. The influence was there, but I think that I spent a lot of time to find other ways. I wasn't there to keep doing what I was doing before."

Being in a new city, Colman wanted to embrace the new techniques that he was learning in school and keep an open mind to how other art genres could influence his work. He became fascinated by the detailed portraiture that was prevalent in Renaissance paintings as well as the simple, two-dimensional quality of Byzantine-era work. Colman took this experience as an opportunity to start learning about as many artistic mediums as possible. "While I was in school and even before that," he says, "I've always found that kind of stuff very interesting, just through very simple gesture and the direction in which someone is looking and all of those subtle details."

During this time, Colman also found inspiration among his fellow students. "It's pretty rare when you can be in an atmosphere where everyone is making things and you could see what fellow classmates and

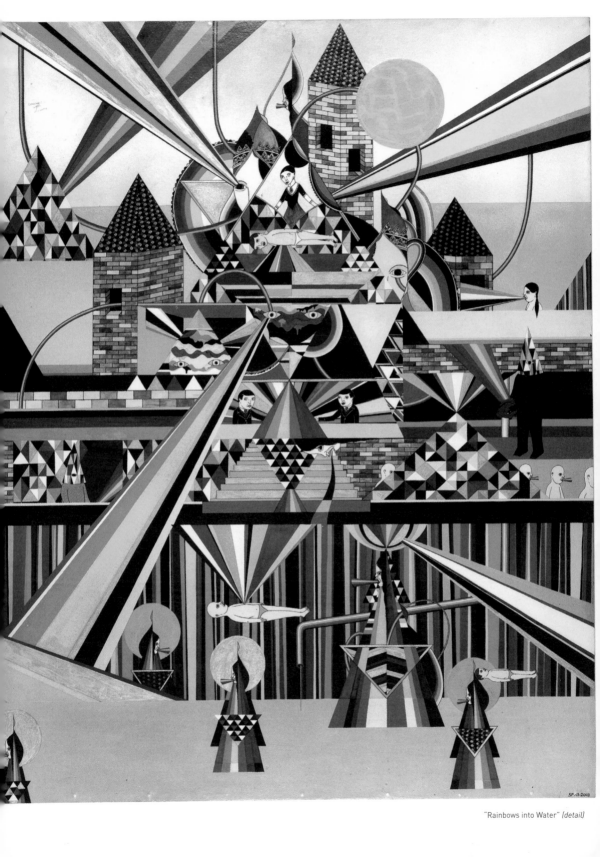

"Rainbows into Water" *(detail)*

"Untitled (Pipe)," 2008, graphite, gouache, acrylic, and ink on paper on wood

"Filtration," 2009, gouache and ink on paper and wood

friends were doing," he says. "I would find that excit- ing, happening right in front of you. I was introduced into way more things that way than from the classes, because when they present it to you, it is very im- personal. When people are making things…you can actually be involved in that."

Although Colman's previous graffiti work may not have had a direct influence on the direction that his art was taking, he still kept ties with the friends that he made within the graffiti scene. It was this group that really taught Colman how to start considering the professional side of the art industry by prompting him to create pieces for their art shows. It was through this experience that he learned how to market and promote his work. His graffiti past also taught him to remain in the moment when creating work but also

to consistently brainstorm new ideas well in advance. "I still see [my art] as kind of impermanent," he says. "With graffiti art, you do the next spot or whatever it is that you want to do, but you're thinking of the next one because you don't know how long that will run. It becomes about the next thing, and that really kind of stuck with me. Even when I'm working now, I'll be doing a painting and be thinking five paintings ahead. It's really about getting the busy work done so that I can get on to the next thing."

In 2002, Colman moved to New York and worked odd jobs while pursuing his burgeoning art career. This relocation caused him to completely reconsider the direction of his work. While in school, Colman could create his pieces in a roomy studio on campus, but space constraints in his new Lower East Side

apartment caused him to downsize the images in his paintings considerably. "There was no real room to work," he says. "There was this little kitchen, which was more like a hallway, which was probably the only big wall in the apartment. So I would set up these paneled pieces for ink drawing, and they were probably about eight feet long and two feet high.

hagen, White Walls Gallery in San Francisco, and New Image Art Gallery in Los Angeles. Colman started noticing that galleries on the West Coast were gravitating towards his style, so in 2005, he decided that it would be in his best interest to relocate to Los Angeles. "At that point, most of the galleries that I was showing at were located, if not in Los Angeles,

"I STILL SEE [MY ART] AS KIND OF IMPERMANENT. WITH GRAFFITI ART...YOU'RE THINKING OF THE NEXT ONE BECAUSE YOU DON'T KNOW HOW LONG THAT WILL RUN. EVEN WHEN I'M WORKING NOW, I'LL BE DOING A PAINTING AND BE THINKING FIVE PAINTINGS AHEAD."

When I was working on them, I really couldn't back up to see how the piece was progressing, so I was always really close. So that's how the really little stuff started because I was only looking at this stuff from only a foot or two away."

The constrictions actually became beneficial to Colman, because in turn, he began taking a more detailed approach to his portraiture and started integrating a sense of plot throughout his images. These narrative elements, which can be found in his current work, started out as little ways of incorporating embellished versions of his own experiences into his paintings but have since taken on a life of their own. "A lot of the work that I'm working on, it's rooted in that narrative thing because that's where I started, and I still feel really close to it," he says. "But the work now is finding different ways of abstracting that narrative."

Since 2002, his work has struck a chord with numerous galleries, including V1 Gallery in Copen-

then on the West Coast," he says. "Why spend all of that money on shipping work over when I could just drive or walk it over?"

Creating a new life in California proved to be quite an adjustment for Colman, who had spent his entire life on the East Coast. "Los Angeles is just very different," he says. "The pace of the lifestyle was and still is very different to me—like I don't think that I could ever get comfortable there. You don't have that thing where you just run into people. I'm more prone to being a hermit and working."

Colman's move to the West Coast (he currently lives in San Francisco) has since inspired him to add abstract elements, geometric designs, and high-voltage colors to his repertoire. It also motivated him to continue redefining his personal aesthetic. "Any time that you make any sort of change," he says, "it changes your work, and it changes your perspective." Ⓐ

# OVERLOOKED ALBUMS

BEN SOLLEE & DANIEL MARTIN MOORE

BORIS

CLERIC

DANGERS

DAUGHTERS

TIM FITE

THE MAGNETIC FIELDS

MELT-BANANA

MR. GNOME

RAISE THE RED LANTERN

WHITE HILLS

WHITE MICE

RUDI ZYGADLO

# BEN SOLLEE AND DANIEL MARTIN MOORE
*Dear Companion*

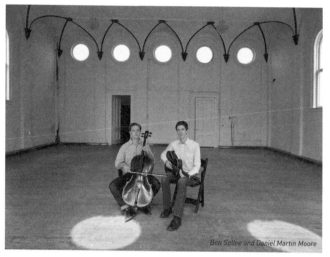

Ben Sollee and Daniel Martin Moore

When Sup Pop Records began in the late '80s, it started far from the mainstream. The Seattle-based label catered largely to grunge/alt-rock and was driven by young, loud, raucous bands like **Nirvana**, **Soundgarden**, and **Mudhoney**, propelled by their throat-shredding vocals, screeching and distorted guitars, and thrashing, ear-popping drums. The label seemed intent on breaking through by making ears bleed, blowing speakers, and annoying parents. And it succeeded.

But now, more than 20 years later, Sub Pop has aged considerably and has grown from its original angst-ridden revolution of youth and music. But it has aged well. With more and more singer/songwriter-oriented bands like **Fleet Foxes**, **Iron & Wine**, and **Tiny Vipers** coming to fruition in recent years, Sub Pop (in addition to its still readily available boisterous indie) has become a music hub for sensible and sophisticated indie folk. And for this reason, *Dear Companion*, the debut album from **Ben Sollee and Daniel Martin Moore**, feels right at home.

From the onset, *Dear Companion* evokes front-porch, lazy-day jamborees mixed with rustic mountain-folk music. Equipped with mellow and pleasant melodies, masterful acoustic guitars, lamenting cellos, and brush-stroked percussion, the album explores new terrains while using traditional instruments and styles. Though the songs aren't as ghostly as Fleet Foxes or as romanticized as Iron & Wine, Sollee (a classically trained cellist) and Moore (discovered after Sub Pop

came across an unsolicited demo of a few simple songs) craft delicate, soft-spoken, sincere compositions. Many bands today are busy exploring indie folk—and blurring the two genres together—but Sollee's stylish cello playing and Moore's rest-assured, euphonic vocals and guitar work go a step further, exploring what an indie-bluegrass record might sound like. And the result—recorded in just 11 days—is no doubt a favorable one.

Many of the songs are soft, soul-searching musings and reflections, but *Dear Companion* isn't content to sit back and let you fall asleep. The album opener, "Something, Somewhere, Sometime," and the title track are head-bobbing, foot-tapping hoedowns that allow the band to show its fangs. These moments supplement the calmer, more subdued tracks like "My Wealth Comes to Me" and "Needn't Say a Thing." With the saw-tooth highs and lows of the album, Moore and Sollee pull off a number of musical styles, marrying numerous aspects of bluegrass, folk, and indie.

But though the duo excels at superb, heartfelt songwriting, Sollee and

Moore are sure to not take themselves too seriously. "Only a Song" doesn't make itself into anything more than what it is—a laidback acoustic tune to wake up to on a Sunday afternoon. However, from the underplayed yet intricate finger picking on "Flyrock Blues" to the weeping cellos of "Sweet Marie," Sollee and Moore take the homegrown roots of different genres and make them into something more, breaking down barriers while appearing on the same label as **No Age**, **Pissed Jeans**, and **Wolf Eyes**. A lot of bands that successfully blend genres rely on various tricks up their sleeves, but there are no bells or whistles here. *Dear Companion*'s intrinsic value and success comes from its stripped-down, minimalist approach, backed by good, solid songwriting—no more, no less. [MD]

**Ben Sollee**: www.bensollee.com
**Daniel Martin Moore**:
www.danielmartinmoore.com
**Sub Pop**: www.subpop.com

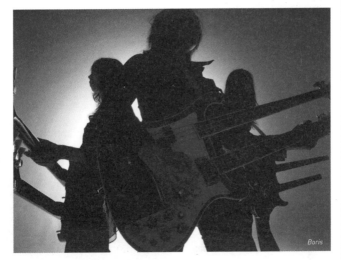

Boris

# BORIS
*Japanese Heavy Rock Hits,*
*V. 1–3*

A discussion of Japan's **Boris** inevitably leads to a rambling discourse on the origins of rock 'n' roll, the questionable merits of genre classification, and the supreme display of artistic expression. But at the end of the day, when you drop the needle on wax, press play on iTunes, or turn your bar stool toward the stage, the only thing that matters is whether the band kicks ass.

And after nearly 18 years, 20 albums, and a smattering of collaborations and EPs, Boris still kicks ass.

The reason for this is deceptively simple: the Tokyo trio will try anything and everything to flesh out a song. Maybe this number should have droning amplifier feedback; maybe this one should be a super-long ballad; maybe this one should be pop hook after pop hook over a punk riff. It's all fair game. Or, as put by drummer and backup vocalist Atsuo Mizuno, it's an "important mission for us to consider, 'What is a song and [what is] song writing?' or 'What is Boris?'"

Esoteric questions such as these aren't usually pondered while on tour, although wandering around a foreign country could certainly bring such ideas to a rolling boil. As it often does, musical inspiration strikes unexpectedly and Atsuo, guitarist and vocalist Wata, and bassist and lead vocalist Takeshi had to set some ideas on the back burner while traversing the USA two years ago.

"[For] most of year 2008, we toured a lot [and] thus got frustrated [that] we

didn't have enough time," Atsuo says. "Even we had some ideas that we wanted to try quickly." This "musicus interruptus" led to fragmented ideas that veered in multiple directions. "Upon return, we kept writing songs but realized that those songs seemed not to fit in the particular album format," Atuso says. "Originally, we thought we made the album that [would never be] released, and recorded a bunch of songs in wilder variations. No one needed to figure out how to fit those songs together, in a specific direction or an album, so we felt free when we worked on them and could write very interesting and exciting [songs]."

What do you do, after all, with a punk burner, a post-punk swagger, a cock-rock anthem, an electro-indie musing, a somber ballad, and a noise-rock monstrosity? The answer for Boris is decidedly old school: release a series of seven-inch singles. And so *Japanese Heavy Rock Hits* V. 1, 2, and 3 came into being.

Can you play them back to back? Sure, but it's not nearly as rewarding as the eclectic Frankenstein of the band's 2008 full-length, *Smile*. These songs

are complete in and of themselves, best appreciated as individual entities. In an age that puts more value on songs as ringtones than as compositions, this is a bold statement of which the members of Boris are well aware.

"[It] seems like releasing vinyl records is going to be the last piece of artist's pride these days," Atsuo says. "In my opinion, Apple has been a great partner for artists for years, but I feel [that] they're [becoming something like the enemy]. They should make a Macintosh with a record player now."

But people will continue to leak and share music on their computers and listen to shit-quality MP3s through shitty speakers. And they won't hear the most recent set of Boris songs. And it'll be their loss. [NMD]

**Boris**: homepage1.nifty.com/boris/top.html
**Southern Lord**: www.southernlord.com

# CLERIC
*Regressions*

There are some things that you should know about **Cleric**. The extreme-metal foursome is more than the summation of any cross-pollinated, genre-straddling string of words (death metal, speed metal, doom, grind-core, noise, thrash, math rock, drone, ambient, etc.) The band has been together since 2003, although its output has been limited to two self-produced EPs and a two-song 12-inch picture disk that is as renowned for its scarcity, ferocity, and ambient experimentation as for its intricate artwork. It's not that Cleric is short on ideas—far from it. Rather, with laboratory precision, the band has arranged everything that it knows into its first proper long player, *Regressions*, a near-impenetrable 76-minute monolith of madness put out by Mimicry.

In the panorama of experiences foisted upon the listener by Cleric, heavy metal rightfully is the lynchpin. *Regressions* was produced by Colin Marston (**Dysrhythmia**, **Krallice**) and recorded over the course of 400 studio hours. As lead singer Nick Shellenberger says, the album was recorded "with as close to a live energy as we could possibly replicate...brutally grounded and with the capacity to let the listener journey through an enormous range of sounds, textures, and moods, and therefore trigger a similarly massive range of emotions." In other words, get ready to flinch. Vocals are multi-tracked to sound like an army, and sharp, fractured riffing leads the patterned noise workouts, each one peaking, holding, and crashing as the whole mess is bloodied by blast beats and dragged across the finish line.

Each track is mercurial, seeming to fight itself from within. Opener "Allotriophagy" clocks in at more than 20 minutes, and each passing set of moments seems packed with an albumful of ideas. If you don't connect with any given moment, give it a second; Cleric never spends too much time meditating on any one idea. Not digging the whispered madness, skuzzy electronics, cascading drums, and swollen atmospherics? Not to worry, because in a minute you'll be lost in a

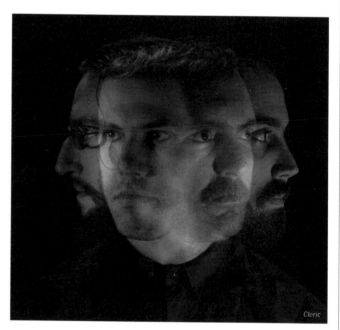

Cleric

volley of guitar-riffed machine-gun fire and words-per-second demon-howled vocals. Cleric will lull you in with a slow chord strum, break into speed-metal thrash, and then pull back all together as electronic detritus blows across the landscape. These are teacup-size maelstroms in the midst of a kettle set to boil.

But these electronics are far more than just peripheral ornaments on the

band's black-metal collage, as Cleric is equally as renowned for its ambient, psychedelic, electronic pieces. Bands such as **The Dillinger Escape Plan** and **Genghis Tron** may draw the first comparisons due to this stylistic convergence, although Cleric collectively agrees that these experimental pieces are inspired by the fact that "we listen to a lot of **Radiohead**." On *Regressions*, these interludes serve as brief reprieves from the frenetic pace of the rest of the album. They range from

found sounds lighting up a bottom-heavy chord to industrial drone that intensifies in waves and grin-inducing heavy-metal chicanery (layering sinister breathing against the backdrop of an otherwise bucolic setting). As standalones, these work just fine, but they're even stronger as finishers. And they do so righteously as ambient electronics wash over the final minutes of "Fiberglass Cheesecake," a piece that reveals itself as a classic piano

## DANGERS
*Messy, Isn't It?*

number. Shellenberger describes this as a proper, cinematic close for the listener: "It's easiest to picture this as the climax of a film that falls into a soft yet very powerful mood for the end credits. It was very much inspired by that type of experience."

The profuse level of detail inherent in Cleric's music can also be found in the intricate artwork that accompanies the album. A friend of the band, Maria Juranic, came in for photographs after Cleric had made all the scraps for the cover shot, built the door (depicted above), compiled the collage, and created the set that is seen on the last page of the insert. This setup is central to an elaborate narrative that runs through the album, including lyrical and pictorial metaphors. Shellenberger explains, "The intention with the art is to attempt to show certain elements of the story that aren't told overtly in the lyrics, and to add dimension to the album as a whole instead of just illustrating the music." Suffice it say that the storyline in **Mastodon**'s *Crack the Skye* has nothing on *Regressions*.

Whether Cleric continues to blend wholesale metal, ambient experimentation, and visual arts or perhaps set each of these spinning on its own, Cleric's will be a story worth watching unfold. [JE]

**Cleric**: www.iamcleric.com
**Mimicry**: www.webofmimicry.com

"I don't know that any fans of music will enjoy our record," says **Dangers** vocalist Al Brown. "It's rather hard to pick out the 'music' from the

assessment that his band's latest album has quite the lyrical bite to it. The veteran vocalist has plenty to say amid the chaos and, yes, noise of the Southern California punk outfit's second full-length release. The album's lyrics are intensely personal, dealing with subjects ranging from addiction and disease to love and broken relationships.

Nonetheless, "personal" shouldn't be confused with "petty." *Messy, Isn't It?*

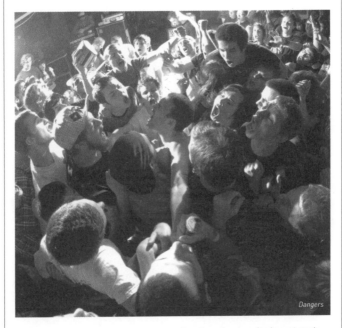

*Dangers*

'noise.' The standard answer here would be that fans of punk or hardcore or loud music would like our record, but I'd bet that a lot of those human beings end up hating our record. I'd like it if fans of honesty liked our record. That'd make me happy."

Although *Messy, Isn't It?* doesn't stray far from the standard musical framework of modern hardcore and thrash punk, Brown is correct in his

is not another exercise in post-punk screamo ranting. Personal this album may be, but the Dangers crew was clever enough to intertwine its songs with hard-hitting themes that tend to be both universal and, at times, political. There is genuine old-school punk attitude at play here, starting with the building rage of "Stay-At-Home Mom" and perhaps best embodied by the full-on swagger of "Opposable." Tracks like these employ a pummeling

CHAPTER 06



assault to drive the socially conscientious lyrics home, burning and igniting everything along the way.

"It's more a record that your ears agree to disagree with," Brown says, "like maybe your ears are in a fight with your brain, and on any given day, one or the other might win out. In this instance, our sympathy lies with the brains. Ears are for dullards."

Regardless of whether brains or ears have won by the time a cloud of guitar feedback closes out the album, Brown's comments shouldn't be taken as an indication that those with an ear for accessible musicianship will be disappointed. On the contrary, even the most chaotic tracks are delivered with genuine focus and clear expertise.

However, the album also features the strongest musicianship of any Dangers release to date, most likely due to the addition of guitarist Justin Smith. Smith, who also happens to be the main man behind Vitriol Records, lends quite a bit of six-string flash to the record without sacrificing even a stitch of the punk rawness that makes Dangers such an effective band in the first place. This is helped by the fact that the band decided to record in a lower register this time around, resulting in a consistently heavier, dirtier vibe.

"It was much more of an 'album' rather than a 'collection of songs' idea," Brown says, "and maybe that's why it's so long and exhausting for a punk record, but it's more honest and considered and meaningful for all of us."

The end result is a modern-sounding album that engages the brain while offering plenty of timeless punk appeal. [MS]

**Dangers**: www.wearedangers.com
**Vitriol**: www.graforlock.com/vitriol
**Penguin Suit**: www.actsofsedition.com/psr

# DAUGHTERS
*Daughters*

Elitists beware: **Daughters** has released its sell-out album. This self-titled release, the band's third "LP" since 2003, features ear-friendly grooves and a healthy serving of rock-and-roll spirit. The band still is loud and crazy, but now it is quite a bit more fun too (with songs that run longer than two minutes). If selling out means that mathcore purists will be forced to share this convulsive Rhode Island outfit with the rest of us, then so be it. Daughters rocks.

"I grew tired and bored of playing spastic, disjointed guitar parts everyday," says guitarist and principal songwriter Nicholas Sadler. "It got old. I just craved some plain-old rock-out parts and a basic rhythm section."

Not that anyone will be catching this refined version of Daughters anytime soon—or ever. The unofficial word from Sadler is that the band is done. That's too bad, because *Daughters* is a monster of an album that could have catapulted the band into the "big time." Only time will tell if the remaining band members will find a way to resolve their differences, but in the meantime, their audience has been left with a loud-ass slab of whirring guitar trickery that takes no prisoners. In this sense, Daughters never changed at all. Sadler admits that the new LP is "still a noisy, abrasive, discordant, frantic, and mostly ugly piece of music."

It is, however, infused with brawny, approachable grooves that are fueled by the album's killer production. But picking up the wrong pair of head-phones results in *Daughters* being plagued by some truly nasty clipping issues. The production pushes the album's low end to the absolute limit, emulating the sensation of standing about six inches away from a seven-foot stack of amps blasting at maximum volume. With the proper sound system, this approach is very effective, generating plenty of mandatory head banging in a properly equipped car or home-entertainment system.

"I wanted certain parts to retain the feeling of CD skipping and others to get to the point of nonsense where parts would basically melt or become incomprehensible," Sadler says. "I felt like the record should rock hard and really just rip. I wanted it to come off frenzied and contradictory."

The good news is that each and every band member is willing to match the commitment that they require of the listener. *Daughters* is genuinely fucking tight. If the band had any sense that this would be its farewell album, it's clear that it wanted to go out on a high note. Whether blasting through calculated precision on the "The Virgin" or offering a more-traditional metal sensibility on "The Hit," these guys present the same focus and energy in the studio that their fans saw in live outings.

Special recognition should go to vocalist Alexis Marshall, who rides on the energy of the instrumentation and gives the listener something solid to grasp onto. Oh, yeah—and he brings the fun. Much of this album's newfound accessibility comes from the way Marshall creates a real party atmosphere over top of the raw pandemonium offered up by Sadler and crew. Marshall seamlessly transitions from **Electric Six**-esque club choruses to seemingly **Jim Morrison**-inspired verses without ever losing the listener along the way. In short, his charisma drives the album's rock-'n'-roll confidence.

Tim Fite

Daughters

# TIM FITE
*Under the Table Tennis*

The toughest thing to swallow about the recent financial crisis was the fact that no one quite knew what to do. The same investment firms that put us into this mess by investing in high-risk mortgages and derivatives were the ones getting hundreds of billions of dollars in government help. When people started losing their jobs and defaulting on their mortgage loans, banks were bailed out while Americans lost their homes. In the increasingly interconnected worlds of finance and politics, people weren't considered too big to fail. We learned quickly that one can't afford a financial crisis in the middle of two wars and a bursting housing bubble.

Multi-instrumentalist rapper/singer **Tim Fite**, who has been making unclassifiable collage-rock records for the past six years, hasn't been immune to budget cuts and layoffs. "My personal financial downturn just happened to coincide with the world's downturn," he says. "I felt it not only on a personal level but within the collective conscious. It was unavoidable to make [these] songs."

*Under the Table Tennis*, Fite's latest free digital album, is his first to deal directly with the recession, defaulted mortgage loans, inadequate healthcare, and bailouts. The album begins with thumping beats that could be found at both a barn dance and a **Depeche Mode** concert. "This one's for closure" Tim Fite repeats over a distorted guitar squall, venting the frustration of nearly a million people that lost their homes to shady adjustable rates and a weak market.

If this is the last Daughters album, then at least the band can say that it went out kicking and screaming. It's an album that practically dares you to slam a fifth of your favorite poison, strap on a pair of boxing gloves, and challenge your nearest friend to a two-man mosh pit. That's the nature of this beast: even if you take a beating, you'll enjoy it. It's just that fun. Just make sure you don't play this one through your laptop speakers. If you're going to half-ass something, choose your relationship or your job, but not this. Only approach this album when you're ready to go all the way. [MS]

**Daughters**: www.myspace.com/daughters1
**Hydra Head**: www.hydrahead.com

Realism

*Under the Table Tennis* succeeds in its ability to make the listener understand the emotional landscape of an American recession far better than any news report or *Time* article can. He doesn't give us mind-numbingly high numbers and an alphabet soup of acronyms; he gives us stories that are at once deeply personal and universally relevant. "Not Covred" lays out the dilemmas of an uninsured single mother being forced to choose between food and medical bills over a suddenly devilish nursery-rhyme bounce. "It's tough gettin' hurt when you can't afford it," Fite says. It's not so much a political statement as it is a rallying cry against insurance companies treating human life like a business. The audio clip that crackles its way into the song doesn't seem contrived like old movie quotes in house-music breaks; it feels like it's taking part in the conversation, similar to the brilliantly conversational **Avalanches** album *Since I Left You.*

The beats will be familiar for Tim Fite fans, drawn equally from forgotten records and the darkest caverns of his mind. But as Fite says, "It's less 'whoop-dee-dee' and more 'what the fuck?'" "Someone Threw the Baby Out" is a lurching desert ballad that sounds like the last-call ramblings of a withered and weathered alcoholic spewing his complaints into the wind. He sounds defeated, as beaten down as someone who has lost his or her job and has no options left but unemployment checks and cheap booze. It's this lack of blind optimism that makes this an honest document of the recession.

When Fite is asked whether he is optimistic about the future, about his own future, the future of his music, and America's future, there is an uncharacteristic silence, a break in the mind of a man who is always ready to talk. "No," he sighs. "Right now I'm just trying to figure out what I'm doing and if it's worth it."

We can't forecast the future any better than the market analysts who told people to buy Bear Stearns stock days before it filed for bankruptcy. But at least now we have an album that personally chronicles a period in our history that will be a turning point for our nation. [AP]

**Tim Fite**: www.timfite.com

# THE MAGNETIC FIELDS
*Realism*

Sometimes it is strange to think that more than a decade has passed

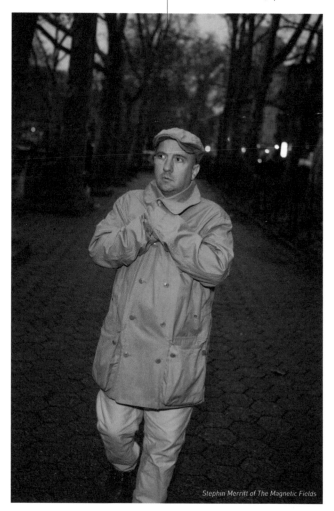

*Stephin Merritt of The Magnetic Fields*

since **Stephin Merritt** and his quirky pop ensemble, **The Magnetic Fields**, released their seminal 69 *Love Songs*. At the close of last century, Merritt essentially cemented his reputation as a peculiar and unassumingly off-kilter indie star, as the triple-disc album combined multifaceted synth pop and an overly sweetened sensibility to create a diverse and unique entry into the singer/songwriter's one-man world of experimental romanticism.

In this century, Merritt has continued his quest to conceive and devour other realms of the pop genre. The Magnetic Fields' 2008 album, *Distortion*, took many by surprise (though it was not unwelcomed), as Merritt and co. traded in their ukuleles and xylophones for electric guitars and noise, noise, noise. It felt like a strain if not an all-together departure for the group.

On the other hand, it was clear that *Distortion* was just another step on the tight wire that Merritt's music constantly walks, and now the balancing act has paid off in full. *Realism* is the antithesis of *Distortion*, an album completely devoid of electronics, or even drums for that matter. Reportedly, Merritt conceived *Realism* and *Distortion* as companion pieces, yin and yang to each other, balanced by their extreme opposition. Whereas *Distortion* shrieked and shredded, *Realism* sways and subtly laments.

Though still wildly varied, *Realism* is filled with the folk-pop flourishes of Merritt's latest fascination, and the album predominantly evokes an acoustic '60s communal vibe, as well as the psychedelic orchestrations that dominated the flower-power generations. Still, each track is a display of originality and experimentation. Simply put, nobody writes pop songs like Merritt. His slant on everything from melody to production is a world unto itself, this time the flip side to today's folk regressions and standard bearers.

The only constant in The Magnetic Fields seems to be the contrasted joy and bleakness that the lyrics incite, and *Realism* continues this tradition. These songs are populated with romantic, though often devastating, chronicles of aggrieved partners, confused messages, and, oddly, even the occasional "hootenanny." *Realism* also has some of the most trippy little moments, such as the child-like "Doll's Tea Party" and "Everything is One Big Christmas Tree," the former reminiscent of a teddy-bear picnic and the latter a surreptitiously festive fallout that even throws in a German chorus for good measure.

At face value, the record is not without faults. Merritt's dedication to concise pop music leads to some awkward fadeouts before a song can complete itself, and the vocals from Claudia Gonson and Shirley Simms have not held up as well as Merritt's own sub-bass doldrums. But overall, this could be considered a return to form for The Magnetic Fields if it weren't so unique. And though this album is as devoid of synths as it is reverb, this is the album most closely resembling the vision set forth by 69 *Love Songs*, and a welcomed turn for the ever-wandering Merritt. [CS]

**The Magnetic Fields**:
www.houseoftomorrow.com
**Nonesuch**: www.nonesuch.com

# MELT-BANANA
*Melt-Banana Lite Live: ver.0.0*

Though self-reinvention can pose a grave threat to underground acts that can't necessarily afford to lose fans, the confusingly titled latest offering from **Melt-Banana** isn't likely to test the loyalty of the colorful Japanese outfit's audience. In fact, the album arguably represents the full blossoming—some 17 years after the fact—of a sound and vision that were highly distinct from day one. The most radically expansive work of Melt-Banana's catalog to date, *Melt-Banana Lite Live: ver.0.0* documents a three-piece, no-guitar/no-bass variation of the usual lineup forging into unexpected territory while nonetheless keeping the essence of the band's sound intact. (Bassist Rika Hamamoto does not appear on the recording but has not left the band.) No small feat, this new configuration manages to come up with a completely fresh take on Melt-Banana's usual approach yet still employs several of the trademark elements that have wowed American and European audiences since the band's first international tours in the '90s.

*Lite Live: ver.0.0* features latest drummer Inomata along with mainstays Yasuko Onuki and Ichirou Agata, both of whom play samplers while Onuki sings and runs her Minnie Mouse-like yelps through an array of effects. Fans need not worry that the absence of Agata's guitar, a cornerstone of Melt-Banana's sound, compromises the new music, or even that this incarnation of the band comes across as "lite" at all. Because Agata has pushed the sonic envelope so far with the guitar already, his new palette of sampler-based sounds doesn't actually

Melt-Banana

stray far from the breathtaking range that he established years ago. Truth be told, listeners might not initially notice that guitar and bass are absent, as the buzz-saw crackle and low-end thrum of the samples often creates the illusion that Agata and Hamamoto are both present doing their usual duty.

Kicking off with "Feedback Deficiency," a hard-driving Inomata groove sets the album's tone and, within the first minute or so, negates any apprehension that this so-called "lite" version of Melt-Banana has relinquished any of the original band's heft. Soon thereafter, a flurry of blast beats sends the music hurling away from the pop-leaning direction of Melt-Banana's last album, the 2007 release *Bambi's Dilemma*. Several songs from that album appear here but are essentially subsumed and reframed almost beyond recognition by their new textures. And texture is what Onuki, Agata, and Inomata deliver here in spades. Though this is a live album, the startling clarity and spatial depth of the recording simultaneously capture and transcend Melt-Banana's live energy, making this the first time that the band has proven itself able to sustain its tremendous power over the course of an entire album.

Though Melt-Banana has always shown remarkable ingenuity at grafting no wave, grindcore, **Ramones**-inspired punk, video-game sounds, etc. into a

potent, ultra-unique blend, *Lite Live: ver.0.0* provides nuanced headphone thrills that not even the band's most fervent fans could have expected from them this late in the game. And though the music is indeed fully structured, Inomata's looseness, combined with his ability to maintain the music's pulse in the midst of a chaotic maelstrom of noise, makes due on the previously unfulfilled promise that **John Zorn** made so long ago when he compared **Napalm Death** to free jazz. It may not be the closest relative to *Interstellar Space*, but this album certainly does take you on a mind-bending journey, one that reaches across astoundingly vast distances of the sonic cosmos for being less than half an hour long. And when, about half-way through the song sequence, the music lands in a glimmering pool of neon-pixel radiation with the eerily resplendent "Cat and the Blood," it is as if Melt-Banana has crossed a threshold in the space-time continuum that leaves both band and listener irreversibly changed. *Bambi's Dilemma* had its ambient moments, but here ambience actually combines with noise for a sound so unprecedented it's as if it originated in a future century.

If anyone was going to take grindcore to the furthest reaches of the galaxy and beyond, in hindsight it makes perfect sense that it was going to be Melt-Banana. Still, the fact that the

band has so insistently evolved and been so successful at developing its sound shouldn't detract from the credit it deserves for the quantum leap that it takes on *Lite Live: ver.0.0*. The album closes with the one-two ambient suite of "Last Target on the Last Day" and "Humming Jackalope, Waiting for the Storm...," where chaos and beauty circle and entwine each other before imploding in what could very well serve as the soundtrack to all the world's technological systems crashing at once. In one symphonic— and strangely soothing—gasp, the music disintegrates into an ocean of white noise.

These last two songs alone would constitute a stunning achievement by any artist's standards. The fact that they come from a doggedly obscure act that surely must have once appeared doomed to novelty is nothing short of a revelation. The world at large may not notice right away, but Melt-Banana has hereby pushed music into a literal state of hyper-originality. Where noise and grind were once seen as end-of-the-line destinations to be pursued for their own sake, for the sheer pleasure of exerting explosive amounts of energy before pulling back again, *Lite Live: ver.0.0* proves that, in Melt-Banana's hands, extremity is a realm of florid possibility, a place where the adventure is only just beginning for those sufficiently armed with imagination and the daring to use it.

Eventually, of course, other bands will surpass its achievements and reach newer ground, but *Lite Live: ver.0.0* will always serve as the map to consult on the way there. Until then, it's a hell of a thrill getting dragged along for the ride, and nobody else can take you on a ride at full-on warp speed quite like Melt-Banana can. [SRK]

**Melt-Banana**:
www1.parkcity.ne.jp/mltbanan
**A-Zap**: www.a-zap.com

## MR. GNOME
*Heave Your Skeleton*

The duo known as **Mr. Gnome**, comprised of lead singer / guitarist Nicole Barille and drummer Sam Meister, is a musical tour de force where Barille's billowy, echoing vocals are offset with Meister's forceful, direct beats. Formed in Cleveland in 2005, the band put out two EPs before its 2008 debut full-length album, *Deliver This Creature*, created a buzz among critics and fans for its fusion of mellow vocals, feverish percussion, and trippy guitar riffs. The follow-up, *Heave Yer Skeleton*, delivers on all the potential that its predecessors promised, showcasing a sound that is alternately fragile and powerful.

"I don't think we ever limited ourselves to what we wanted to sound like," says Barille, who counts trip hop, heavy music, and indie rock among the band's musical inspirations. "Our sound is more [based on] what riffs you gravitate towards and what melodies come out of what you're working on."

Mr. Gnome's sound is distinguished by its primary ingredients: the soft drawl of the lead vocals and the alt-metal-inspired drums. The accompanying underpinnings of guitar serve as a background that adds a disjointed, psychedelic feel.

Barille's lyrics tend to be cryptic and difficult to decipher, but she says that her everyday experiences in Cleveland often are the catalyst for her writing. "We always try to keep things as natural as possible [when writing songs]," she says. "Just being inspired by life might change the way you write, and you hope that you evolve in some way or

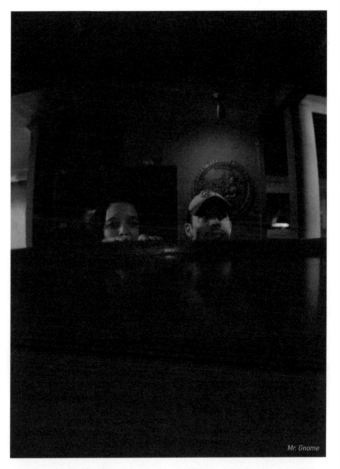

*Mr. Gnome*

maybe find a different direction to go to and not be scared to take it to areas you didn't before. I think that's all we try to do, to keep an open mind. We try to always love what we're doing, or else it would get really boring."

With two highly praised albums under its belt and a dynamic two-song EP released earlier this year, the band has humble goals for its future. "If we could just keep on doing this until we don't want to do it anymore and make enough money not to have to get jobs,

that'd be good," Barille muses. "All we want out of this is to be able to play music." And if recent critical response is any indication, Nicole Barille and Sam Meister aren't going to have to update their résumés any time soon. [AR]

**Mr. Gnome**: www.mrgnome.com
**El Marko**: www.elmarkorecords.com

# RAISE THE RED LANTERN
*Raise the Red Lantern*

The second full-length from this Chicago quartet immerses listeners in a patchwork style of the heavy-metal genre in a remarkably cohesive way. The eight songs on this album—which call to mind the roar of apocryphal beasts and unspeakable Lovecraftian horrors—are like shotgun blasts at ungodly, malformed creatures. It's metal, but with a down-to-earth, hybrid punk-rock sensibility and style that slays the disabling attitudes that these mythical monsters might represent.

Dylan Patterson, one of the band's two guitarists, says that *Raise the Red Lantern* is a rebirth. "We've put together the lineup that we felt was right, and I feel like it's a lot different

than what we used to do," he says. "We just decided to start over, and this album is more of a starting point or an indication of where we've landed." And **RTRL** has landed somewhere inside the creative space of progressive metal, with ever-shifting tempos and approaches—thrash, stoner, death, fist-pumping anthemic power—that are all over the place without being tangential or distracting. Part of this blend is because RTRL has added drummer Jim Staffel, of the genre-bending Chicago metal outfit **Yakuza,** who "has an undeniable metal style," Patterson says.

Recording this self-titled album at Volume Studios in Chicago was a "pretty easy, natural process," Patterson says. "I don't feel like we forced anything on this record." And nothing feels forced or disjointed. Because RTRL imposes few limitations on its sound, the songs breathe; band members allow themselves to take different directions rather than sticking to a boring, straightforward script. This can be off-putting at first, as on the opener "Ritual in CM,"

in which a hardcore-style breakdown erupts with very little buildup and throaty, black-metallish screams echo in and out. But within the context of the flow of the album, it is an appropriate leadoff and sets a premise for where *RTRL* will take you. The next number, "Thick as Thieves," begins with a mid-tempo rhythm-guitar chug, while the lead guitarist overlays choppy, high-end hammer-ons and pull-offs. About four minutes in, the song stops and then guitars, bass, and drums come together in a harmonious groove for the next three minutes, with singer/guitarist Kris Milkent warning us to "embrace what we fear."

By the time you get to "Oracle," a six-minute track that rises and falls with double-bass blast beats and meandering guitar solos that interlace nicely, *RTRL*'s tempo shifts and the blend of wandering styles feels more organic. You might even wonder why other metal bands think that they need to amputate their songs and/or compress their sound into a rigid style.

"Deliver Us/Deliverance" is a nice interlude between the first four tracks and the final three. Courtesy of bass player Craig Thompson, this three-minute long solo is as reminiscent of **Big Business** as it is early **Metallica**. It's also a great segue into "No Man's Land," a four-minute galloping-into-battle charge that fires on all cylinders to take down enemies of metal.

Asked how the band's sound has evolved over its six years of existence, Patterson is a bit reluctant to comment but eventually explains: "Over time, I guess, we just kept on getting better at the instruments and kept on getting louder and heavier. And then we got Jim in the band [from Yakuza]. So we just ended up being metal. It wasn't really like a conversation or anything; it was just kind of a natural progression from punk to metal."

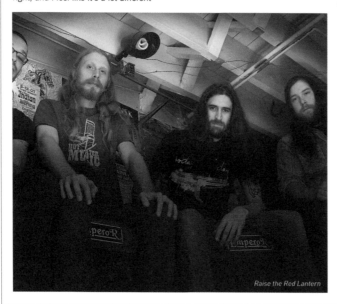
*Raise the Red Lantern*

The cohesiveness that makes RTRL's blend of approaches feel natural is due, at least to some degree, to the band members' working relationships. Three of the four guys work for Emperor Cabinets, a company that Patterson and Milkent started, where they custom build guitar and bass cabinets for bands. Having a practice space in their shop enables them to practice a lot more than they used to. "You hear about a lot of bands spending too much time together, getting on each other's nerves, so they break up," Patterson says. "We're spending so much time together that it's past that. We're stuck together; there's no way out. We don't really fight that much or bicker or anything, because between the band and the company, we've got so much invested in each other."

Friendships and shared goals often make for the best artistic projects and yield the biggest payoffs. This is the case with *Raise the Red Lantern*, an album that is a product of a unified vision. It demands a lot of its listeners, but open-minded metal heads are likely to embrace it. [BD]

**Raise the Red Lantern**:
www.myspace.com/raisetheredlantern
**At a Loss**: www.atalossrecordings.com

# WHITE HILLS
*White Hills*

There are many roads leading from '60s-era psychedelia. Some are lightly used footpaths to weirdness that even the drug-soaked forefathers of the genre most likely would struggle to comprehend, whereas others are more like super highways where the sounds and aesthetic are as banal and to the lowest common denominator as a Stuckey's. The latter is everywhere; it's all the same, and listeners who know better walk away feeling like they've had a little piece of their soul removed and replaced with something ugly and worthless like a truck-stop snow globe.

There's another path somewhere between, as there usually is with these sorts of things, where the ideas of what psychedelic music meant are un-

derstood, put into a great pot of ideas, and ejected back into the universe as something that comes off as less of an imitation or interpretation and more or a natural extension of the genre given all that's happened in the intervening 50 or so years.

To complicate matters further, Dave W., frontman for the band **White Hills**, rejects the term psychedelic as a descriptor for his band, despite the fact that said band sounds, at times, an awful lot like **Hawkwind** or the **Pink Faries**, two bands for which he admits a deep admiration. Instead, Dave W. prefers the term "space rock," a subgenre of psych that includes the aforementioned Hawkwind but also some big names such as **David Bowie** and modern groups like **Comets On Fire** and **Monster Magnet**.

"I think people use the term psych way too loosely," Dave W. says. "Most of it isn't psychedelic. True psych makes you feel like you're hearing something you've never heard before. I specifically set out and labeled us as space

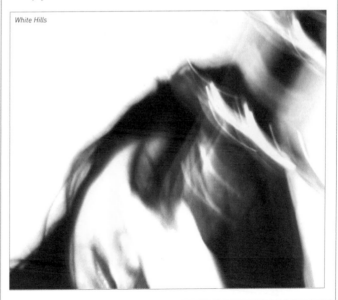
*White Hills*

rock. I didn't do that because we're like Hawkwind. I love Hawkwind. I love the Pink Faries, but I don't want to be them."

Labels aside, White Hills is a band with a unique and compelling sound that adds as much as it takes from the canon of weird rock music gone by. Fuzzed-out, overdriven guitars meld with odd, seemingly cryptic lyrics and the noises of ordinary life—from a barking dog on the streets of New York City to Austrian church bells—to create something truly original.

"That's psychedelic," Dave W. says of the found sounds on White Hills' self-titled record. "You weren't expecting that. You weren't expecting to hear footsteps or a dog barking. It's something different. Living in New York City, there's all kinds of noises. It's kind of like music. It's the heartbeat of the city. I'll often just walk around and record the things I hear with a little digital recorder instead of tracking synths and whatever. It's right outside your door. It takes the tunes to a different level. It's creating a mood."

Despite White Hills having little in common with the typical "jam" band, Dave W. says that this album is the result of a much more laid-back approach than he is used to. "I spent the least amount of time on the production of this record than any record we've done," he says. "I wanted to capture the essence of the moment. This one is so raw. There were so many variables that could happen because we didn't really rehearse. We never played any song more than three times."

The "less is more" attitude toward songwriting pays off for White Hills. Spontaneity replaces precision, and creativity blooms. Album opener "Dead" is a hypnotic, reverb-soaked lesson in heavy yet subtle rock, rife with imperfection but beautiful in its ruggedness.

"I brought that in the day before we recorded it," Dave W. says. "We didn't record that song more than once. In the last part, there's a point where Kid [Millions] dropped a drum stick and the cymbals drop out, and it's just kick and snare. Then it goes up another level when he picks up his stick, hits that cymbal, and kicks back in."

Yes, imperfections abound. The song "Let the Right One In" changes tempo over and over, and the final song on the album, by Dave W.'s own description, "falls apart all over the place." He makes no excuses, chalking up every misplaced noise to experimentation.

By abandoning the quest for perfection and refusing to concede allegiance to a genre of music from which it clearly stems, White Hills opens doors for itself. The self-titled album, its eighth overall, owes as much to **Mudhoney** ("Polvere De Stelle") and **Lungfish** ("Three Quarters") as it does Hawkwind, but there's still something undeniably psychedelic about that combination of influences. Even Dave W. is helpless to deny it when pushed.

"It's head music," he says. "It's just what comes out. Some people call it stoner rock. Let them. Get high and rock out." [OC]

**White Hills**: www.whitehillsmusic.com
**Thrill Jockey**: www.thrilljockey.com

## WHITE MICE
*Ganjahovadose*

It's hard to get a sense of who **White Mice** are. The ever-rotating cast of musical miscreants hides behind a bloody veil of violence and absurdity to say nothing of its nightmarish, Frankenstein-ed masks. Interviews are typically off topic and filled with more cryptic allusions than a Robert Anton Wilson novel. And unlike dealing with **The Residents**, there's no form of management to prod. This makes traditional coverage of the group difficult if not impossible. Here's what can be safely written.

White Mice began on a lark for a Halloween party in New Jersey in 2001. Its name—based on British slang for used tampons and tissues floating in the sewer—was allegedly inspired by a shitty plumbing incident a few days before the show. The band collaborated with a host of musicians over the next couple of years and self-released a few records, each of which had its own punny pseudonyms. Oh yes, they love those kind of puns (which, for the record, are technically homophones). Each liner note, song title, and pretty much any text associated with the group is filled with wordplay that would shame Piers Anthony and small-town newspaper editors.

The band's core remains bass, drums, and electronics, but it has been known to include guitarists and additional personnel at shows. White Mice shows often include blood-squirting props, saw blades, and the occasional kiddy pool of blood or an eight-foot-tall piñata filled with trash. Its yearly birthday party / Halloween show usually takes place in an abandoned ware-

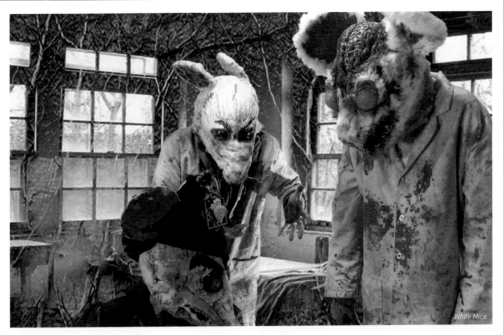

White Mice

house in New Jersey. According to the band, the 2009 festivities included a White Mice cover band with drums, tubas, and saxophones. Apparently, a friend of the band broke her neck during White Mice's set, quite seriously at the sixth vertebrate. Judging from the show footage floating around on YouTube, it's surprising that this kind of thing doesn't happen more often.

For the band's 2009 release, *Ganjahovahdose*, it has created its 23rd generation of costumes. This is either a matter of artistic rebirth or simply the fact that composite materials can't hold up to regular use for more than four months at a time. As for the role of the masks in the band, the White Mice are forthright: "[They're] mostly as blindfolds, to make playing challenging music more challenging to the deeply challenged, but more photogenic." They go on in an uncharacteristically sharp exposition that wavers somewhere between Joseph

Campbell and Jim Carrey in *The Mask*. "[It's] a symbol of anonymity, hiding from death, an escape or rebirth, a new face. When people put on masks, they do so to maybe hide their inner alcoholic, coke-slut, freak serial killer—to appear 'normal,' or to release that demon or other impulsive spirits, [whether it's] animal, primitive, or alter-ego, etc. One side is more 'real,' but who's to say which one?"

It's probably just the mixing, but *Ganjahovahdose* captures White Mice at its most direct. The drums punch the songs forward, with bass seeping in and out of prominence and noises lost in the din. The singing—oh yeah, there's singing—remains raw and gravelly, barely discernable and undoubtedly full of blasphemy and puns. For more adventurous listeners, it'll take extreme volumes to hear the nuances of what's really going on, but that's likely the point. *Ganjahovahdose* highlights the fact that, at the end of the

day, White Mice plays actual songs, not just noisy jams. Still, it's hard to categorize its music as anything other than noise rock, something of which the band is well aware. "We are [often] labeled 'noise grind.' Aficionados of either genre will attest [that] we are neither. Those labels/scenes/genres/opinions are like someone else's pants, butt just ass (sic) confusing, they don't quite fit us."

Perhaps it's best that White Mice remains obscured in filth and grime. The band is more interesting as symbols—the embodiment of personal nightmares and unadulterated chaos. Whether you love it or love to hate it, White Mice demands rapt attention and elicits a visceral response. The cheesy jokes are mice too. [NMD]

**White Mice**: www.thewhitemice.com
**20 Buck Spin**: www.20buckspin.com

# RUDI ZYGADLO
*Great Western Laymen*

Rudi Zygadlo

When Scottish songwriter **Rudi Zygadlo** set out to create an album, situated in a Glasgow flat between two looming church spires, his original goal was to arrange the Latin mass for electronic music. Raised by artist parents who helped nurture an early interest in music, Zygadlo instead abandoned that idea in favor of creating a brilliant debut album that touches, however lightly, on themes of church and religion.

*Great Western Laymen*, his debut album on Planet Mu, fuses electronic music with pop structures and classical aspirations, taking the mid-tempo lurch and chunky bass lines of dubstep and marrying them to glossy, mutating pop songs. Zygadlo sings on almost every track, and his voice, which he says is "there more for its instrumental value rather than its poetic value," features prominently as a lead.

Though the formal songwriting may have been abandoned, the lyrical content stays focused on the ecclesiastical. Titles such as "Something About Faith," "Song of Praise," and the closer "Opiate of the Mass" all connote an anti-religion concept, a suggestion that Zygadlo rejects. "[My lyrics] aren't very explorative, and I don't think I'm asserting any particular beliefs or prejudices," he says. "They are whimsical vignettes, fleeting expressions." This serves the immaculately produced album well. The vocals are omnipresent, panning everywhere and usually multi-tracked, pitch shifted, time stretched, vocoded, and tweaked beyond intelligibility. The vocals fight

with wonky basslines for supremacy in a crowded (but never cluttered) midrange.

Though many of the tracks would play well in a club setting, *Great Western Laymen* also makes for excellent headphone dubstep, and Zygadlo never falls into the boom-bap plod that plagues much modern bass music. Instead, the music is full of surprises, like the **Mount Kimbie**-esque percussion tics of "Something About Faith," which features restless drum patterns that splinter into fragmented rushes and stutters of sound. Zygadlo also maintains a tension between the deliberate stomp of dubstep bass lines and the organic flourish of live instrumentation. "Magic in the Afternoon" opens with, in Zygadlo's own estimation, "probably the heaviest riff in the album." However, the riff is abruptly discarded in exchange for a piano solo, played by Zygadlo. "Adding this gave the track a new dynamic," he says. "The juxtaposition of laboriously programmed electronics and instantaneous solo improvisation can be really effective, I think."

To complete the album, he enlisted a few friends: Leah Gouh-Cooper provides an alto-sax solo to open "Missa Per Brevis," weaving her line around a

wandering bass line and an insistent arpeggio; Gerry Mckeever plays a simple trumpet line at the close of the album. Neither instrument lasts long against Zygadlo's filters and cut-up aesthetic, but both provide humanity against a largely synthetic backdrop.

With *Great Western Laymen*, Zygadlo has crafted an album of stunning density and variety. Most dubstep albums don't have half as many hooks, and most pop albums don't have this level of head-nodding funk. Zygadlo set forth to combine what he loved about dubstep and IDM with song structures that borrowed from jazz, pop, and classical, and he's succeeded marvelously. [PH]

**Rudi Zygadlo**:
www.myspace.com/rudizygadlo
**Planet Mu**: www.planet.mu

**Music Reviewers**
[OC] Oakland L. Childers
[BD] Brendan Dabkowski
[MD] Michael Danaher
[NMD] Nick DeMarino
[JE] Jonathan Easley
[PH] Patrick Hajduch
[AP] Arthur Pascale
[AR] Adam Redling
[SRK] Saby Reyes-Kulkarni
[MS] Matt Seager
[CS] Charlie Swanson

# ALSO FROM
# ALARM PRESS

### ALARM 37: Rules Were Made to be Broken

Fueled by an ever-growing need, the musicians and artists of *ALARM 37* never cease to explore and conquer new frontiers. Featuring Converge, Vic Chesnutt, Tortoise, Why?, Themselves, A Place to Bury Strangers, Kid Koala, Vernon Chatman, and more.

### ALARM 36: Art is Life, Life is Art

The individuals profiled in *ALARM 36* represent a variety of distinct personalities from today's irrepressible cultural underground. Featuring Om, Sunn O))), Vieux Farka Touré, Serengeti & Polyphonic, Thee Oh Sees, Ian Svenonius, Health, and more.

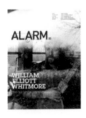

### ALARM 35: Music from Nowhere

Good music often comes from the most unlikely places. *ALARM 35* presents a plethora of unique artistic voices, whether they come from a faraway land or just up the street. Featuring William Elliot Whitmore, P.O.S, Fever Ray, Dan Deacon, Richard Pinhas & Merzbow, Bob Log III, Dälek, and more.

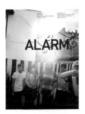

### ALARM 34: Fucked Up

Uncompromising in taste, style, and spirit, *ALARM 34* provides a glimpse of real, living, breathing independent culture. Featuring Fucked Up, Nick Cave, The Bad Plus, Black Moth Super Rainbow, Kieran Hebden & Steve Reid, Brazilian Girls, Young Widows, and more.